THE ART OF THE
SPORTS CAR

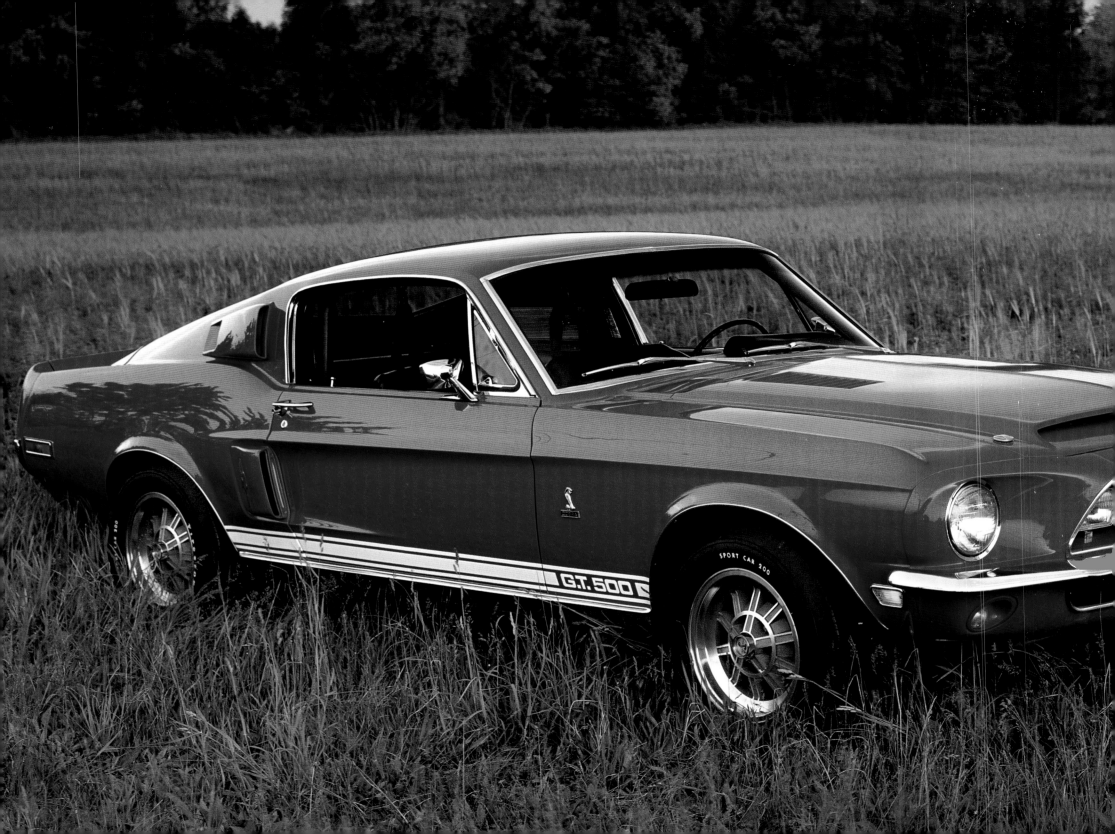

THE ART OF THE SPORTS CAR

The Greatest Designs of the 20th Century

WRITTEN AND WITH PHOTOGRAPHS BY

DENNIS ADLER

HarperResource
An Imprint of HarperCollinsPublishers

HarperCollins books may be purchased for educational, business, or sales promotional use. For information please write: Special Markets Department, HarperCollins Publishers Inc., 10 East 53rd Street, New York, NY 10022.

FIRST EDITION

DESIGNED BY RENATO STANISIC

Library of Congress Cataloging-in-Publication Data

Adler, Dennis, 1948–
 The art of the sports car : the greatest designs of the 20th century / written and with
photographs by Dennis Adler.— 1st ed.
 p. cm.
 Includes index.
 ISBN 0-06-018885-5
 1. Sports cars—Collectors and collecting. 2. Sports cars—Design and
construction—History—20th century. I. Title.

TL236 .A35 2002
629.222'1'09—dc21 2001051810

02 03 04 05 06 WBC/IM 10 9 8 7 6 5 4 3 2 1

To Jeanne

Was a red Corvette first caught my eye,
But the driver who stole my heart

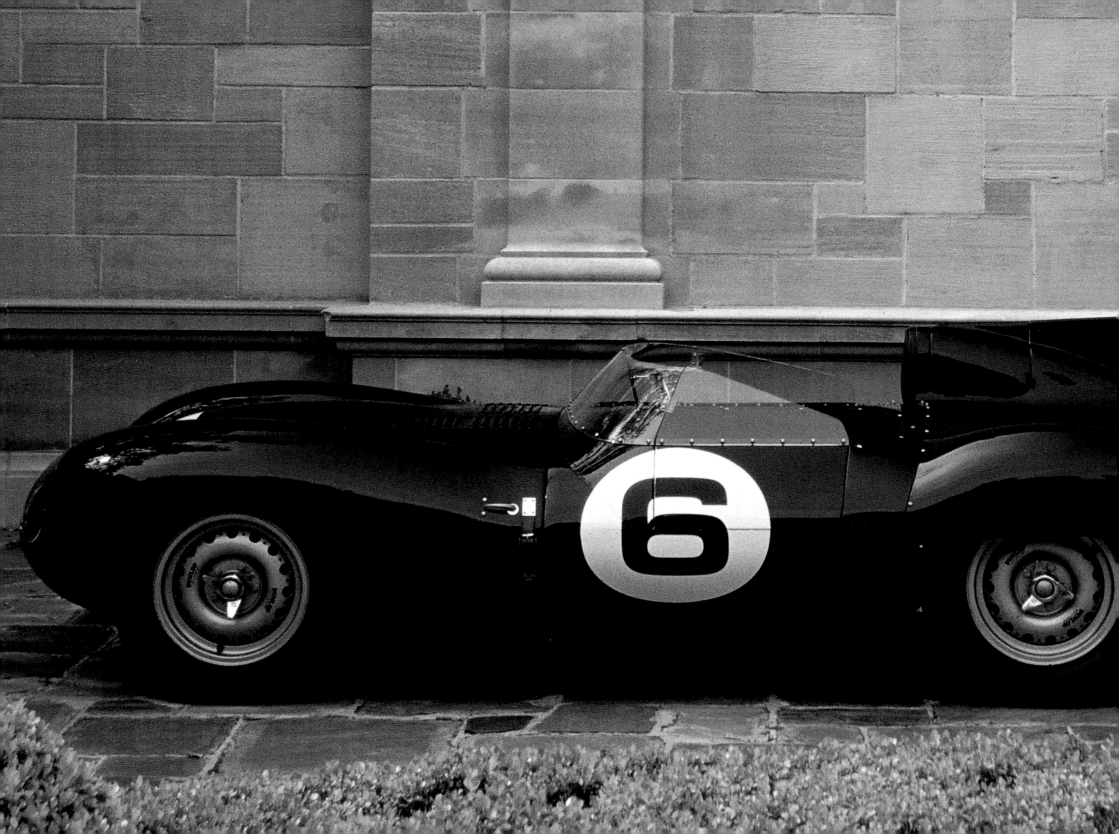

CONTENTS

FOREWORD

STRENGTH HAS NOTHING TO DO WITH WEIGHT. THE MENTALITY OF THE MAN WHO DOES THINGS IN THE WORLD IS AGILE, LIGHT, AND STRONG. THE MOST BEAUTIFUL THINGS IN THE WORLD ARE THOSE FROM WHICH ALL EXCESS WEIGHT HAS BEEN ELIMINATED. STRENGTH IS NEVER JUST WEIGHT—EITHER IN MEN OR IN THINGS." THAT'S WHAT HENRY FORD SAID IN 1923, AND IT IS THE BEST DEFINITION I HAVE EVER HEARD OF A SPORTS CAR, THOUGH FORD PROBABLY DIDN'T HAVE A SPORTS CAR IN MIND WHEN HE SAID IT. • WHEN YOU LOOK AT ALL THE FAMOUS SPORTS CARS THROUGHOUT HISTORY, HENRY'S EDICT HOLDS TRUE, FROM THE MERCER RACEABOUT OF 1911 TO THE Z06 CORVETTE OF TODAY—THE IDEA BEING TO TAKE A PRODUCTION AUTOMOBILE, STRIP AS MUCH WEIGHT

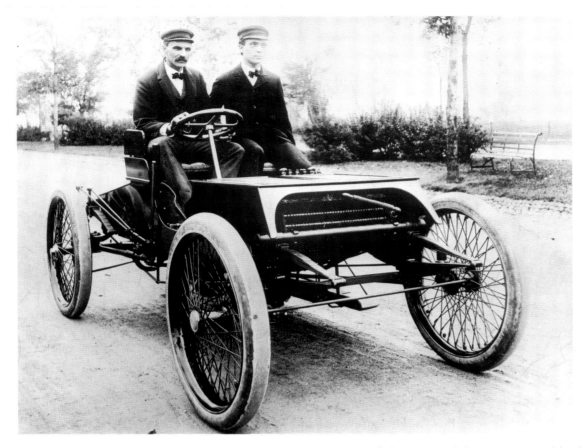

Among the many inventions credited to Henry Ford is a car he named Sweepstakes, built in 1901 by the then 38-year-old Ford to race against Alexander Winton's 1901 raceabout. Pictured with Ford (at the wheel) is his colleague Oliver Barthel. (Photo courtesy Ford Motor Company)

just a little longer, Benz would have had to share the honor with Gottlieb Daimler and Karl Maybach, two engine builders a mere 100 kilometers away in the town of Cannstatt—less than an hour's drive today. More than 115 years later, Benz, Daimler, and Maybach are the three names most closely associated with the invention we call the automobile. But there were so many more.

Personally, I like to think of old Henry as the inventor of something much more exciting than the automobile. Yes, he created what history regards as the first moving assembly line (although there is debate even on that point), and he most certainly put America on wheels in 1909 with the Model T, but he built something else, back in 1901, two years before the Ford Motor Company even existed, something that few people at the time recognized as a turning point in the evolution of the automobile. Henry Ford built a sports car. He wasn't alone. In the same year Henry assembled a racer he named Sweepstakes, Daimler introduced the first automobile to bear the Mercedes name, a swift, 40-horsepower, sports two-seater that swept the racing and hill climb events at Nice Week in March and wrote itself into history as the first modern automobile.

Here in America, Henry Ford also accomplished something quite remarkable in 1901. He built Sweepstakes with a single purpose: to go as fast it could, any way it could. His goal back then was to best a feisty Scotsman named Alexander Winton, a successful Cleveland automaker and accomplished racer. In the contest, which took place at a one-mile dirt oval in Grosse Pointe, just east of Detroit, Ford prevailed, catapulting himself into the limelight of the emerging 20th-century American automotive industry. He had built a better car than Winton and had proven it in competition before a crowd of 8,000 spectators and a group of reporters from the nation's leading newspapers. The 38-year-old Ford had not only won a $1,000 prize and a cut-glass punch bowl, he had also beaten the best in the country that day, which elevated his stature enormously. The notoriety helped him gain the financing needed to start the Ford Motor Company on June 16, 1903.

In 1902, Henry had built another speed machine, this one driven to a new threshold of performance by a daredevil named Barney Oldfield. Suddenly, everyone was aware that these noisy, foul-smelling mechanical carriages emerging from every corner of the country might indeed amount to something. The early racers and their sporting cars had created something very tangible: curiosity.

By the early 1900s, the automobile had progressed from a novelty into a means of practical personal transportation, albeit one best suited for the wealthy. Henry Ford would change that too, with the introduction of the Model T. Furthermore, as America entered the second decade of the 20th century, the nation's infrastructure was undergoing revolutionary changes. Horse-drawn carriages still outnumbered motorcars, but the main streets of America were seeing more and more autos sharing the thoroughfares each year. And as passenger cars grew in popularity, so too did the charisma of the open-bodied, two-seat sports car.

Throughout turn-of-the-century Europe, sports car racing had gone beyond America's early flirtations with speed, owing to the greater number of paved roads and the long-standing rivalries among nations to prove their superiority over one another. Motor racing was vastly more practical than war, and generally more entertaining. As might be expected, the lines were primarily drawn between France, England, Germany, and Italy, all of which had enterprising automakers and national pride—the fundamental motivation for building and racing sports cars for the last 100 years.

On our side of the Atlantic, the first 500-mile race was held at the new speedway in Indianapolis, Indiana, in 1911. On board tracks across the length and breadth of our land, men were pitting their skills against one another, and sportsmen were taking to the open road with the latest, fastest, and best-designed open two-seaters of the day.

Throughout the early years of the 20th century, the

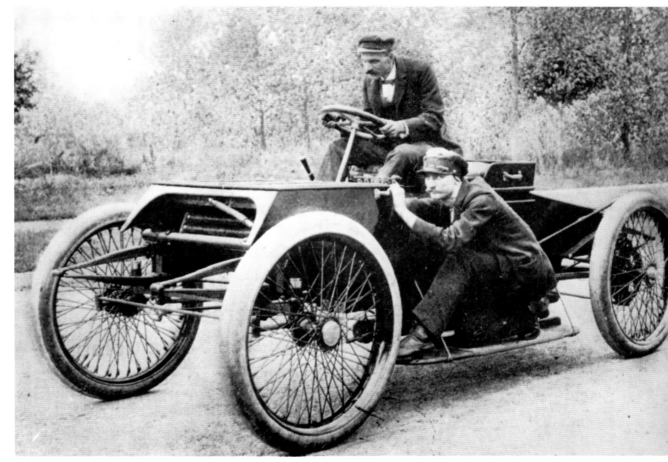

Ford at the wheel of Sweepstakes, with riding mechanic Spider Huff in his position on the running board. Ford and Huff raced against Cleveland, Ohio, automaker Alexander Winton in the summer of 1901. The triumph over Winton came to be known as "the race that changed the world." (Photo courtesy Ford Motor Company)

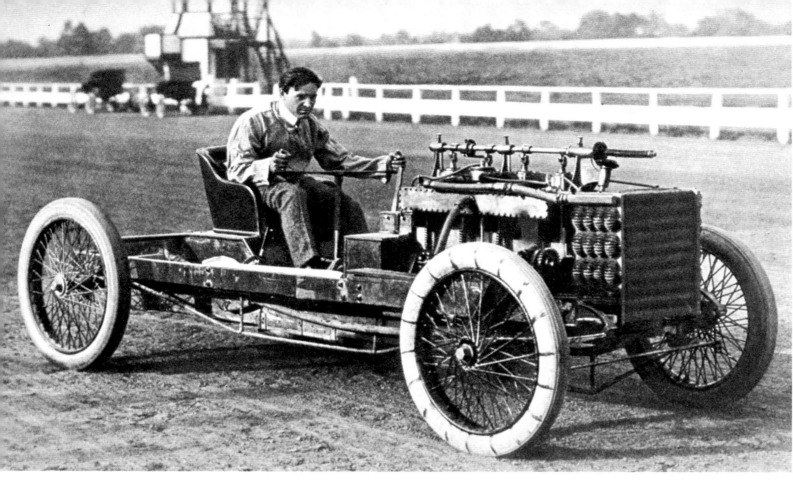

sports car was in the simplest form it would ever be—minimal bodywork, two seats, and the wind in your face. In the early 1900s, the line that divided sports cars from racecars was all but nonexistent.

In Mercer County, New Jersey, the Mercer motorcar company set the American road on fire in 1911 with a model called the Raceabout. Stutz, in Indianapolis, Indiana, followed suit with a racy model named the Bearcat, and every young buck with a toolbox and few spare dollars was trying to build a sporty two-seater.

The legendary Ford 999 sports racer was built for a rematch with Winton at the Grosse Pointe track on October 25, 1902. This was the race that launched the career of Barney Oldfield. With one week to practice, Oldfield handily defeated Winton and two other challengers in the five-mile race for the Manufacturer's Challenge Cup. (Photo courtesy Ford Motor Company)

Like the motorcar itself, the sports car was in constant change. By the early 1900s one could simply purchase a speedster body and mount it on a Model T chassis, rebuild the flathead Ford motor, and handcraft a sports car at home (this would later evolve into another American phenomenon after World War II—the hot rod), but most men, and a handful of adventuresome women, chose to purchase one of the established sporting cars of the day, such as the Mercer, Stutz, or Marmon. Those of extraordinary wealth either imported the best sporting models from Europe or acquired bare chassis and had them mounted with hand-built roadster and racing bodies of exceptional quality, leading to one of the most exciting eras in all of automotive history.

In place of the interlopers, the true heirs were about to set foot upon the stage by the early 1930s, both in America and in Europe. Within the narrow limits that defined a sports car, or perhaps what was better characterized during the 1930s as a *sporting car*, were the models of Mercedes-Benz (created by the merger of independent automakers Daimler and Benz in 1926), Alfa Romeo, Jaguar, Hispano-Suiza, Isotta Fraschini, Voisin, Bugatti, Delage, Delahaye, and Talbot-

Lago, among leading European marques. In the United States, a handful of sports models were produced by the nation's foremost automakers—and by one independent producer in Indianapolis, Indiana, whose models would leave the most indelible mark on the 1930s of any American automotive manufacturer: Duesenberg.

By the time of the Great Depression, the sports car had evolved into a singular idea: a two-seater (with the occasional rumble seat) with sleek, open coachwork, and the most powerful engine that its maker could shoehorn beneath the hood. It was not uncommon to find V-12s, V-16s, and supercharged straight eights powering lightweight roadsters and speedsters. Unfortunately, what was uncommon in the 1930s were buyers for such cars. Some of the greatest automobiles in history arrived at the worst possible time.

By the late 1920s and early 1930s, the sports car had taken a turn down a different road from purebred racing cars. One could race a sports car, but racecars (grand prix cars) were now built solely for competition, making them mostly unsuitable for the open road. This brief but exciting era came to a hasty end in 1939, but the desire to build swift, agile-handling cars could not be eliminated by war, and within a year after the hostilities had ceased in Europe, automakers were dusting off the ruins of their industry, righting drafting tables, rebuilding metal and wood shops, and setting about the task of creating a new postwar generation of automobiles.

In the post–World War II era, the sports car as we know it today began to appear as a smaller, more purpose-built design with the form and function European automakers had begun to establish by the late 1930s with cars like the little MG TB, Alfa Romeo's sporty 6C 2500, and the Mercedes-Benz sport roadsters.

In England, the Jaguar XK-120 emerged in 1948 as one of the first modern sports cars of the postwar era. From a small converted sawmill in Austria, the first 356 Porsche saw the light of day, and an Italian emigrant named Luigi Chinetti, who had become a U.S. citizen during the war, returned briefly to Italy to help an old friend, Enzo Ferrari, establish a new company that would build sports cars of unparalleled performance and beauty.

Between the turn of the century and the end of World War II, the automobile became a necessity for transportation, for commerce, and most assuredly for pleasure. If nothing else, one thing had become perfectly clear in the minds of manufacturers, designers, and consumers: If the automobile satisfied our needs, then the sports car fulfilled our passions.

This book, then, is about passion. It is about shapes and colors and sounds, and lust. It is about the tangible and the intangible things that make an automobile pleasing to the eye. It is about whatever fuels your desires when a sports car passes and you feel your pulse suddenly quicken, your breath catch, and you whisper to yourself, "I want one."

SPORTS CARS AT THE TURN OF THE CENTURY

Going as Fast as You Can, Any Way You Can

The first definition of a sports car was the 1901 Mercedes. This design, that of a two-passenger roadster, set the standard for early sporting and competition models. Pictured are Daimler race driver Wilhelm Werner and young Baron Henri de Rothschild. (Photo courtesy DaimlerChrysler Classic Center)

FOLLOWING THE TURN OF THE CENTURY, THERE WERE HUNDREDS OF UPSTART AUTOMOBILE

MANUFACTURING COMPANIES IN THE UNITED STATES. DETROIT WAS THE HUB OF THE AMERI-

CAN AUTOMOTIVE WHEEL, BUT THE SPOKES STRETCHED AS FAR AS INDIANAPOLIS, INDIANA;

READING, PENNSYLVANIA; AND TRENTON, NEW JERSEY. MOST SMALL AUTOMAKERS

SCARCELY GOT BEYOND A PROTOTYPE VEHICLE AND A HANDFUL OF PRODUCTION MOD-

ELS BEFORE CLOSING THEIR DOORS. THE AUTOMOBILE WAS A CRAZY IDEA. AND THAT

MADE IT ALL THE MORE DESIRABLE, PARTICULARLY TO SPORTSMEN, WHO VIEWED

THE MOTORCAR AS A NEW MEANS OF PROVING ONE'S METTLE. UNTIL THE

PACKARD—ASK THE MAN WHO RACED ONE

It didn't take long for American automakers to catch on, and new designs were appearing every year, but most were for touring—larger cars than sportsmen were seeking. Only a handful of models were designed for speed and to seat just two. Packard, America's premier automaker, was one of the first to address the needs of the few and the wealthy. In 1904, the company introduced the Model L Runabout. The Detroit automaker improved upon the design almost yearly and in 1907 introduced the Model 30 Runabout, a sporty two-place roadster priced at an astounding $4,200. To give a little perspective, a 1907 Ford Model T roadster, a smaller, less powerful, and somewhat uninspiring car compared with the Packard, sold for $750. Before long, almost every American automaker was offering a sporty, two-place car, but they weren't necessarily sports cars.

THE AFFORDABLE LITTLE HUPP

In 1910, Robert Craig Hupp introduced a dashing little two-seater billed as "the smartest and best little car ever marketed in America at anything like the money." The Hupmobile Runabout sold for $750 and was powered by a 2.8-liter, four-cylinder engine developing 20 horsepower. A simple car with no gauges, just two seats, a foot and hand brake, gear selector, clutch, gas pedal, and steering wheel, surrounded by little more than a hood and four fenders, Hupp's sporty-looking runabout reached sales of 5,340 in 1910! The Hupmobile went on to become one of America's most successful independent automotive marques in the 1920s and early 1930s, producing a wide variety of sports, touring, and family cars up until 1940, when the financial burdens wrought by the Depression, combined with declining sales, forced the company into bankruptcy.

THE AMAZING MERCER

It has been said that if Henry Ford was responsible for putting America on wheels, then Mercer was responsible for spinning those wheels faster. The 1911 Mercer Raceabout was a thundering, bare-bones road car with nothing more than a pair of seats attached to a handsomely painted frame and a rotund gasoline tank mounted at the rear. There was barely enough bodywork to cover the large wooden artillery wheels and 34-horsepower, four-cylinder Mercer engine. The Raceabout's obvious lack of coachwork, however, was amply offset by enough brass trim to make the car literally glisten in sunlight.

Among three different models, including a five-place Touring (with substantially more coachwork) and a Toy Tonneau four-passenger model, the Raceabout was Mercer's most famous model. Although not powered by a particularly large engine, just 300 cubic inches (small for the early 1900s), the T-head four, mounted to the lightweight chassis, was more than enough to achieve record speeds. The cars were equipped with a superb three-speed transmission (improved to a four-speed in 1913), and an oil-wetted, multiple-disc clutch, which contributed to the Raceabout's agile performance.

In 1911, Mercers won five out of the six major races in which they were entered. At the Los Angeles Speedway in 1912, race driver Ralph DePalma established eight new world records with a Raceabout, and Spencer Wishart took a Mercer Model 35 right off the showroom floor of an Ohio

ABOVE: *The Mercer Raceabout was the most successful sports model of its time. While others would follow in Mercer's path, the 1911–13 Raceabout set the standard.* (William B. Ruger Sr. collection)

RIGHT: *The Mercer Raceabout was simple in its execution yet remarkably complex in design, providing high performance with a reliable four-cylinder engine, selective gearshift, and a suspension suitable for both road and track.* (William B. Ruger Sr. collection)

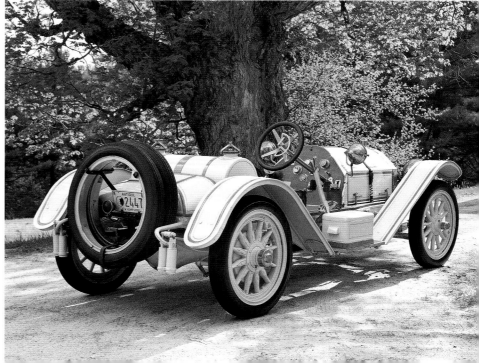

dealer to prove every car was race ready. He handily won a 200-mile race in Columbus and established four new dirt-track records in the process!

Mercer's successful string of racing victories through 1916, with daredevil drivers such as DePalma and Barney Oldfield, established the company as a leader in early motorsports competition.

A Mercer Raceabout was not an inexpensive car, despite its lack of substantial coachwork. On the average, a Raceabout sold for $2,500 by 1913, better than twice that of the average automobile.

Mercer continued to build a variety of sporting and touring models through 1921 despite the deaths of all of its founders and chief officers: F. W. Roebling, C. G. Roebling, and his son, Washington A. Roebling II, who had been responsible for the original 1911 Raceabout. He was one of the many who went down with the *Titanic*. In 1917, F. W. passed away, and in 1918, C. G. Roebling.

Although still producing a substantial number of automobiles, the company was in organizational chaos when a Wall Street syndicate, which had named itself the Mercer Motors Company, came calling. The original Trenton, Mercer County, New Jersey, factory was to become the foundation for a new conglomerate, but it was not successful and Mercer ceased building cars in 1924. Another attempt to revive the name was made by a New York investment group in 1928, but with the stock market crash of 1929, their hopes were dashed. The last car to bear the Mercer name was a prototype model shown at the 1931 New York Automobile Show. It was never built.

Since the dashboard had yet to be invented, controls and instruments, what there were of them, were confined to the fire wall. At this time, all motorcars were right-hand drive with the gear selector and hand brake mounted to the frame. The gas pedal is the narrow brass lever to the right of the brake pedal.

BILLY DURANT'S OAKLAND

In its time, the Mercer had been an inspiration to many automakers, including Harry Stutz, who introduced the equally exciting Stutz Bearcat in 1912, a car that looked and performed conspicuously like a Mercer Raceabout. The idea wasn't wasted on W. C. Durant at General Motors, either. In 1909, he had acquired the Oakland Motor Car Company (later to become the Pontiac Division of GM) and by 1912 had a sporting model available with the rather genteel name Sociable Roadster. By 1915, it had evolved into the Mercer-like and Stutz-like Oakland Model 37 Speedster, a somewhat more stylish and refined take on the bawdy Raceabout and Bearcat.

With only 39 horsepower, the Oakland didn't exactly provide chest-swelling puissance, but given the weight of the body, it was power enough to attain better than 60 mph. At the same time, Oakland also offered the Model 49, powered by a six-cylinder engine, and the Model 50, with eight cylinders. However, the Speedster body appears to have been offered only in the four-cylinder line.

Rudimentary raceabouts such as the Model 37 were not long for the automotive world, as styling, engineering, and performance improvements led to faster and more refined sports cars, including the Oakland Model 34 Roadster, which became the marque's leading sports model in 1917. By then, the era of the open-bodied Stutz, Mercer, and Oakland Speedsters was over, and maybe with it, some of the innocence and rugged adventure that had made the gentlemen's sport of motor racing so exciting in those first years following the turn of the century.

Oakland offered one of GM's first sports models, the 1915 Model 37 Speedster. With a four-cylinder, 39-horsepower engine, it performed admirably in reliability runs and hill climbs, winning no fewer than 25 of the latter by 1916. (John McMullen collection)

World War I put the skids on the European automotive industry by the end of 1914, but America's entry into the battle in 1917 had little effect on U.S. factories. A year later when the armistice was signed, things were back to normal, but a change was on the horizon, a new decade was just around the corner, and the American automotive industry was about to drive headlong into the Roaring Twenties, an era of prosperity, jazz, speakeasies, and fast cars.

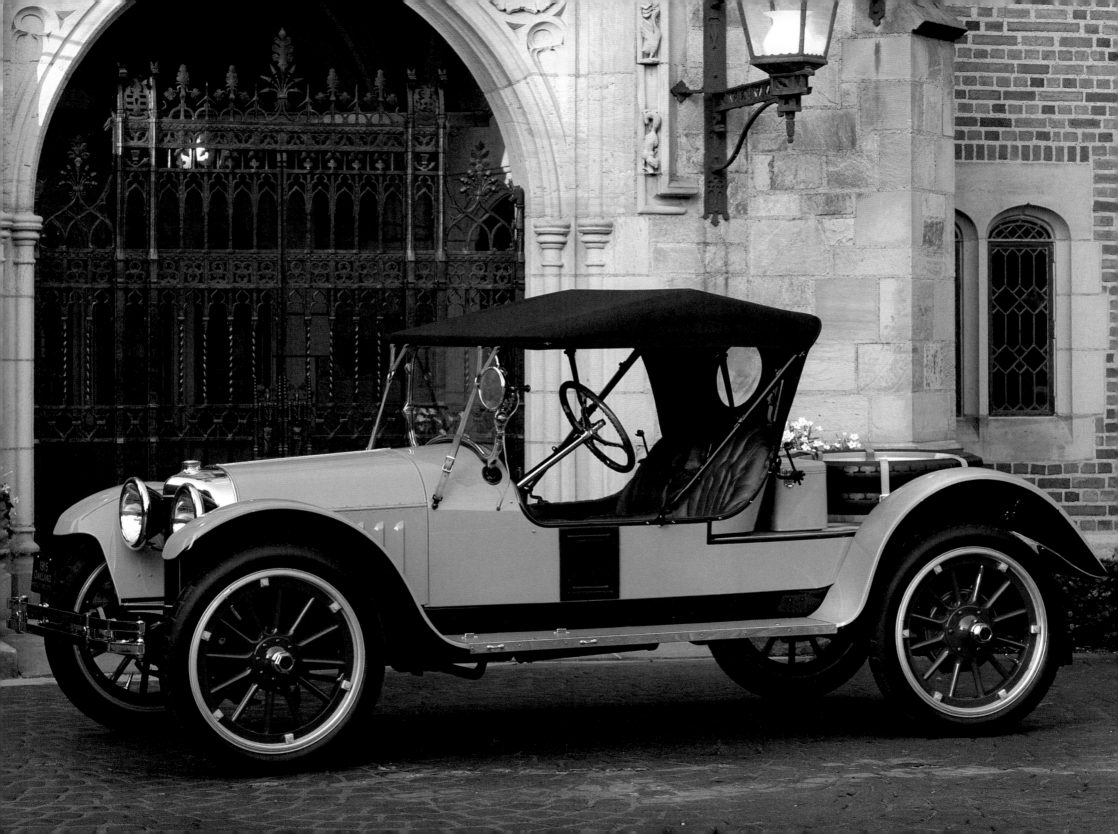

THE MARMON SPEEDSTERS

In Indianapolis, the county seat of the early American automotive industry, Howard Marmon advanced the engineering, construction, and manufacturing of sporting cars to new heights, and in 1916 he unveiled one of the most significant automobiles of the pre–World War I era, the Marmon Model 34.

Howard Marmon's innovative design incorporated the running boards, their supporting members, and the splash pans into the load-bearing structure of the car, which proved to be a breakthrough in platform design, achieving both a reduction in weight and an increase in strength. The advanced design of the Model 34 and later Model 34B, introduced in 1920, featured what Marmon described as "unification construction," making the body and chassis nearly one—essentially an early form of unibody construction, a manufacturing technique that would become an industry standard half a century later.

Marmon offered a variety of body styles, including limousine, landaulet, town car, and convertible sedan. But the best and sportiest were the Model 34B Speedsters, with coachwork manufactured by the Hume Body Company of Rochester, New York, and made entirely of lightweight aluminum over a braced framework of ash. Total weight of the Speedster was a mere 3,295 pounds.

The Marmon 34B Speedster was noted for its dashing appearance and exceptional speed. Equipped with a special 3.0:1 ratio axle, a Speedster was timed around the two-and-one-half-mile Indianapolis Motor Speedway at two minutes six seconds—an average of 71 mph—in 1920, an exceptional top speed for anything that wasn't built for racing.

Impressed by its performance, the race committee selected the Marmon Speedster to be the official pacesetter for the eighth running of the 500 Mile Memorial Day Classic in 1920. Legendary racer Barney Oldfield was asked to be the driver, but Oldfield, like others, was skeptical of the Marmon's ability to maintain a high enough speed to lead the racecars around the track and also get out of the way when the race began. To the surprise of everyone, including Oldfield, the Marmon shot around the brickyard at a top speed of 80 mph. Even Ralph DePalma, who had the pole position that year, remarked that the Marmon might have been the fastest car there!

Oldfield was so impressed with the Marmon's performance that he purchased it after the race. This turned out to be the greatest endorsement the company could have received. Oldfield drove the Indy pacesetter coast to coast eight times promoting a line of tires bearing his name. The car became so popular with the public that three months after the race, Marmon announced it would produce a series of Wasp Speedsters identical to Oldfield's, painted Marmon

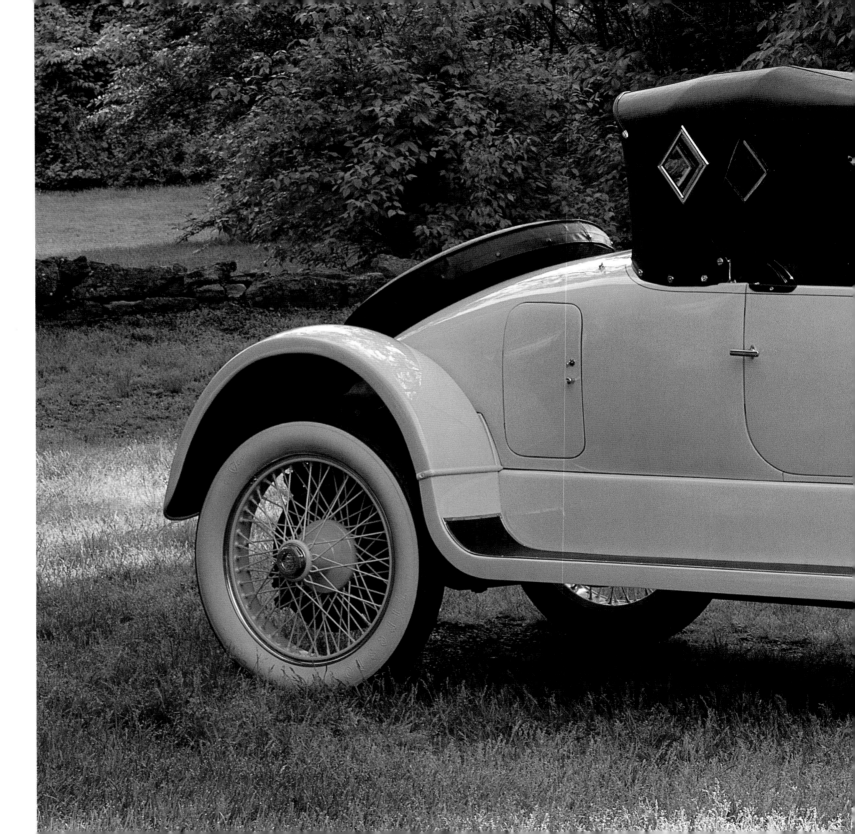

It was the fastest car of its time. In 1920, this strikingly handsome Marmon Model 34B was the pace car for the eighth Indianapolis 500. Driven by legendary automotive daredevil Barney Oldfield, the Marmon circled the track at an astounding speed of 80 mph! (Jack Dunning collection)

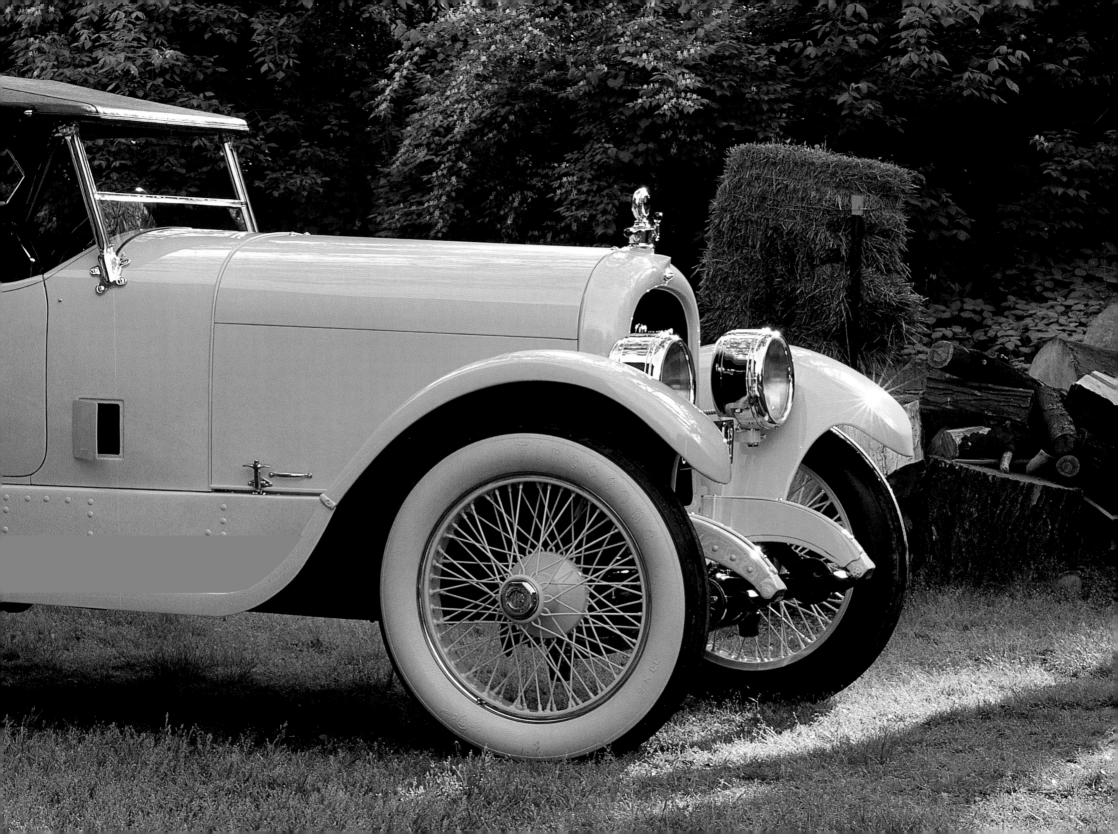

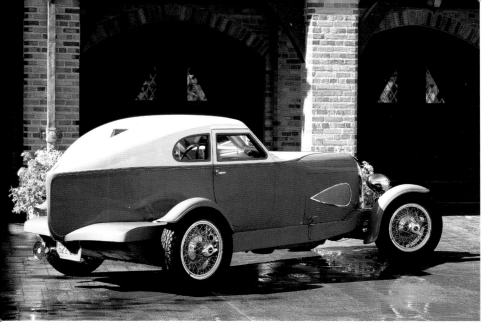

Racing Yellow and equipped with a special 3.0:1 axle (3.75:1 was standard) and a 0–100 mph speedometer.

The 1920–21 Marmon Wasp Speedsters began a tradition that has, from time to time, resulted in some popular and collectible models known as Indy pace car replicas. GM, Ford, and Chrysler, when called on to provide the pace car, have been offering limited-edition replicas since the 1950s, but none has ever been exactly like the actual pace car, except for the very first, the 1920–21 Marmon.

THE AUBURN SPEEDSTERS

Plumes of gray smoke darkened the sky while weary firemen tried in vain to subdue the flames that had razed the 1929 Los Angeles Automobile Show. During the

Dr. Peter Kesling of La Porte, Indiana, had two examples of the Auburn Cabin Speedster re-created in 1985 by Bill Woodke and his staff at Kes Autos Restoration. The original one-off design was destroyed in the great L.A. Auto Show fire of 1929.

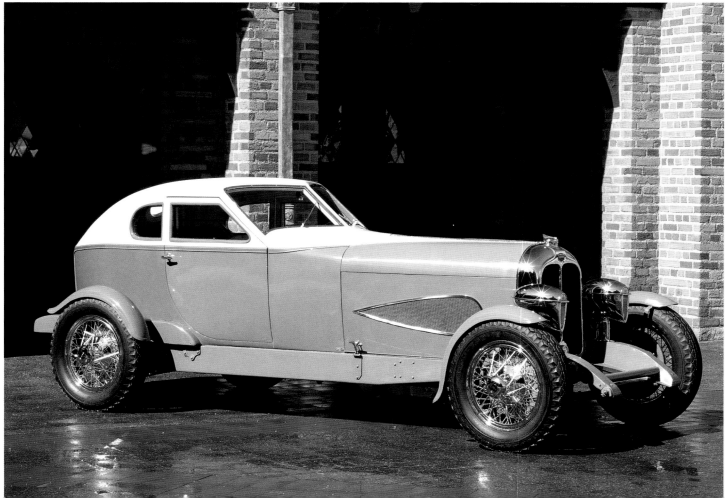

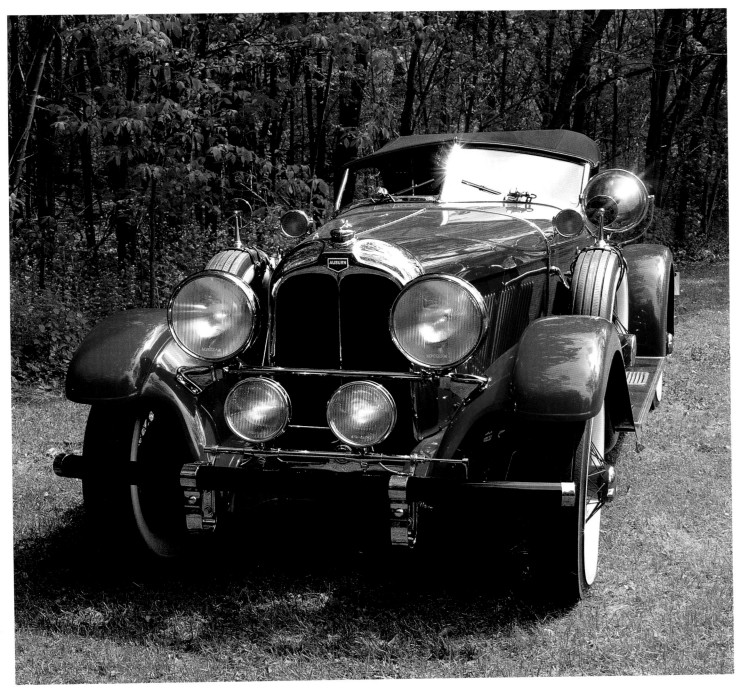

The sporty Boattail Speedster design was pioneered by Auburn in 1928 on the new Model 8-115. The body was designed by renowned stylist Count Alexis de Sakhnoffsky and produced in 1928 as the 8-115, in 1929 as the 8-120, and in 1930 as the 8-125. A 125-horsepower Lycoming straight eight was used to power the cars, which were capable of reaching better than 90 mph. The price in 1929 was a very reasonable $1,895. (Jack Dunning collection)

lightweight cycle-type fenders, and the omission of running boards. The interior treatment was also minimalist with simple door panels and "aeroplane-type" basket-weave seat frames similar to those used in E. L. Cord's personal plane. The sleek, fastback body shape had a small rear backlight referred to as a "periscope window," which was being kind; rear visibility was practically nil, whereas the view from the driver's seat, through a rakishly angled V-type windshield resembling those used on aircraft, allowed the driver and the passenger to see the sky overhead. Both the windshield and side windows were made of laminated safety glass.

A simple, aircraft-styled interior design allowed room for the spare tire and wheel to be stowed underneath a removable shelf inside the tapered tail. The front seats tipped forward to allow access to the storage shelf and were easily removed to facilitate access to the spare tire. The Cabin Speedster was a purely functional design, no frills, but no shortage of thrills, either. The car was guaranteed to reach 100 mph powered by a stock 298.6-cubic-inch, 125-horsepower Lycoming straight eight.

It could have been an exceptional production car, but none was ever built, and after the prototype was destroyed in the Los Angeles fire, the design was never duplicated, even though Auburn had orders for the Cabin Speedster from both the New York and L.A. shows. It has always remained a mystery as to why E. L. Cord canceled the Cabin Speedster.

Dr. Peter Kesling of La Porte, Indiana, may have found the answer. He had two examples of the Auburn Cabin Speedster re-created in 1985. In the 25th anniversary issue of *Automobile Quarterly*, Dr. Kesling wrote: "If the Cabin Speedster were re-created, then not only its performance but its practicality as well might be evaluated—and answers found to a mystery already a half-century old." After building the cars, Dr. Kesling finally surmised that Auburn never produced the Cabin Speedster because, although beautiful, it would have been remarkably uncomfortable.

Cars like the Cabin Speedster and the Auburn Boattail were the inspiration for a variety of sporting car designs that came about in the 1930s. Packard, in particular, took up the idea, offering several boattail models throughout the decade.

ANOTHER GENERATION OF PACKARD SPEEDSTERS

In 1930, Detroit automaker Packard brought out the Model 734 Boattail Speedster, a car automotive writers of the time looked upon as a kind of factory-built hot rod. Packard's performance maestro, Jesse Vincent, who had created the world's first production V-12 engine in 1915—a decade and a half before Cadillac introduced its V-12—headed the engineering team for the new model. For the Boattail Speedster, Vincent created a high-performance

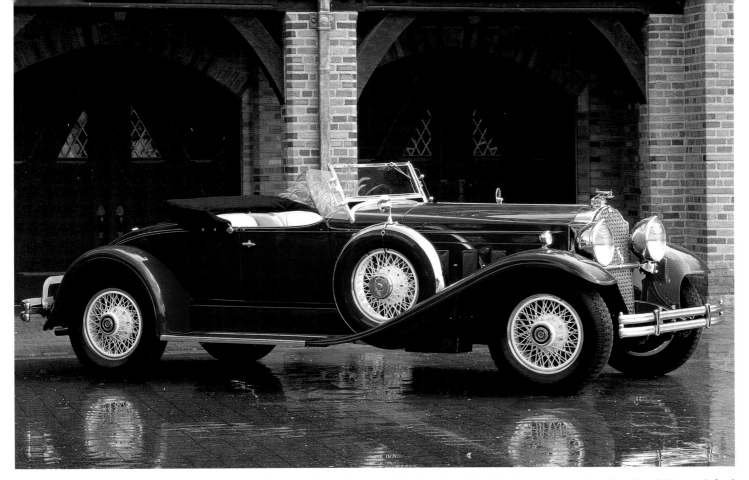

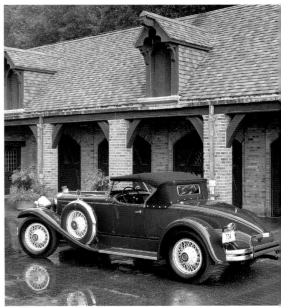

version of the company's 384.8-cubic-inch straight eight, combining it with a high-compression head, additional fuel pump, two-barrel carburetor, and a finned exhaust manifold set off at a 45-degree angle. The last adventurous touch Vincent added to the design was an exhaust "cutout" activated by a lever through the floor near the driver's seat. One turn allowed the exhaust to bypass the muffler, and the Packard eight thundered down the road emitting a music that rattled windows and scared small children and animals.

The Model 734 produced upward of 160 horsepower and could reach a top speed of just under 110 mph. Built on a short, 134-inch wheelbase chassis and fitted with a rakish tapertail body, the Packard 734 would have been difficult to describe as anything but a sports car! And an even more dramatic-looking version appeared briefly in 1934 on the 12-cylinder Packard Model 1106 chassis. One of the 1106 LeBaron-bodied speedsters was sold to film star Douglas Fairbanks Jr., and another, purchased by Carole Lombard, was a gift for Clark Gable. The cars sold for $7,745, making them among the most expensive Packard models of the 1930s.

THE SPORTING CADILLACS

As the decade worn on and the "stock market correction of 1929" turned into the Great Depression of the 1930s, most automakers turned conservative. Cadillac, however, had already committed itself to an aggressive new model line just as Wall Street collapsed and, on the threshold of the worst economic period in American history, introduced a V-16 model line, followed by a V-12 series in 1931. Although sales were brisk for the first year, with 3,251 deliveries, after that they began to dwindle until no more than 50 V-16s a year were being sold by 1937. But Cadillac, with the financial backing of General Motors, weathered the storm and along the way

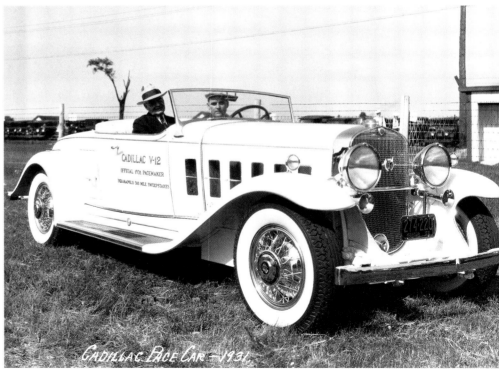

produced a handful of V-12 and V-16 models cataloged as "Roadster for Two-Passengers," a sporting car ideally suited to moments alone on an open stretch of misty morning road. Powered by Cadillac's 452-cubic-inch, 185-horsepower V-16, the cars were capable of reaching nearly 100 mph. Though production of the sports models was never high, their presence at country clubs and along the main streets of corporate America created an image that was perhaps larger-than-life, leaving an indelible image of Cadillac as a maker of sporting cars, which in fact it never was.

THE GREAT MODEL J DUESENBERG

No American company produced a better or more powerful sports model than Indianapolis, automakers Fred and August Duesenberg.

The Duesenberg brothers had a checkered history as automakers. The Duesenberg Company was technologically advanced but financially strapped as far back as 1920, when the first production car to bear the name was introduced. They were always just one step ahead of their creditors until automotive and aviation tycoon E. L. Cord entered their lives in 1926. Three years later, Fred and Augie introduced the Model J, launching a brief and wondrous era that ended in 1937.

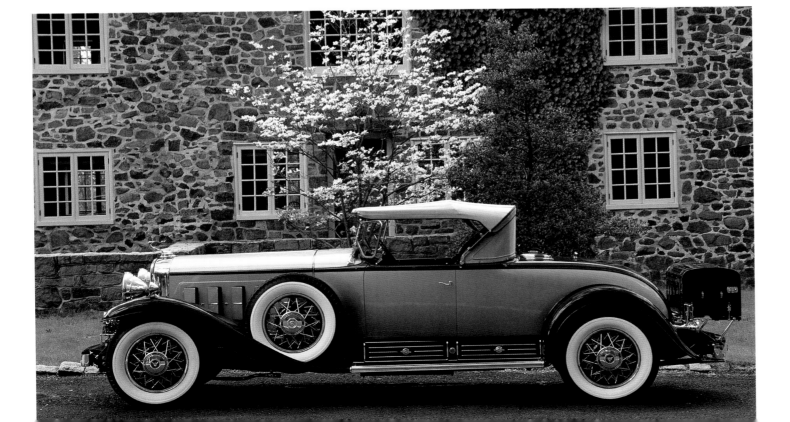

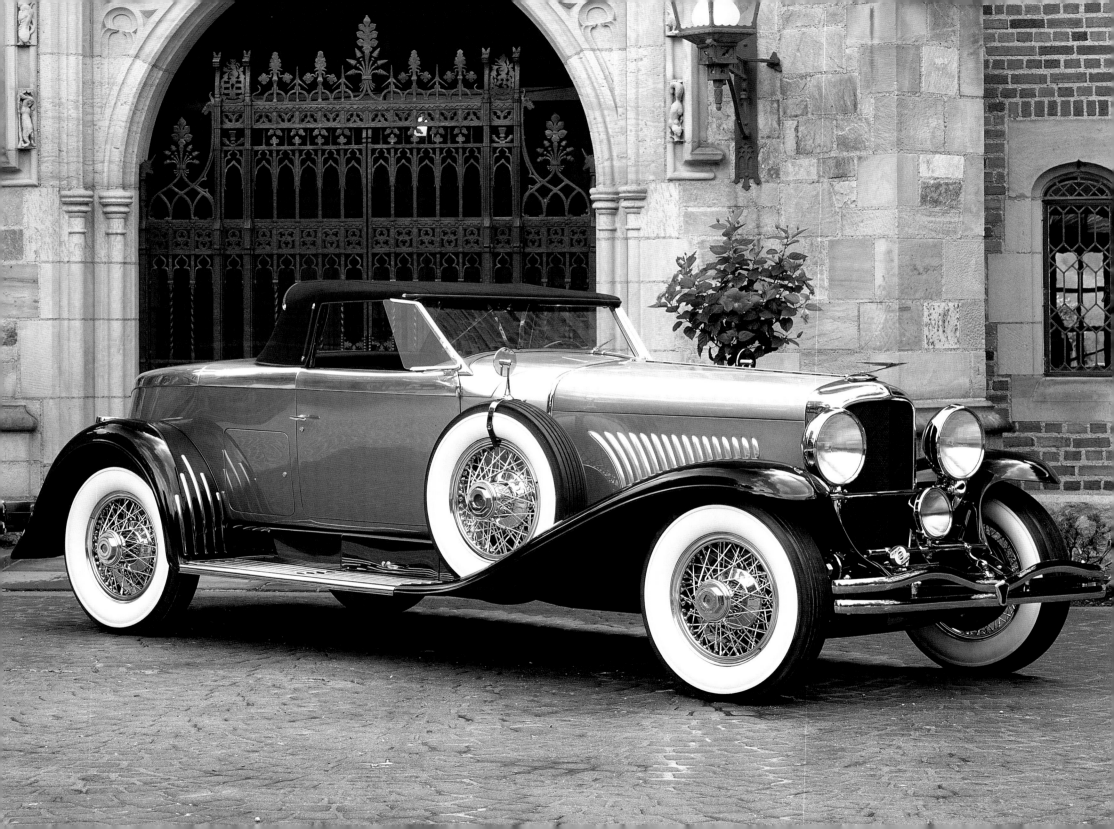

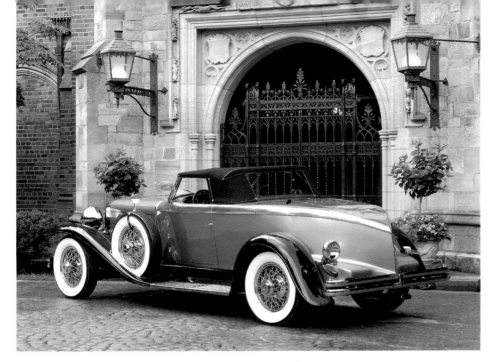

For Fred Duesenberg, the tale of success and failure had begun in a small turn-of-the-century machine shop where he built racing engines for Maytag and Mason motorcars in Waterloo, Iowa. Maytag later moved from motorcars to washing machines. Quite a segue.

By 1913, Fred and his younger brother had moved into a new shop in St. Paul, Minnesota, where they began manufacturing engines for racing cars, boats, and aircraft. Three years later Duesenberg engines were turning up everywhere on the national motorsports scene, including the Indianapolis 500, where a Duesenberg-powered racecar finished second.

During World War I, they entered a partnership with Loew-Victor, forming the Duesenberg Motor Company in 1917, with an engine assembly plant in Elizabeth, New Jersey. The production of Duesenberg engines for a variety of military uses kept the company flourishing for about a year, but following the armistice the Duesenberg's military contracts were terminated, and the marine engine division was sold out from under them to the Willys Corporation.

Back on their own, Fred and Augie began work on a new eight-cylinder engine and formed the Duesenberg Automobile & Motors Company, with financial backing from Newton E. Van Zant and Luther M. Rankin. Their first passenger car, the Model A Duesenberg, was introduced at the 1920 New York Auto Salon.

The innovative new car designed by Fred Duesenberg offered two features appearing for the first time on any American automobile: a straight-eight engine and four-wheel hydraulic brakes. Although fitted with beautifully styled bodies by a number of America's leading coachbuilders, the Model A Duesenberg never quite caught on. The brothers' racecars, on the other hand, were doing exceptionally well. In 1924, they entered four of their Duesenberg Specials in the 12th Indianapolis 500, claiming the checkered flag with America's first supercharged racing car. Of all his achievements, even the legendary Model SJ, Fred Duesenberg regarded the victory at Indianapolis as the greatest.

One would think that the reputation of Duesenberg production cars benefited greatly from the Indianapolis

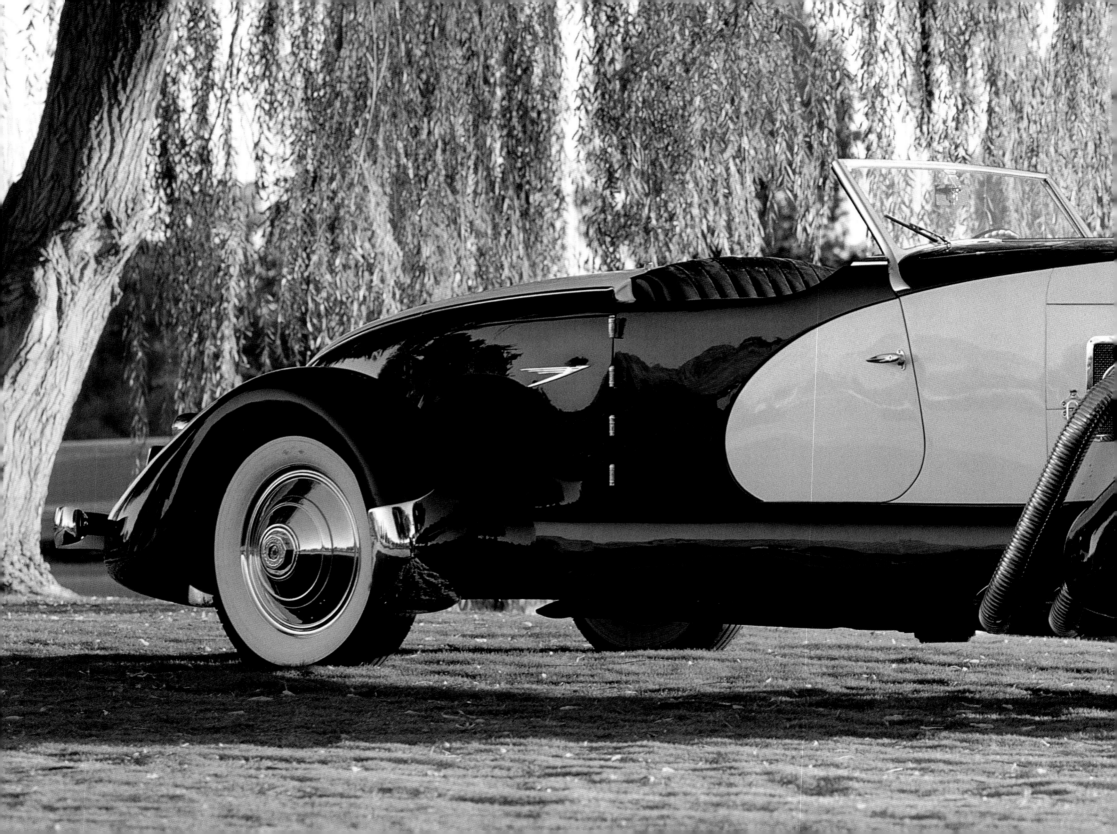

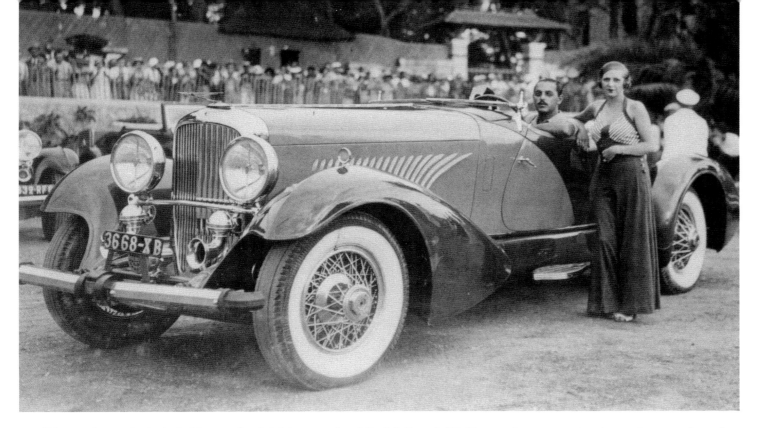

Throughout their brief but colorful history, the Model J and SJ Duesenberg remained peerless engineering marvels. A 1934 advertisement in *Vanity Fair* pictured a well-attired gentlemen standing on the deck of a schooner, a gust of wind blowing his silvery gray hair and necktie straight back, while the captain, depicted stern-faced in the background, manned the helm. Nowhere in the ad was an automobile pictured. The only copy was a single line at the bottom of the page: "He drives a Duesenberg."

No other American car, neither Lincoln nor Packard nor even Cadillac, had so commanding an image. Legendary automotive writer Ken Purdy perhaps best summed up the car and its creator: "Fred Duesenberg had done what is given few men to do; he had chosen a good course and held unswervingly to it. With his mind and his two good hands he had created something new and good and in its way immortal. And the creator is, when all is said and done, the most fortunate of men."

No more fortunate, though, than the man who owned a Duesenberg.

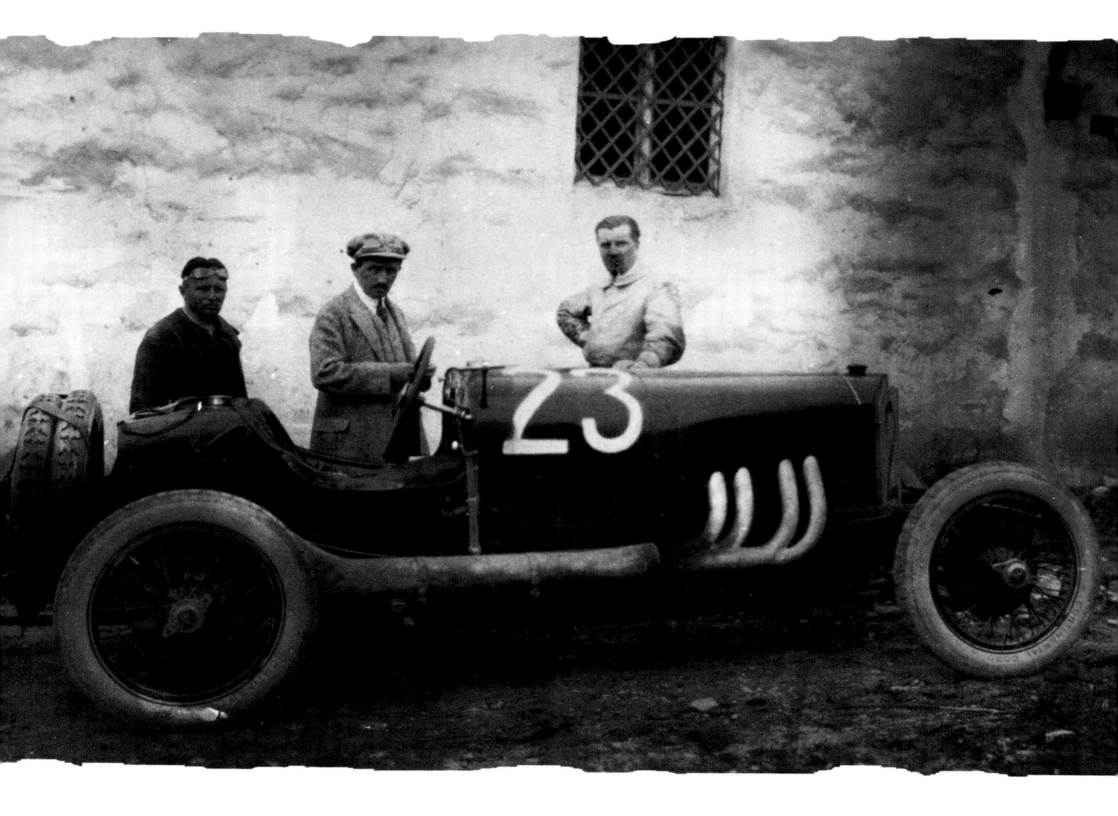

THE EUROPEAN APPROACH

French Curves, Teutonic Arrogance, and Italian Zeal

I T'S INTERESTING HOW ONE SEEMINGLY IRRELEVANT EVENT CAN CHANGE THE COURSE OF HIS-

TORY. PAUL DAIMLER, THE ELDEST SON OF DAIMLER-MOTOREN-GESELLSCHAFT FOUNDER

GOTTLIEB DAIMLER, HAD RISEN THROUGH THE RANKS OF HIS LATE FATHER'S COMPANY TO

BECOME CHIEF ENGINEER BY 1907. HE HAD APPRENTICED AT THE SIDE OF HIS FATHER'S

CLOSEST ASSOCIATE, WILHELM MAYBACH, AND HAD BEEN INVOLVED IN THE CREATION

The first car designed by Ferdinand Porsche (center) for Mercedes was the 1924 Targa Florio. The legendary Alfred Neubauer, then a race driver with Mercedes, is pictured at Porsche's right. (Photo courtesy DaimlerChrysler Classic Center)

OF THE FIRST MODERN MOTORCAR, THE 1901 MERCEDES. YOUNG PAUL HAD ALSO

SERVED AS THE FIRST CHIEF DESIGNER OF THE COMPANY'S AUSTRIAN DIVISION,

AUSTRO-DAIMLER, WHICH BECAME INDEPENDENT IN 1906, LEADING TO HIS

return home and appointment as chief engineer for D-M-G a year later. It would have seemed that his future was a certainty. Yet in 1923, Paul Daimler resigned and took a position as chief engineer with Horch, one of the four companies that would form the mighty German Auto Union in 1932. His replacement was the man who had succeeded him at Austro-Daimler in 1906, a talented, though temperamental, German engineer named Ferdinand Porsche. In 1923, Porsche assumed the position of chief engineer for Daimler, thus concluding what would be a significant turn of events.

At the time of Porsche's arrival, Daimler was going through a difficult period. The German economy was in a severe recession following World War I, and automobile sales were well below expectations. In Mannheim, Daimler's principal competitor, Benz & Co., was experiencing like problems.

Having already agreed in principle to a mutually beneficial sharing of resources, on May 1, 1924, Daimler and Benz entered into an "Agreement of Mutual Interest," a noncompetitive and cooperative arrangement, which served as a prelude to their merger two years later in June 1926. The formation of Daimler-Benz AG consolidated their engineering and production capabilities into the largest automobile manufacturing company in Germany. The merger also catapulted Porsche into the position of chief engineer for what was now the largest and most powerful automotive concern in Europe—Mercedes-Benz.

With Porsche at the engineering helm of the new company, Daimler-Benz began to develop innovative products, not only for the road but also for the track. With the racing experience he had gained at Austro-Daimler, Porsche often blurred the line dividing road car from racecar.

The first product of Mercedes-Benz was the Model K, introduced in 1926. It was based upon the Type 630 Mercedes first seen in 1924 and was principally the work of Porsche, who improved upon Paul Daimler's pioneering overhead-camshaft, six-cylinder engine design and Roots-type supercharger. Designed by Daimler-Benz to attain a top speed of 90 mph, in 1926 the Model K was the fastest standard-production model of its type in the world.

The Roots-type supercharger was the nucleus for an entirely new and more powerful generation of Mercedes that would emerge in the late 1920s and flourish throughout the following decade. As Mercedes-Benz so poignantly noted in *The Fascination of the Compressor*, a 1998 book on the history of the company's supercharged cars, "[in the 1920s and 1930s,] the sound and appearance of the Mercedes-Benz engines were testimony to the raw power beneath the hood. This was innovative technology encased in the most elegant car bodies of the time. The high-gloss chrome exhaust pipes that peeked from the side of the hood became synonymous with superchargers, the symbol of power and glory. These mighty machines were like creatures from ancient legends. The only way to escape their beguiling melody,

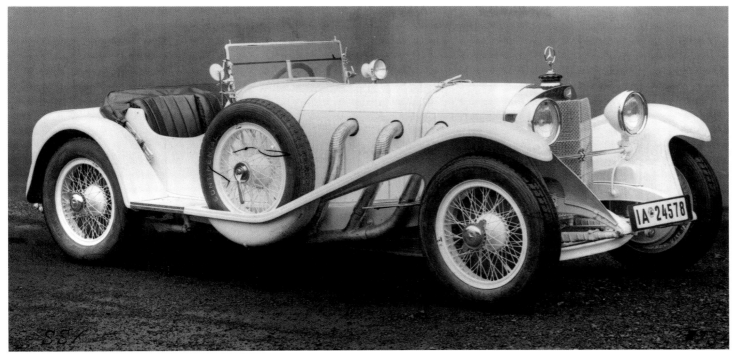

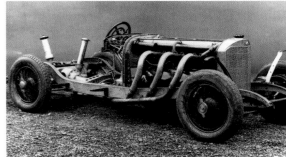

their aura, their fascination, was to hide yourself away and stop up your ears." Such was the image Mercedes-Benz and Ferdinand Porsche had fashioned by the late 1920s.

Porsche's greatest achievement at Daimler-Benz was the Model S, introduced in 1927. It was to become the fundamental design around which an entire generation of Mercedes sports models would be built. The S provided the underpinnings for the legendary SS, SSK, and SSKL models built through 1934. All four were assembled around Porsche's innovative drop-center frame. To further improve handling over earlier Mercedes cars, Porsche had also moved the radiator and engine about a foot rearward on the chassis, resulting in a better front-to-rear weight distribution and a lower center of gravity. The lower chassis further encouraged more rakish, open-bodied coachwork.

With chassis improvements came greater performance, 120 horsepower under normal aspiration, 180 with the supercharger engaged. The updated engine in the Model S, the single strongest tie to Daimler, had its bore increased from 94 to 98 mm. With a 150mm stroke, this brought displacement up to 6,789 cc, about 414 cubic inches!

While Porsche is credited for the entire S series, all of the later improvements that appeared on the models SS, SSK, and SSKL were the work of Dr. Hans Nibel, who had been chief engineer at Benz prior to the merger, and Fer-

dinand Porsche's successor at Daimler-Benz in January 1929. Porsche had originally gone to work for Daimler prior to the union with Benz and had decided not to renew his contract with the new concern when it expired in December 1928. He returned to Austria, where he accepted a position as technical director at Steyr, but after a year he resigned and moved back to Stuttgart, where he established a design and engineering firm. Throughout the 1930s, Ferdinand Porsche's counsel would be sought by many German automakers, including Mercedes-Benz.

Dr. Nibel's magnum opus in the 1920s was the SSK, which was powered by a 170/225-horsepower (increased to 180/250 horsepower in 1929) Roots supercharged in-line six, capable of reaching the magic 100 mph mark, a speed that, for the time,

OPPOSITE: Of the 33 Mercedes-Benz SSK models produced, this is the most magnificently styled. Built for Count Carlo Felice Trossi, an Italian aristocrat and accomplished race driver, this SSK, chassis No. 36038, was built in 1930 but not purchased until 1932. Although there is no documentation, it is believed that the coachwork was by Jacques Saoutchik. (Ralph Lauren collection)

every builder of performance cars claimed to achieve. Unlike most, however, the Mercedes could actually do it. Racing versions with higher-compression engines running on Elcosine—an alcohol-fuel mixture used for competition—attained speeds of 125 mph. The culmination of the S Series was the SSKL, which appeared in 1931 as a lighter, more powerful version built for motorsports, but was equally at home on the open road.

Of the 33 Mercedes-Benz SSK models produced, the most famous and perhaps most magnificently styled was a car built for Count Carlo Felice Trossi. An Italian aristocrat whose family dated back to the 14th century, Trossi was a proficient race driver and president of Scuderia Ferrari (the Alfa Romeo race team) in the early 1930s. In 1933, Trossi won some minor Italian events, but whether he drove the sleek SSK in competition is not documented. In 1934, he entered Grand Prix racing and twice finished second to Tazio Nuvolari! By the end of the 1930s, he was one of the top drivers in Italy and after the war raced for Alfa Romeo. He won the Italian GP in 1947 and the European GP in 1948, ending that year as European champion. During his career, he finished in the top three places some 40 times. Trossi died of cancer in 1949 at age 41. Today his Mercedes SSK is one of the few cars in history ever to

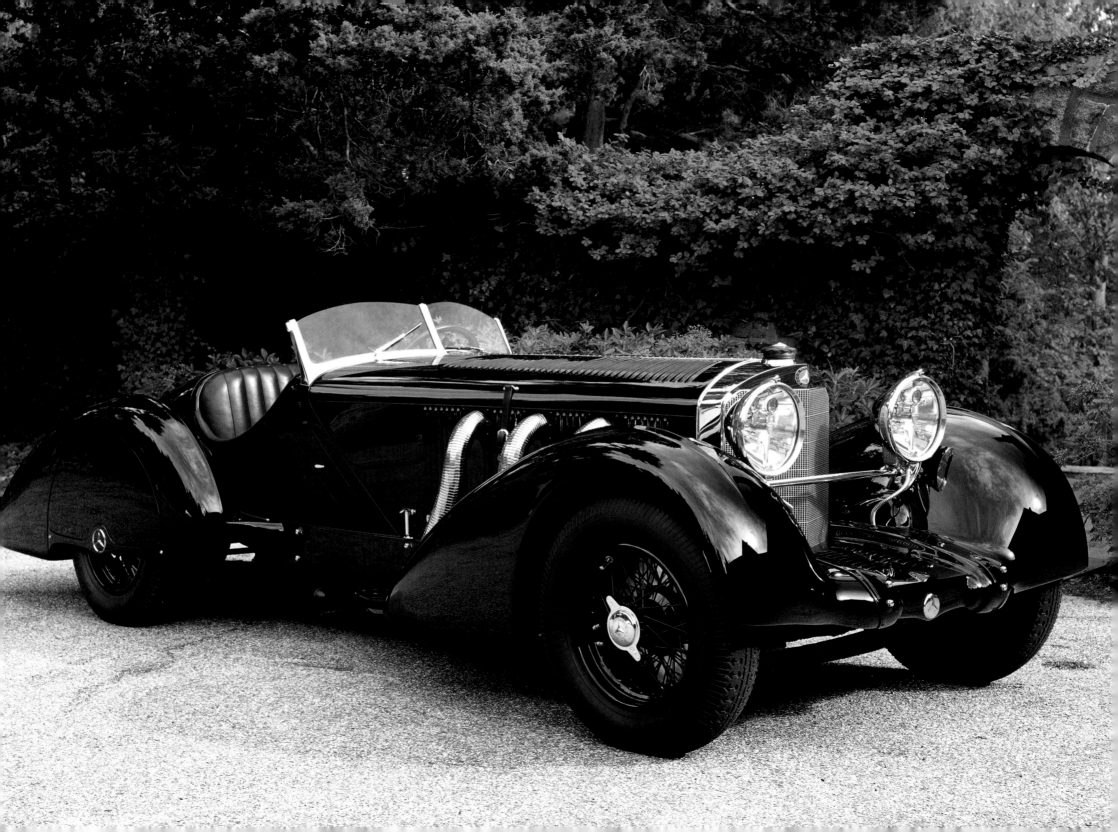

RIGHT: *The Trossi family says that the coach-work for the SSK, credited to Jacques Saoutchik, was actually the work of a little-known English panel-beater named Willy White, who was living in Italy, and that the body was designed by Trossi himself.* (Ralph Lauren collection)

BELOW LEFT: *The instrument panel of the SSK was built to Count Trossi's specifications, and it is believed that he personally lettered the tachometer to indicate top speed at rpm. The car has won at every major Concours d'Élégance, including Pebble Beach in 1993, and is considered one of the most beautiful automobiles in the world.*

BELOW RIGHT: *The in-line six in the SSK was fitted with the greater-capacity Elephant supercharger giving the car an estimated 250 horsepower. The polished exhaust pipes, cascading through the hood and into the fenders, was one of the Mercedes's most dramatic features.*

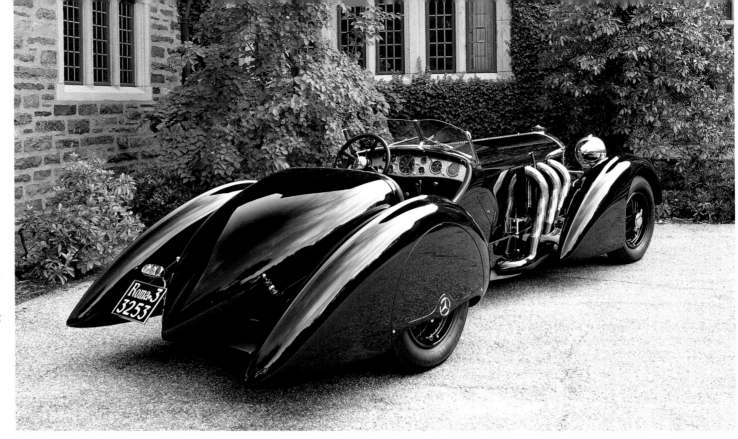

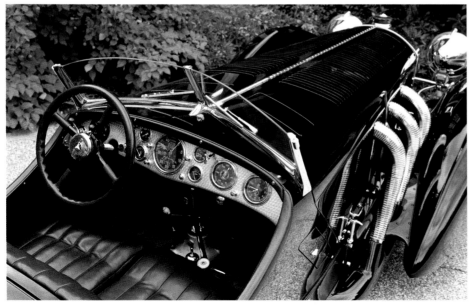

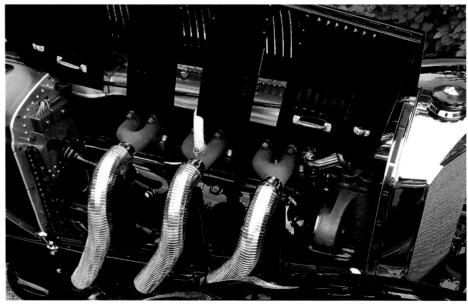

become known by an owner's surname. More than 70 years after it was built, this stunning SSK is still referred to as the Trossi car.

Total production of the 180-horsepower supercharged S "Sport" model had been limited to 128 chassis. Another 111 SS "Super Sport" models, with improved 7.1-liter engines turning out from 200 to 225 horsepower, were built, and a scant 33 SSK "Super Sport Kurz" (*kurz* meaning "short" wheelbase) 250-horsepower examples. The rarest models were seven 300-horsepower SSKL competition versions, none of which exist today. This was the factory tally—279 cars—for the entire Model S series produced from 1927 through 1934. Of course, Mercedes-Benz also produced thousands of lower-priced models during this period, but the S series was the flagship, just as it is today.

The merger of Daimler and Benz brought about an era of extraordinary progress in automotive engineering. In 1933, Mercedes made a great stride ahead of its competition with the new Type 380, the first production automobile

Competition models of the SS, such as this 1930 Type 710 SS, helped Rudolf Caracciola earn the title European Sports Car Champion in 1930 and European Mountain Champion in 1930–31. The competition coachwork for this example was produced in England by the firm Forrest-Lycett.

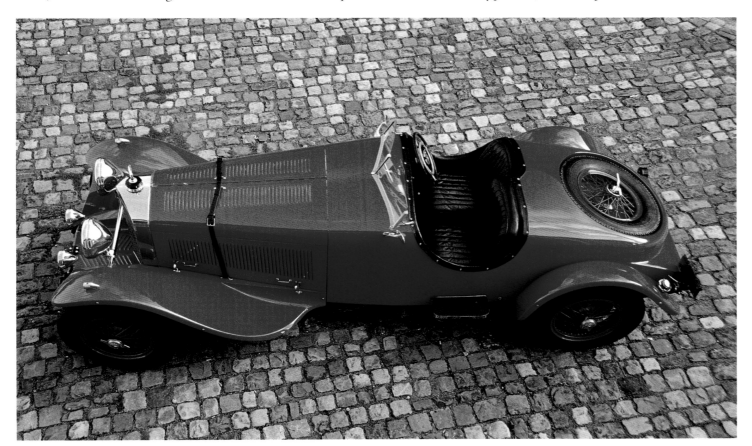

Following the success of the SSK, Mercedes-Benz introduced the 3.8-liter Type 380 in 1933 and improved 500K, 5.0-liter version in 1934. This 1935 Special Sport Roadster is one of the earliest built. Approximately 12 of these true roadsters (with side curtains rather than roll-up windows) were produced in 1935–36.

in the world to offer a fully independent, parallel wishbone and coil-spring front and swing axle rear suspension. The new model was fortified by a catalog of sensational coachwork that would soon be known by the name Sindelfingen, the city where Daimler had first established a factory for the production of aero engines and aircraft during World War I. Sindelfingen was now home to the factory Karosseriewerk, and since 1919, the design and construction of custom bodies had become its most important role under managing director Hermann Ahrens.

What few people today realize is that both the engineering and styling of the legendary 500K and 540K Mercedes were anticipated by the short-lived Type 380, which was introduced in 1933 and discontinued the following year. The 380's undoing was horsepower, which Daimler-Benz deemed insufficient. The solution was that most favored of principles of high-performance aficionados the world over: "There is no substitute for cubic inches." Thus came the 5.0-liter 500K in 1934.

Upon their introduction, the 500Ks proved their exceptional durability and strength in the Deutschland Fahrt (roughly "Tour of Germany") endurance tests. Covering 1,364 miles from Baden-Baden, through Stuttgart, Munich, Nuremberg, Dresden, Berlin (Avus), Magdeburg, Köln, Nürburgring, and Mannheim, and back to Baden-Baden, the factory 500Ks, along with privately owned Mercedes-Benz entries, virtually dominated a field of more than 190 vehicles.

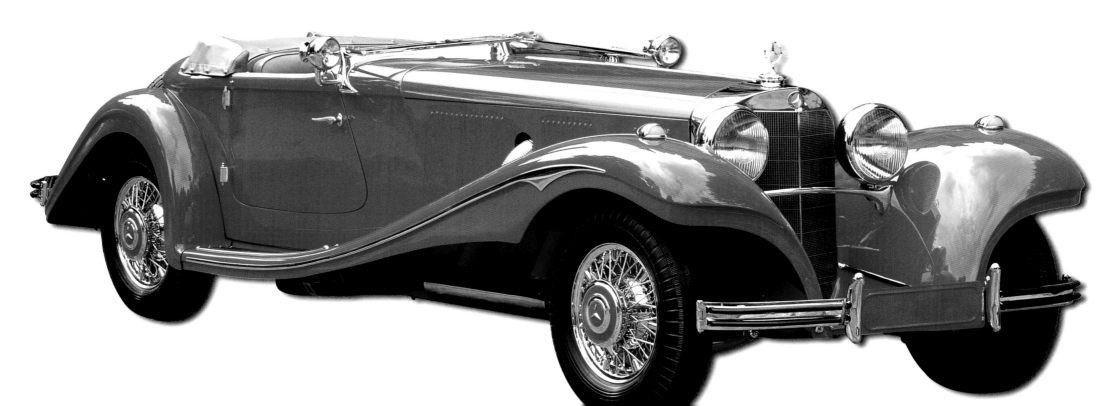

The 500K and later 540K chassis offered an extraordinary platform upon which to build a custom body. The Mercedes chassis was composed of two main frame rails, crossbraced by one heavy front I-beam, which supported the radiator and independent front suspension mounting; a smaller crossmember, used to support the rear of the engine and the transmission; a large box-section crossbrace located behind the transmission; and in the rear, two small crossmembers, which served as supports for the differential. The frame was tapered at the front, to accommodate the narrow radiator, which, along with the engine, was nestled behind the front suspension, allowing the frame rails, and therefore the bumpers, to extend well past the grille, adding character to the car's robust appearance.

With the introduction of the 5.4-liter 540K in 1936, the mighty Mercedes had reached its zenith, producing 115 horsepower, increased to a spirited 180 horsepower with the Roots blower set in motion. Mercedes-Benz had delivered into the hands of its customers one of the most powerful production automobiles the world had ever known.

Although it would be difficult to refer to any 540K as anything less than spectacular, the Special Roadster was one of, if not *the* most striking of all the Sindelfingen designs. The sporting model made its debut at the 1936 Berlin Auto Show and, in the opinion of many automotive historians, is the most beautiful car ever built.

Among the many styling cues unique to the 540K Special Roadster was the use of chromium embellishments along the length of the fenders, hood, doors, and rear deck. These, and the chromed handles for doors, hood, and rumble seat, were all special castings. Another unique feature was the sharply angled V-windscreen. Instruments for the 540K had the appearance of a handmade Swiss timepiece and were usually surrounded by a mother-of-pearl fascia, adding the final touch of elegance to the car's luxuriously appointed interior.

By 1939, when war broke out in Europe, Mercedes-Benz had produced tens of thousands of automobiles, but only 354 500K chassis from 1936 to 1939 and 406 540K chassis—of which only 25 were built as Special Roadsters. In the overall scheme of things, it was an almost trivial number, yet the 500K and 540K's reputation in the automobile world, as is often the case with sports cars, has little to do with production numbers. The 500K and 540K were the jewels in the crown of the German motor industry right up to the beginning of World War II.

In the sweeping rear deck of the two-seater 540K Special Roadster, a spare tire was secreted. A folding rumble seat allowed two additional passengers to ride along, although it was hardly the best seat in the house at 100 mph!

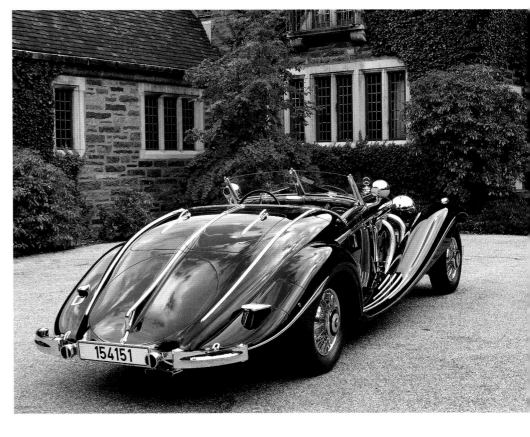

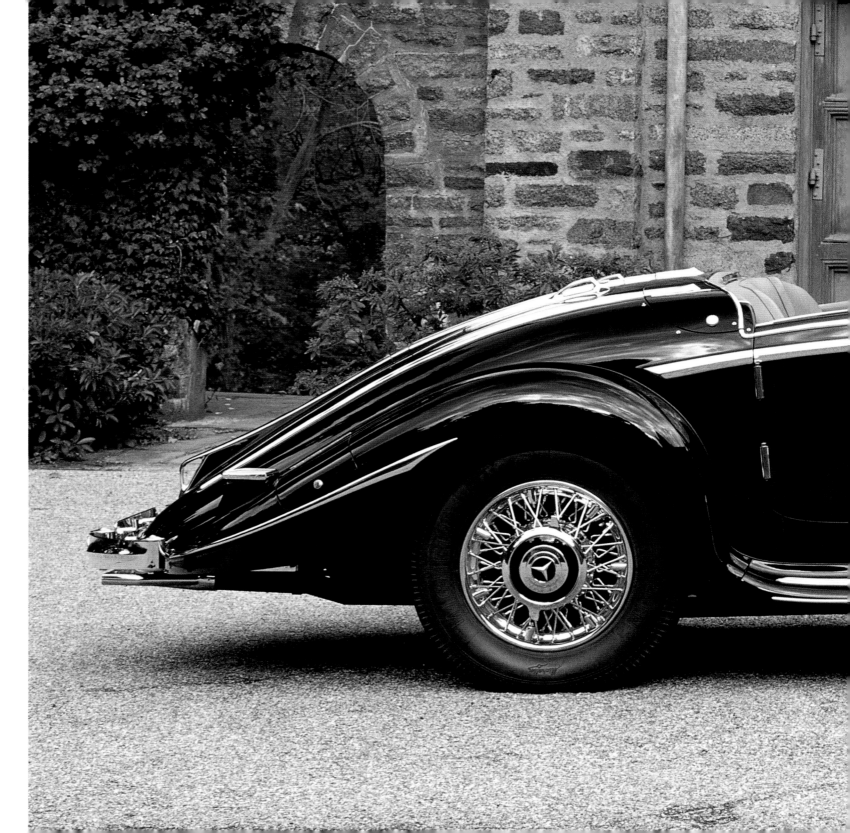

The Mercedes-Benz 500K gave way to the even more powerful 5.4-liter 540K in 1936. The 540K was available in a variety of body styles, but the 180-horsepower model was best suited to the dazzling Special Roadster body style. Only 25 were produced between 1936 and 1939. (Bud Lyon collection)

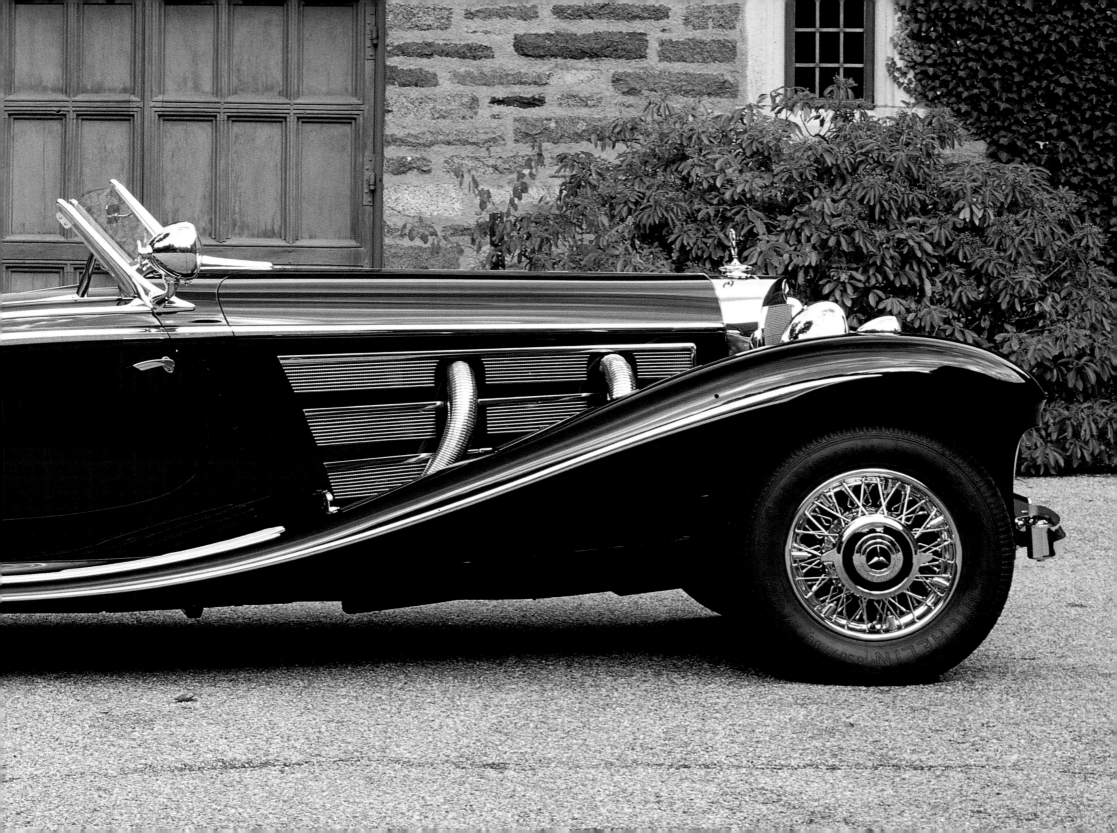

AS ONLY THE FRENCH COULD HAVE DONE IT

At one time, automotive styling was an art form, and when it came to sports cars, there was only one place to go for the most beautifully designed coachwork in the world: Paris. In France, styling was everything. The coachbuilder held the key to success—all that the manufacturer held was the key to the ignition.

From the armistice in November of 1918 to the onset of World War II in 1939, the styling and construction techniques employed by French coachbuilders were among the most advanced in the world. Their flamboyant, avant-garde, almost larger-than-life designs were the envy of every automaker.

In the 1930s, French coachbuilders were almost as famous as their clientele. Jacques Saoutchik, Joseph Figoni, Henri Chapron, Letourneur et Marchand, Jean-Henri Labourdette, and the Franay Brothers, all at various times, and on a variety of both European and American chassis, fashioned some of the most magnificent body designs of the entire 20th century.

By the early 1930s, the ateliers on the outskirts of Paris were a hotbed of activity with France's leading *carrossiers* catering almost exclusively to national marques such as Talbot-Lago, Delage, Delahaye, and Bugatti. Among the great French automakers, Bugatti is perhaps the most revered and the most interesting.

BUGATTI—THE THOROUGHBRED

In the story of the automobile, Ettore Bugatti is one of the more colorful characters, someone about whom tales could be told and whose life, it seemed, was an open book written in a dogmatic and colorful style. Though Italian by birth, Bugatti spent nearly all of his life in France. From around 1910 to 1951, nearly 8,000 cars bearing the Bugatti name were produced at the Molsheim factory located in Alsace, France.

Fifty-two different Bugatti models were produced over the years, ranging from Grand Prix racecars—the famous Type 35—to the most luxurious and costly automobiles ever built, the Bugatti Royales, the cars of kings and millionaires—at least according to Bugatti's hopes. In the 1930s, there were few buyers and only six were produced, and of those, two remained with the Bugatti family.

Somewhere between these two extremes was the Type 57. A triumph both in styling and engineering, the Type 57 were fitted with stunning coachwork, most of which was created by Bugatti's son Jean.

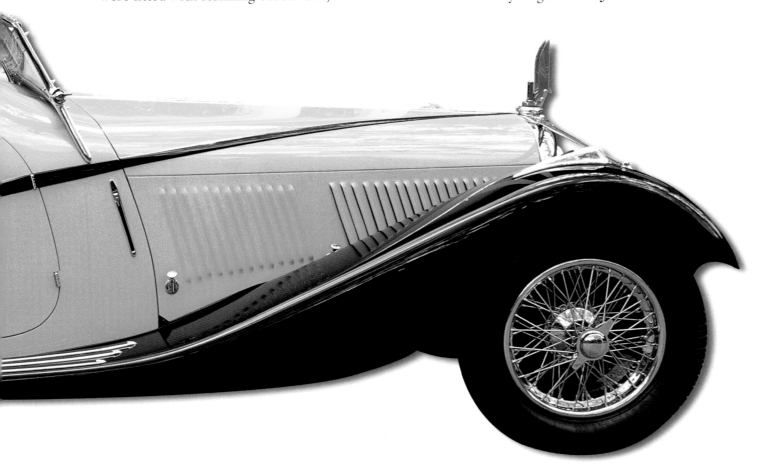

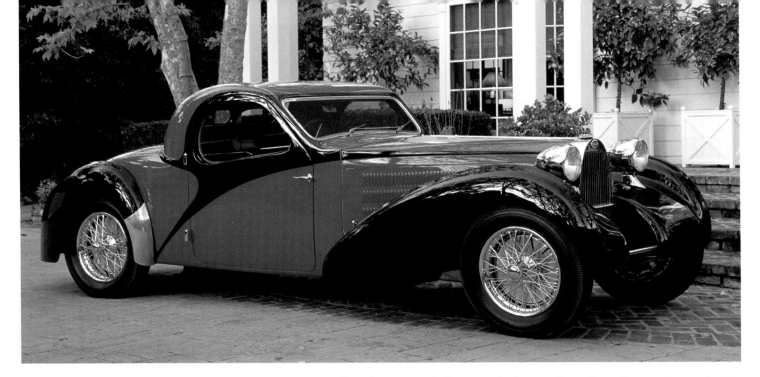

In 1932, after becoming acting director, Jean first began to influence design and engineering at Bugatti. His father, having turned over the day-to-day operations of the factory, moved to a new office in Paris, where he was completing work on a streamlined locomotive, which would be powered by up to four Type 41 Royale eight-cylinder engines, which had proven far more successful than the car. In mid-1933, the Bugatti *autorail* set new commuter-train standards in France, reaching speeds of up to 93 mph. The train became Ettore's crowning achievement. The fleet of 79 aerodynamic commuters provided excellent service in France for nearly a quarter of a century.

While his father built trains, Jean embarked upon the creation of the Type 57, a design somewhat more practical than many earlier Bugatti sports models, and suitable to supporting a variety of coachwork, from sporty cabriolets and coupés to luxurious sedans. He was determined that the Type 57 would not suffer the compromises of sharing its chassis with a racecar, as nearly all Bugatti models

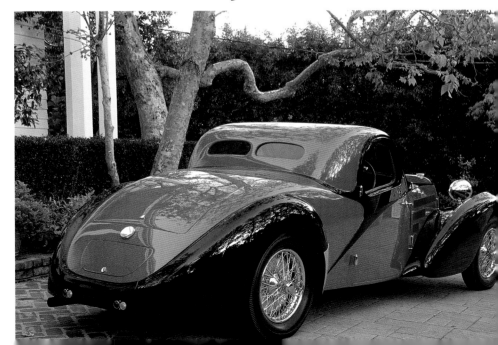

up to this time had done. The Type 57 would be Jean's retort to the popular Delahayes and Delages, breathtaking *voitures* capable of performance without the sacrifice of comfort, luxury, or convenience.

Although new, the Type 57 chassis retained the traditional architecture developed by the senior Bugatti: the familiar horseshoe radiator—a tribute to Ettore's love of Thoroughbred horses; a solid rear axle suspended by quarter-elliptic springs; and a front suspension built around Ettore's artistically striking and complicated solid beam axle. In a design unique to all Bugatti models, the front axles were boxed and pierced at their corners, thus allowing the semi-elliptic springs to pass through the opening, rather than being shackled above or below the axle, as was the practice of every other automaker in the world.

Among its innovations, the Type 57 was the first Bugatti to integrate the gearbox with the engine. A long, floor-mounted shifter was positioned to the driver's immediate left (all Bugattis were right-hand-drive), and on later mod-

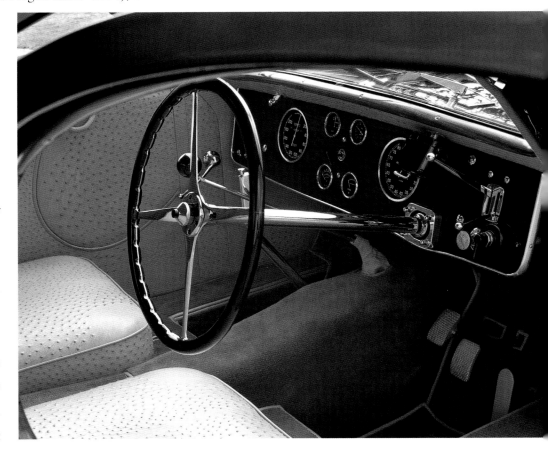

Type 57 Bugatti interiors were usually upholstered in leather, but a few owners chose more exotic hides. This example has been restored with upholstery of tanned ostrich hide. Other models were upholstered in snakeskin and alligator.

els a steering-column-mounted Cotal electromechanical gearbox was offered as an option. The Cotal was a clever mechanism that positioned a miniaturized gated gearbox, about the size of a golf ball, at the end of a stalk mounted to the steering column. The Cotal allowed the driver to shift with the touch of a finger, moving the miniature selector through the gears as one would a full-size shifter. This preset the next gear, which was not engaged until the driver depressed and released the clutch. The advantage lay in allowing the next gear change to be selected ahead of time, so the driver could have both hands on the wheel at the crucial moment, and made the Cotal a favorite of rally and race drivers. A modern adaptation of this idea is the Ferrari Formula 1 shifter, which allows a driver to upshift or downshift without the use of a conventional gearbox. The computer-controlled Ferrari transmission engages the next preselected gear at the appropriate rpm. Far more sophisticated, but essentially the same idea as the Cotal in the 1930s.

Although a new car, the Type 57 was antiquated in many ways, mostly the result of Jean's deferring to some of his father's earlier designs. The chassis was rudimentary in layout, and Bugatti was one of the last European automakers to abandon the use of cable-actuated brakes, a subject of great

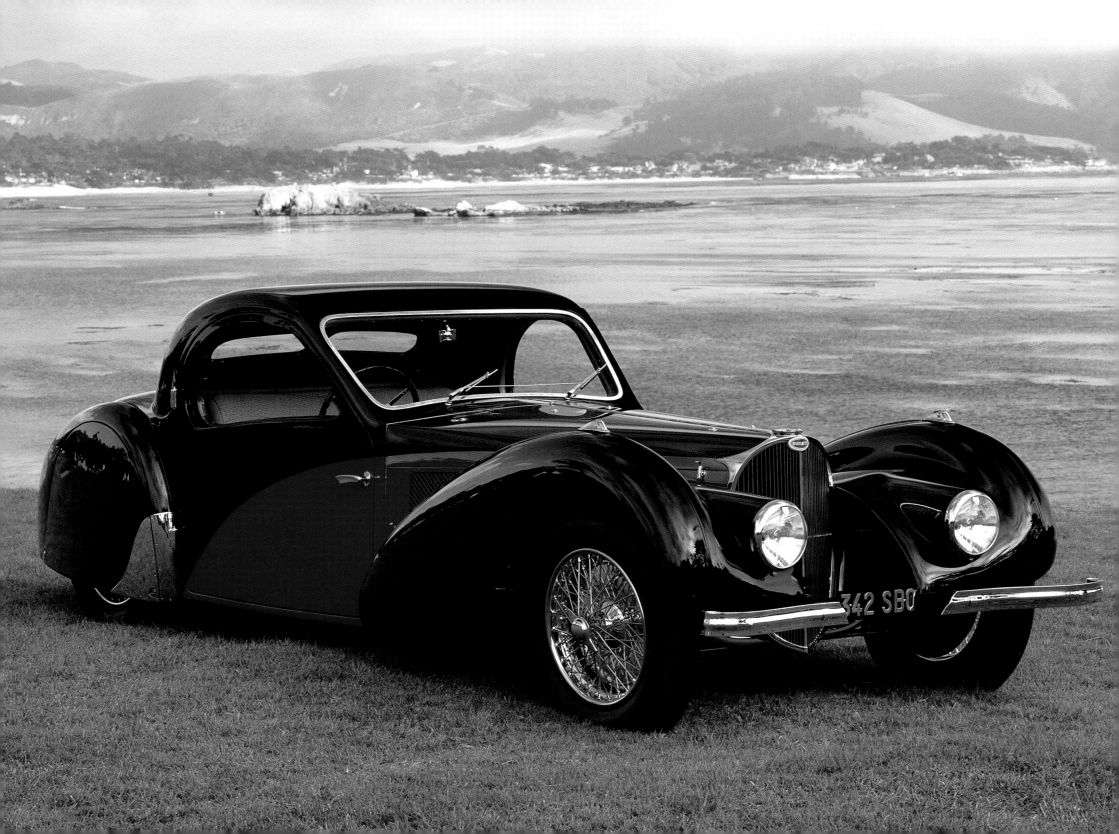

debate and about which some of the better Bugatti tales have been written. Ettore's legendary retort to one critic was "I make my cars to go, not to stop." It might have been true because it took until 1937 for Bugatti to adopt a Lockheed-designed hydraulic brake system with twin master cylinders. The ride and handling were also improved with the addition of Alliquant telescopic shock absorbers.

Despite whatever mechanical shortcomings the Type 57, and later 57C, S, and SC versions, may have suffered, they were the most desirable nonracing Bugattis ever produced.

LA CARROSSERIE

Many of the designs that came out of France during the 1930s were, to put it kindly, outrageous looking, but Parisian designers Jacques Saoutchik and Joseph Figoni were attempting to do more than simply turn heads along the Champs-Élysées. The cars they and others designed were serious studies in aerodynamics.

The French school of aerodynamics followed a principle known as *goutte d'eau* (literally, "a drop of water"), or "teardrop," nature's perfect aerodynamic shape. The master of the teardrop form was Figoni. The majority of his work was for French manufacturers, particularly Bugatti, Delahaye, Delage, and Talbot-Lago. The most famous Figoni design is the Talbot-Lago T150 SS. Only a dozen were built, but their appearance stunned the automotive world of the late 1930s.

TALBOT-LAGO

Coinventor of the Wilson preselector transmission (a British version of the Cotal), Major Anthony Lago purchased the foundering Talbot factory in Suresnes, France, in 1934. Automobiles Talbot and Société Anonyme Darracq were the French subsidiary of Sunbeam-Talbot-Darracq, an old British company that had lost sight of the French market, and interest in it as well. The French branch was about to under when Lago offered to purchase the company's assets.

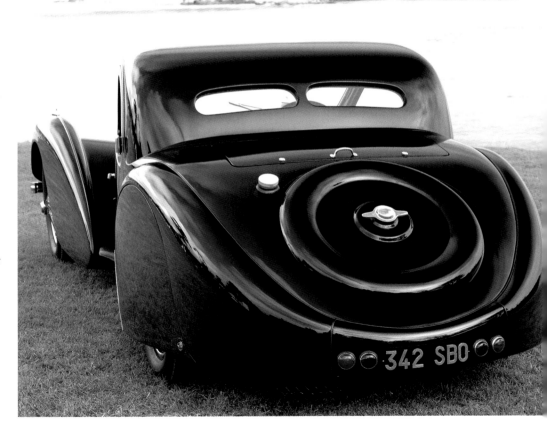

OPPOSITE: *The Bugatti Type 57S Atalante, designed by Ettore Bugatti's son Jean, was one of the most exotic of all Type 57 models. In its final short-wheelbase version, the Type 57 reached its highest design evolution.*

BELOW: *Few automobiles have ever carried coachwork as spectacular as the Type 57S. From any angle, coming or going, there was nothing else quite like it.*

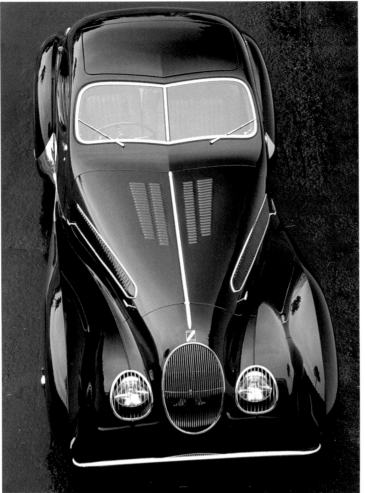

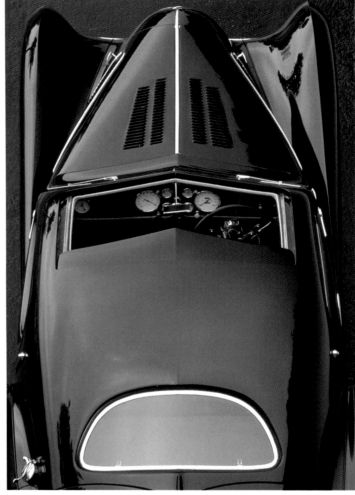

He renamed the cars Talbot-Lago and brought new vitality to the marque by building elegant-looking sports cars that could also double as racecars. While the factory workers thought this was an odd way to rebuild a financially strapped company, by 1937 Talbot-Lagos were in contention with Europe's best, finishing first, second, third, and fifth in the French Grand Prix. Lago's cars also won the Tourist Trophy with drivers Gianfranco Comotti and René le Bègue finishing first and second; Raymond Sommer gave Lago a first in both the Marseille and Tunis Grands Prix; and by 1938 Talbot-Lago was among the top three contenders in French motor racing. Combined with imposing Figoni coachwork, the Talbot-Lago road cars were among the most exciting European models of the prewar era.

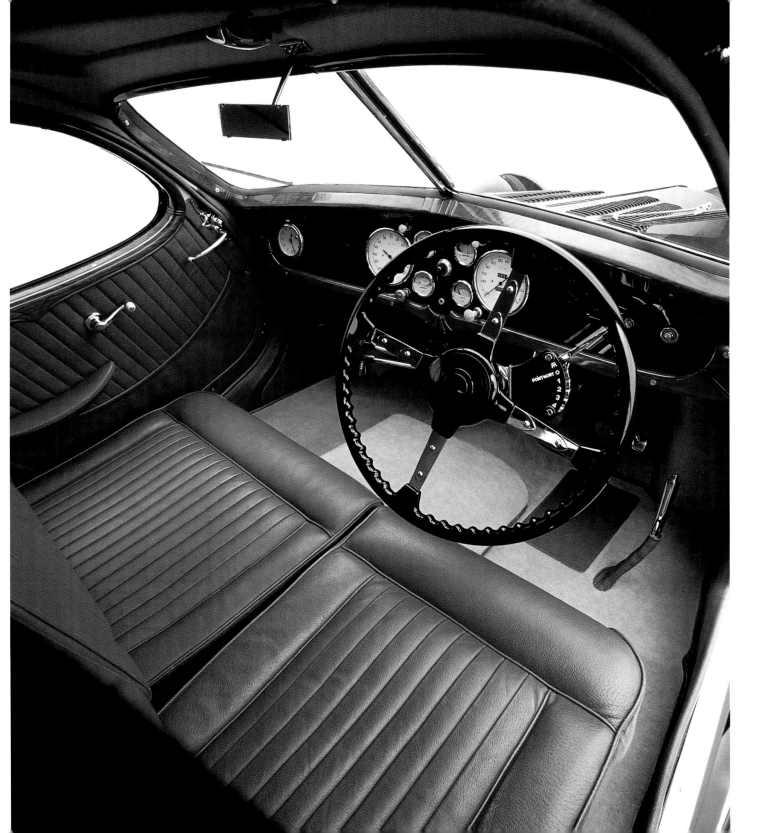

The elliptical doors on the Talbot-Lago T150 SS were unusual, but lent themselves to the shape of the car and the rounded interior. The driver was positioned so the view was over the tops of the highly crowned teardrop fenders and along the low hoodline, providing exemplary forward visibility.

THE DELAHAYE FORMULA:
ONE PART RACECAR, ONE PART BOULEVARDIER

By and large, sporting cars built throughout the period before World War II could have been driven to a hill climb or endurance race and, if not severely damaged, driven home afterward. The 1937 Delahaye 135M Guilloré cabriolet was such a car.

Delahaye was established in 1894, making it one of Europe's oldest automotive names. By the late 1920s, Delahaye was building everything from commercial vehicles and fire trucks to touring cars and record-setting marine engines. Competition was, however, an almost secondary consideration.

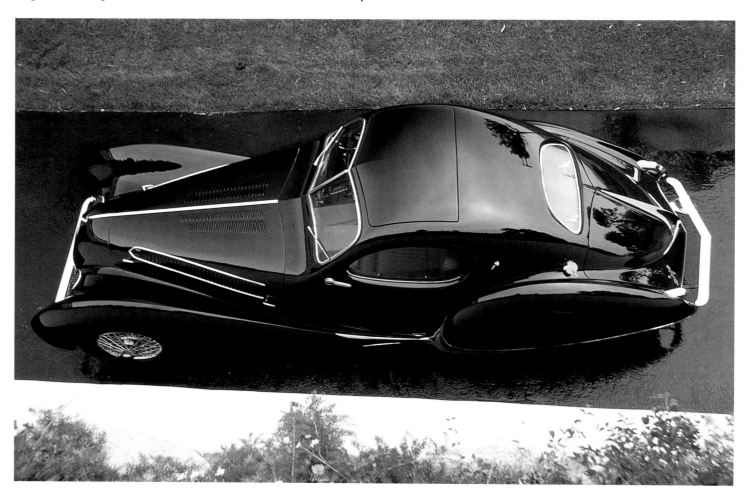

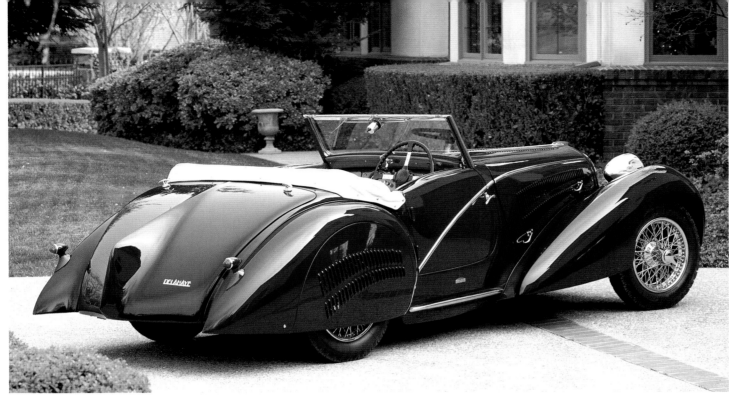

LEFT: *A 1937 Delahaye 135M Guilloré Cabriolet.* (Don Williams/Blackhawk collection)

BELOW LEFT: *The Talbot-Lago used a sturdy in-line six based on the Talbot-Darracq 3.0-liter engine. Fitted with a new Lago-Becchia-designed cylinder head, it developed 160 horsepower. The driveline was coupled via a Wilson four-speed, preselector gearbox, which Anthony Lago had designed in 1930 (and which had contributed to his personal wealth).*

BELOW RIGHT: *By the mid-1930s, many European cars were equipped with illuminated trafficators to signal turns.*

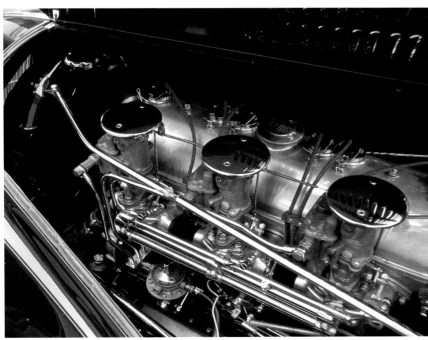

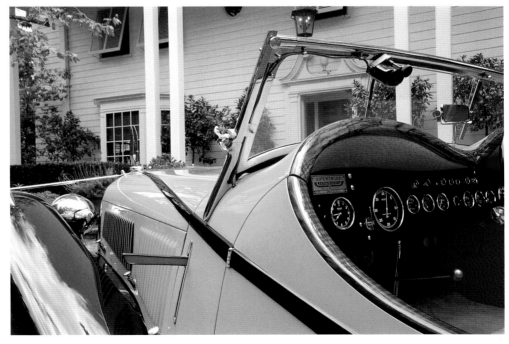

By the time of the Great Depression, Delahaye had come to be known as a builder of "sturdy, reasonable cars for sturdy, reasonable Frenchmen," and it wasn't until 1930 that Charles Weiffenbach (chairman of Delahaye from 1906 to 1954) decided to concentrate on the design and production of more luxurious coachbuilt models and competition cars.

A small company compared with Peugeot and Renault, two of France's oldest and largest automotive manufacturers, Delahaye set out to establish itself in motor racing. The first example appeared on their stand at the 1933 Paris Auto Salon, powered by a 120-horsepower, 3.2-liter, six-cylinder engine, mounted to a chassis that was suitable for either a touring car body or a lightweight competition roadster body. The following year, Delahaye launched the new model as the Type 135, equipped with a slightly larger 3.5-liter engine.

Although the 135 was introduced in 1934, the factory reserved the competition chassis and engines for their own exclusive use until 1936, when they released 20 to preselected clients. Built on a shortened 116-inch wheelbase, the competition cars were fitted with a floor-mounted, mechanical, four-speed gearbox for short courses, and the steering-column-mounted Cotal semiautomatic transmission for longer races. This was the transmission used on the standard Delahaye models as well.

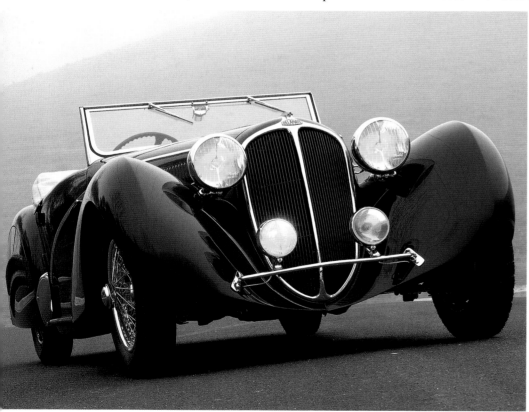

In competition, Delahayes finished an impressive number of races during their brief five-season career, including a first in the 1934 Monte Carlo Rally and the Coupe des Alps; a third overall at Le Mans in 1935; a sweeping second, fourth, fifth, and seventh in the 1936 Automobile Club of France Grand Prix; and a grand sweep at the Circuit de la Sarthe in 1938.

The stunning Guilloré cabriolet was probably designed as both a competition and a touring car. Built in 1937 on the 116-inch-wheelbase competition chassis, it was equipped with the four-speed, manual, floor-mounted transmission and a 3.5-liter, triple-carburetor, overhead-pushrod, six-cylinder competition engine. A simple yet almost unbreakable motor, the fuel-efficient six allowed Delahaye racecars to go longer distances than their competitors without refueling—often just the edge needed to defeat their German, Italian, and British rivals.

Of the many Delahaye designs created, the Guilloré sports cabriolet represents one of the finest examples of a 1930s French sporting car.

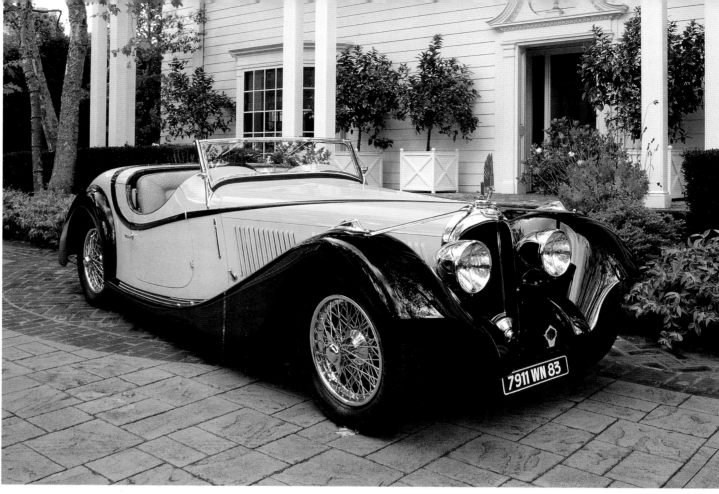

RIGHT: *In 1934, Gabriel Voisin and Joseph Figoni collaborated to design the Voisin Model C.27 Grand Sport, one of the most exciting designs of the 1930s. Figoni incorporated Voisin's traditional fender struts (chromed supports from the fender to the grille shell) into the design.* (Peter Mullin collection)

BELOW: *Even from the rear, Figoni's styling for the Voisin C.27 was striking, with long, flowing lines similar to the Type 57C Bugatti.* (Peter Mullin collection)

OPPOSITE ABOVE: *The Voisin dash-board panel was equipped with full instru-mentation, and Figoni designed two flowing brows, like the cockpit of a racecar, to contain the primary gauges.*

OPPOSITE BELOW:
The C.27 was powered by a 2,994cc, valveless, monoblock, straight-six Voisin engine equipped with twin Zenith horizontal carburetors. While developing only 100 horsepower, the Voisin C.27 weighed just 2,530 pounds, thereby achieving performance through lighter weight.

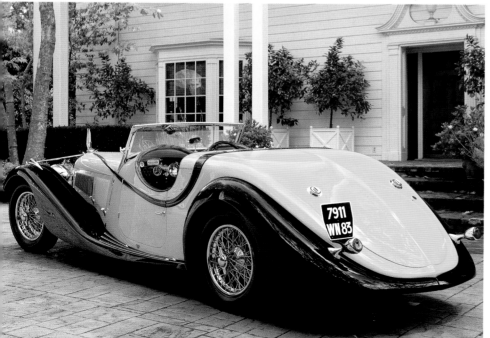

ON THE WINGS OF VOISIN

Perhaps the most obscure French model is the Voisin C.27 Grand Sport Cabri-olet. The Voisin was an uncommon car, even in France. It was the creation of Gabriel Voisin, an aircraft manufacturer from the turn of the century through World War I who claimed to have built a practical airplane before the Wright broth-ers' first flight at Kitty Hawk in 1903!

When his aircraft business fell on hard times in the post–World War I recession, Voisin decided to switch gears and build automobiles. With a huge factory and 2,000 employees at his disposal, he not only designed and manufactured his own chassis, he produced the engines, driveline components, and as many other parts as possible.

By 1920, more than 1,000 cars had been delivered, and the elegant, hand-built Voisin became one of the more fashionable automobiles in which to be seen around Paris. Much of the credit for this went to Gabriel Voisin, who supervised body designs, which quite often were just short of bizarre, but were always interesting. Voisin's collaboration with Joseph Figoni on the 1934 Model C.27 Grand Sport led to one of the most exciting sporting car designs of the era.

The C.27 was powered by a 2,994cc, valveless, monoblock, straight-six Voisin equipped with twin Zenith horizontal carburetors. While developing only 100 horsepower, the Voisin C.27 weighed just 2,530 pounds, thereby achieving performance through lighter weight. As with past models, Voisin made everything for the car, even his own nut-and-screw steering system, and had a hand in modifying other driveline components to his own specifications, which resulted in four-wheel, servo-assisted Voisin-Dewandre brakes, and a Voisin-Cotal electromagnetic transmission.

Only two C.27 short-wheelbase chassis were built: chassis 20110 was the Figoni Two Seater Grand Sport Cabriolet; the second car, chassis 52002, was mounted with a Voisin-designed Sport Coupé body. Unique and rare automobiles, even when new, the cars of Gabriel Voisin are almost in a class of their own, and the C.27 Figoni is by far the most beautiful model to bear the Voisin wings.

The last Voisin was produced in 1939, bringing to a close a chapter in the history of French automotive design.

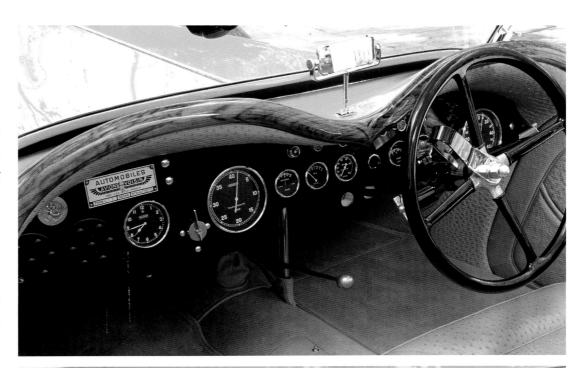

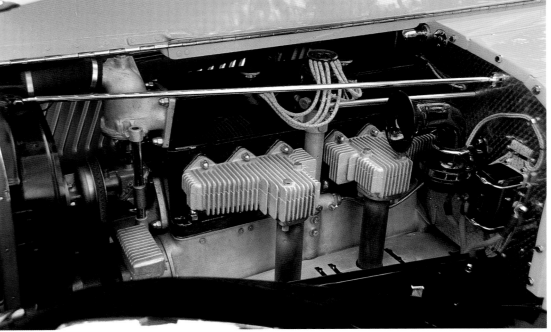

DUBONNET—AN APERITIF FOR THE ROAD

While limited in numbers, the Voisin was still considered a production automobile. However, a handful of cars created in France were virtually one-of-a-kind. This would be unimaginable today, but in the 1920s André Dubonnet, whose grandfather Jean had created the popular aperitif, tried his hand at automotive design and engineering. He was successful.

An action-loving young millionaire, sportsman, and race driver, André was responsible for several remarkable sporting cars produced throughout the 1920s and 1930s. He was particularly intrigued by the idea of combining automotive and aircraft design to create cars that were lighter and faster. In 1924, he designed a lightweight body constructed of tulipwood, attached to an aluminum framework with brass rivets—about 5,000 more or less. The body, built by France's Nieuport Aviation Company, weighed a little over 100 pounds and was mounted to a Hispano-Suiza chassis.

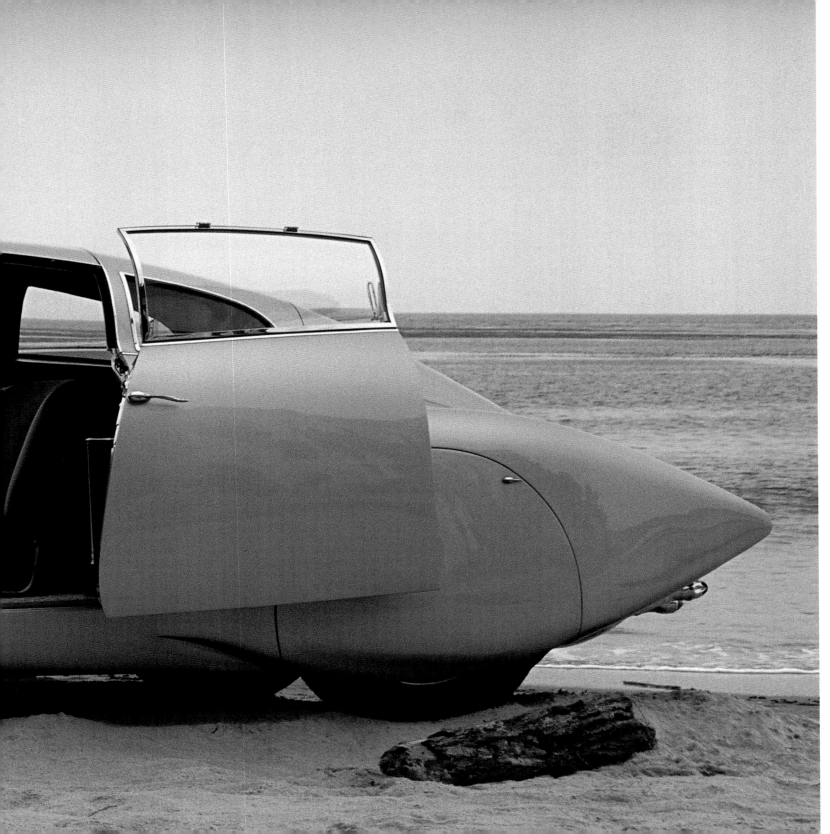

The aerodynamic contours of the Dubonnet were accentuated by the cockpit styling of the roofline and the unique doors, which swung out and slid back along the length of the body. No problem here in a tight parking space!

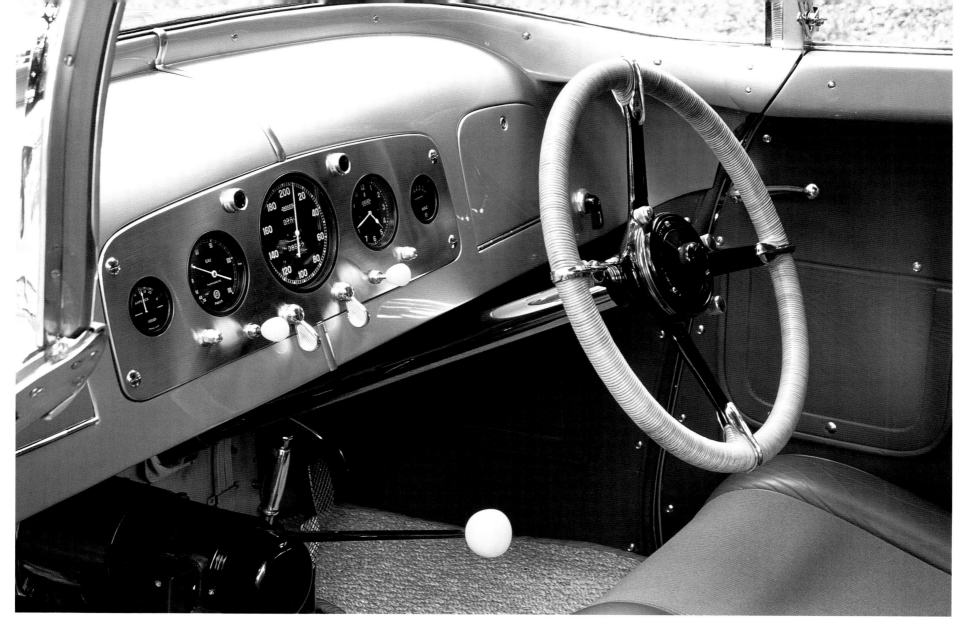

The Dubonnet interior was simple and much like those of sporting airplanes built in the 1930s.

The interior design also followed the styling of late 1930s sports aircraft, with lightweight seats, floor matting, and a metal instrument panel. The streamlined Xenia was equipped with a 160-horsepower Hispanio-Suiza H6C engine, and Dubonnet had planned to attempt several speed-record runs with the car in 1939. World War II undid his plans. The Dubonnet's only public appearance was in 1946 when it inaugurated the Saint-Cloud Tunnel at the start of the great Normandy autoroute.

ALFA ROMEO—BIRTH OF THE MODERN SPORTS CAR

The sports car had many fathers, but the birthright of the modern sports car truly belongs to the Italians, and more appropriately to Alfa Romeo.

Italy was a nation of passionate automobile lovers, and in 1910, the company that would one day become Alfa Romeo was formed out of the failed Italiana Automobili Darracq, a division of French automaker Darracq & Co., which began building cars in Naples in 1906.

The Darracq had proven totally unsuitable for Italian roads, and in 1906, after sales plummeted to only 61 cars and lost 150,000 lire for Alexandre Darracq, he surrendered the Italian branch to a group of local businessmen. With

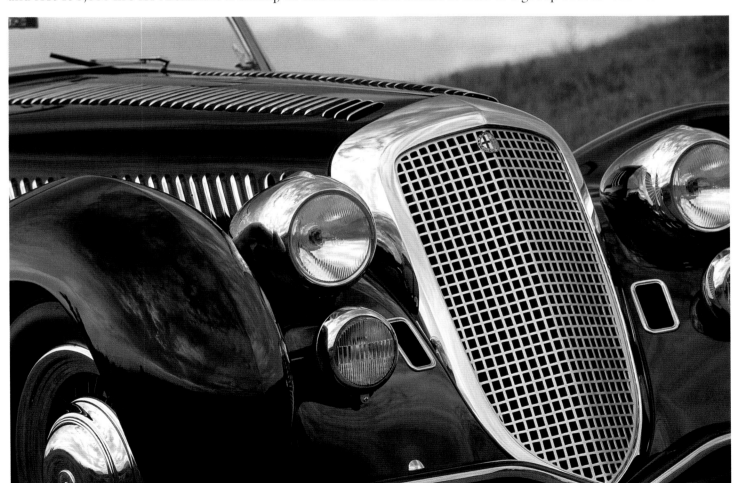

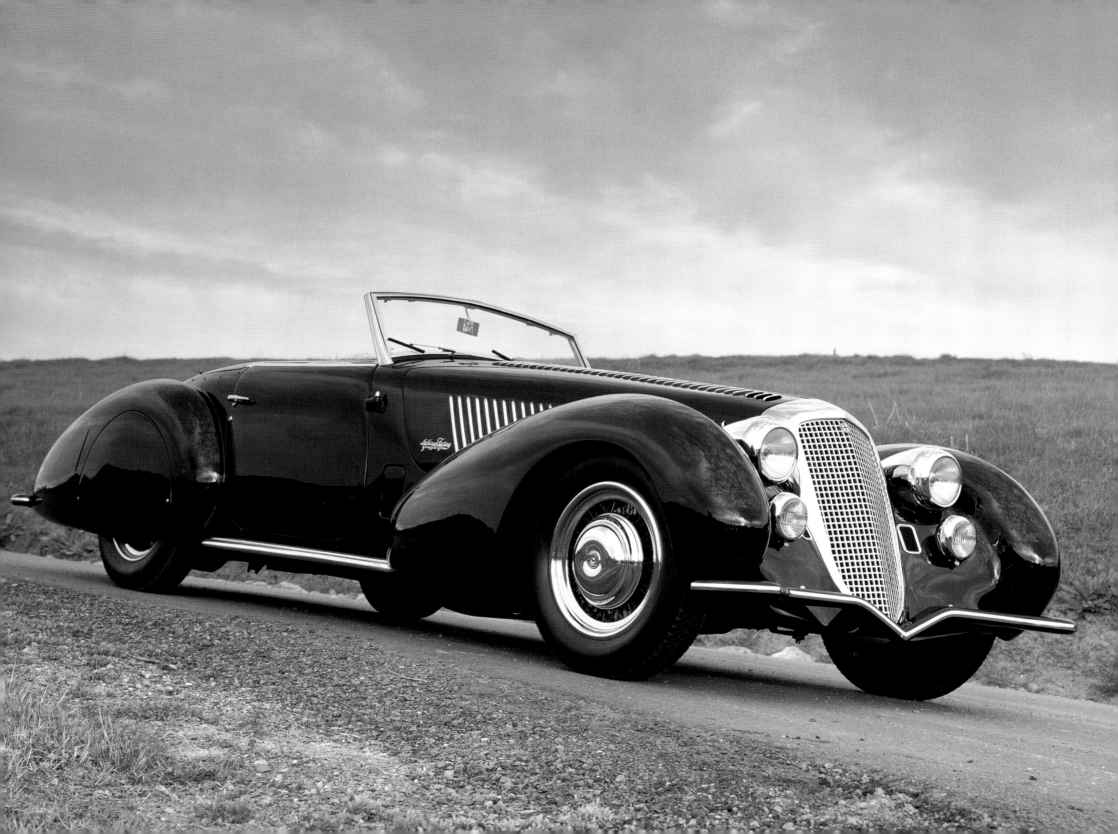

a loan of 500,000 lire from the Banca Agricola di Milano, Anonima Lombardo Fabbrica Automobili (ALFA) was formed on January 1, 1910. Following World War I, the concern was merged with Nicola Romeo & Co., to become Alfa Romeo. Out of this amalgamation came the first great Italian sports cars—trendsetting designs that acquitted themselves well on both road and track.

Alfa made its racing debut in the 1919 Targa Florio, and from then on its reputation was maintained by the finest sports and competition cars of Italian manufacture. Alfas were held in high esteem throughout Europe and Great Britain, having scored victories in virtually every major racing event from Le Mans (four consecutive years, 1931–34) to the Targa Florio (six straight times, 1930–35) to the Mille Miglia (every year from 1928 to 1938).

Until the postwar era, Alfas were essentially hand-built automobiles produced in limited numbers. In fact, from 1910 to 1950 only 12,200 cars were built—that's an average of less than one car per day! Alfa Romeo's survival during the lean years of the Depression was ensured by the Italian government, which purchased sufficient shares to keep the company solvent. In Italy, auto racing was the national obsession, and Alfa Romeo the national champion.

Throughout the late 1920s and well into the 1930s, Alfa Romeo produced an endless stream of remarkable cars suitable for both road and track, such as the 6C 1500, 6C 1750, and the Le Mans champion 8C 2300. Among the most popular road cars were the innovative 6C 2300B, heralded as one of the first production cars in Europe to offer a four-wheel independent suspension. The advanced front-wheel geometry of the 6C 2300B included wheels carried on paired trailing arms and controlled by coil springs and hydraulic shock absorbers. The front suspension was copied by Dr. Ferdinand Porsche and incorporated into many of his later designs. However, according to Alfa Romeo historian Luigi Fusi, this "sharing of ideas" was accompanied by Alfa's use of a Porsche-designed swing axle rear suspension in the 6C 2300B and in all other Alfa Romeos produced from 1936 to 1950.

In 1939, the 6C 2300B was replaced by the 6C 2500, one of the last models built before World War II, as well as the first to be offered when Alfa Romeo resumed production in 1946.

The era of the classic sporting car came to an end in 1939, both in Europe and in the United States. The cars that were created during the 1930s were as diverse as their countries of origin. What they all had in common, however, was a simple goal—to make driving exciting, and if nothing else, they accomplished that.

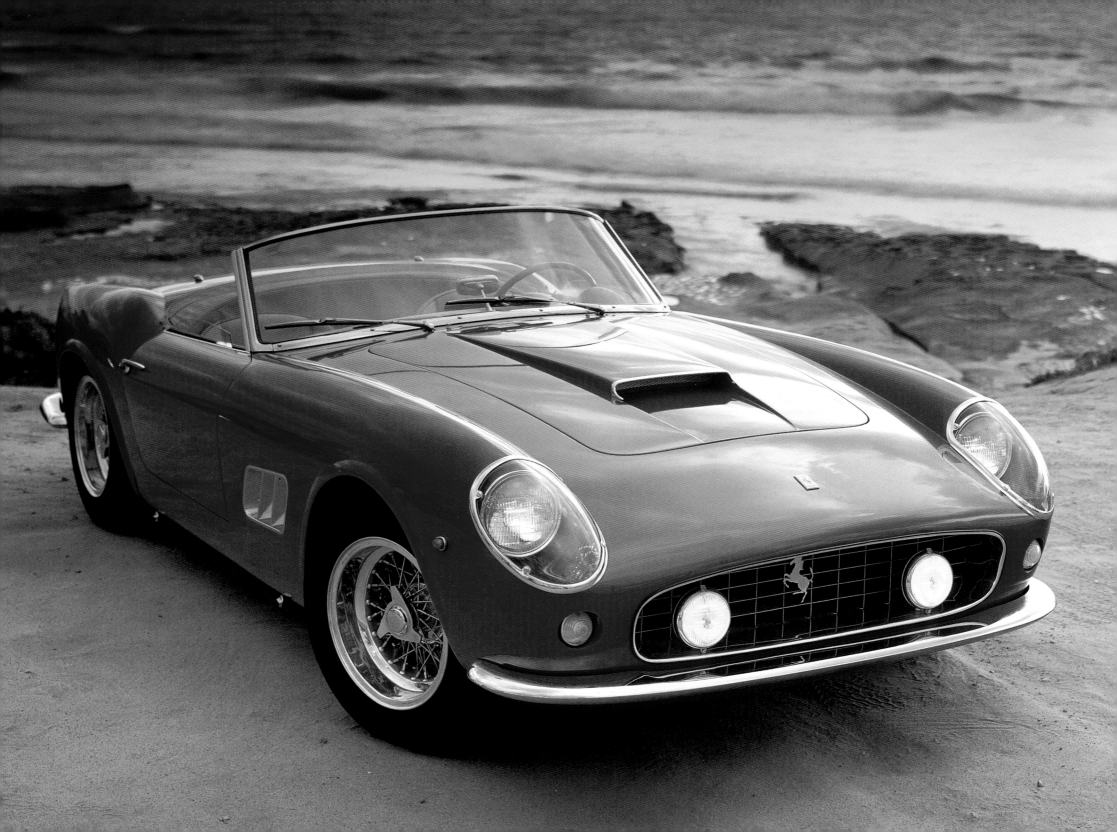

FERRARI

Enzo and the Carrozzeria Italiana

I N ITALY, ENZO FERRARI WAS A LEGEND. AND LIKE MOST LEGENDS, THERE IS AS MUCH FICTION AS FACT SURROUNDING HIS LIFE. HE WAS NEITHER A BRILLIANT ENGINEER NOR A GIFTED RACE DRIVER. HE WAS, HOWEVER, A MASTER WHEN IT CAME TO FINDING PEOPLE WITH SUCH TALENTS AND MANAGING THEM. THAT IS A SKILL FEW PEOPLE POSSESS. • LONG BEFORE HE EVER THOUGHT OF BUILDING HIS OWN CARS, ENZO ANSELMO FERRARI WAS CON- SUMED BY A FASCINATION WITH MOTORCARS, AND AT THE AGE OF 27 IN 1919 HE WENT TO WORK FOR ALFA ROMEO. OVER THE NEXT 20 YEARS HE ADVANCED FROM FACTORY RACE DRIVER TO ENGINEER AND ULTIMATELY TO THE TASK FOR WHICH

Pininfarina designed the 250 GT Spyder California in two series of around 50 each. The long, 102.4-inch wheelbase (pictured) was produced from May 1958 through 1960 in three versions on the GT Berlinetta chassis. The second series, 1960–63, featured a 7.9-inch-shorter wheelbase, lighter weight, and steel and aluminum construction.

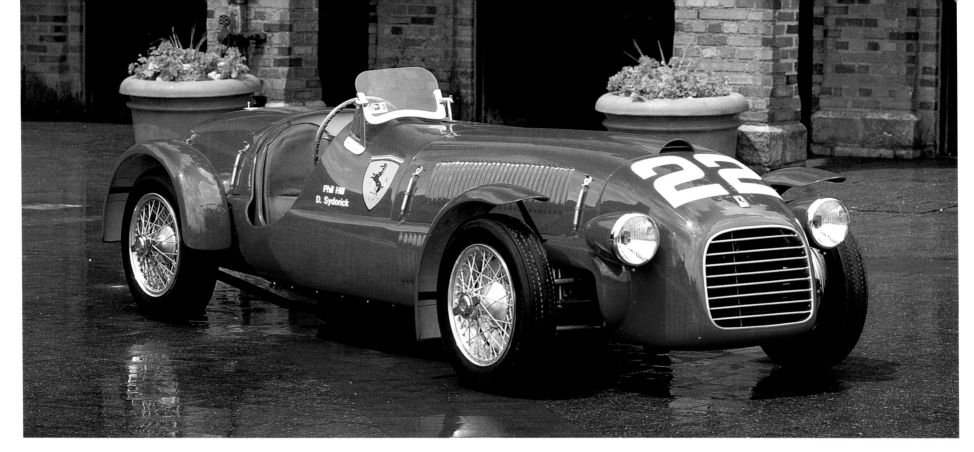

One of the earliest production Ferrari racing models was the 166 Spyder Corsa. This is believed to be the earliest known example. Back in May 1947, a Spyder Corsa was shown at the Piacenza races and later referred to in an Italian newspaper as "small, red, and ugly." History has made it beautiful. (David Sydorick collection)

OPPOSITE BELOW:
The 1,995cc, 60-degree V-12 engine was remarkably powerful for its day, delivering 130 horsepower at 7,000 rpm. The new 166 Spyder Corsa model was victorious in its debut race at Turin in 1947.

he proved himself best suited, the guiding hand behind the triumphant Alfa Romeo racing team—the Scuderia Ferrari—which, under his management, claimed four consecutive victories at Le Mans, six in the Targa Florio, and, in Italy's greatest road race, the Mille Miglia, an unprecedented eleven!

When he retired from Alfa Romeo in 1939, at the age of 47, rather than resting on the laurels of his brilliant career, Ferrari established Auto Avio Costruzione in Maranello, the Emilian town situated on the flat plain of the Po, in the Apennines mountain chain, 10 miles south of Modena. Wrote Ferrari of this decision, "I wanted to show that the level of notoriety I had reached [with Alfa Romeo] was a legitimate and hard-earned outcome of my own hard work and of my own aptitudes." He felt, perhaps, that he had lived off reflected light for too many years, and now after leaving Alfa Romeo it was time to prove that he was more than the maestro.

Indeed, the accomplishments that had made Scuderia Ferrari and the black-and-yellow prancing-horse emblem renowned throughout Europe in the 1930s would establish Enzo Ferrari as an automaker from the moment he opened his doors.

The celebrated Italian race driver Alberto Ascari and the Marchese Lotario Rangoni Machiavelli di Modena commissioned the first cars produced by Ferrari as an independent builder. Completed for the 1940 Gran Premio de Brescia (a replacement for the Mille Miglia that year), neither car bore the Scuderia Ferrari logo or name. Enzo's departure from Alfa Romeo had been amicable, but with one provision, that he not build racing cars under his own name for the next four years, a term easily fulfilled with the outbreak of war in Europe.

By 1945, Enzo was free to begin building cars under his own name and the Scuderia Ferrari banner once more, but there was little demand for expensive, hand-built racing machines in a country that had been on the losing side of the war. The patronage Ferrari had enjoyed before the conflict had all but evaporated, and by 1946, he had resigned himself to remaining in the machine tool business that had kept his factory operating during the war. However, even that was unlikely. His tooling was obsolete and there was insufficient money to remain competitive in the postwar market.

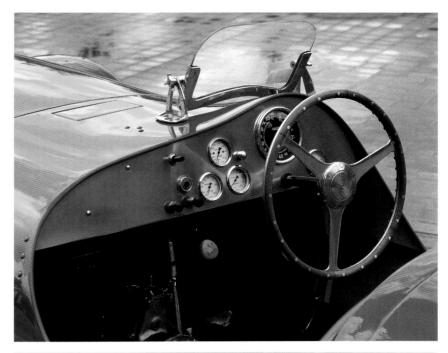

In December 1946, a distraught and somber Enzo Ferrari contemplated a future that held little promise. Then on Christmas Eve morning he received a phone call from an old friend, Luigi Chinetti, a former colleague from his days with Alfa Romeo. Chinetti asked that Ferrari wait for him in Modena, as he had an idea he wished to discuss.

Having heard that Ferrari was about to abandon the automotive business, Chinetti piled his wife and son into a sedan and drove through the night from Paris to convince Ferrari that there was still hope. Luigi Chinetti Jr. recalls that wintry Christmas as being like a scene from an old Ingmar Bergman film. Though only a child at the time, he has never forgotten his first impression of the imperious Enzo Ferrari sitting in his cold, dimly lit office, a single bare bulb hanging from the ceiling above his desk. In the frugality of the early postwar

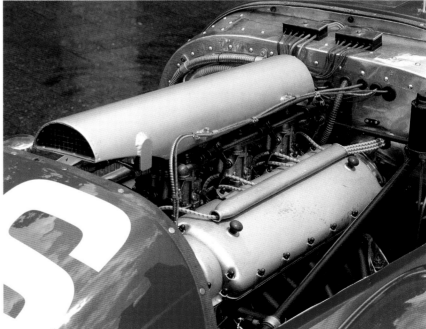

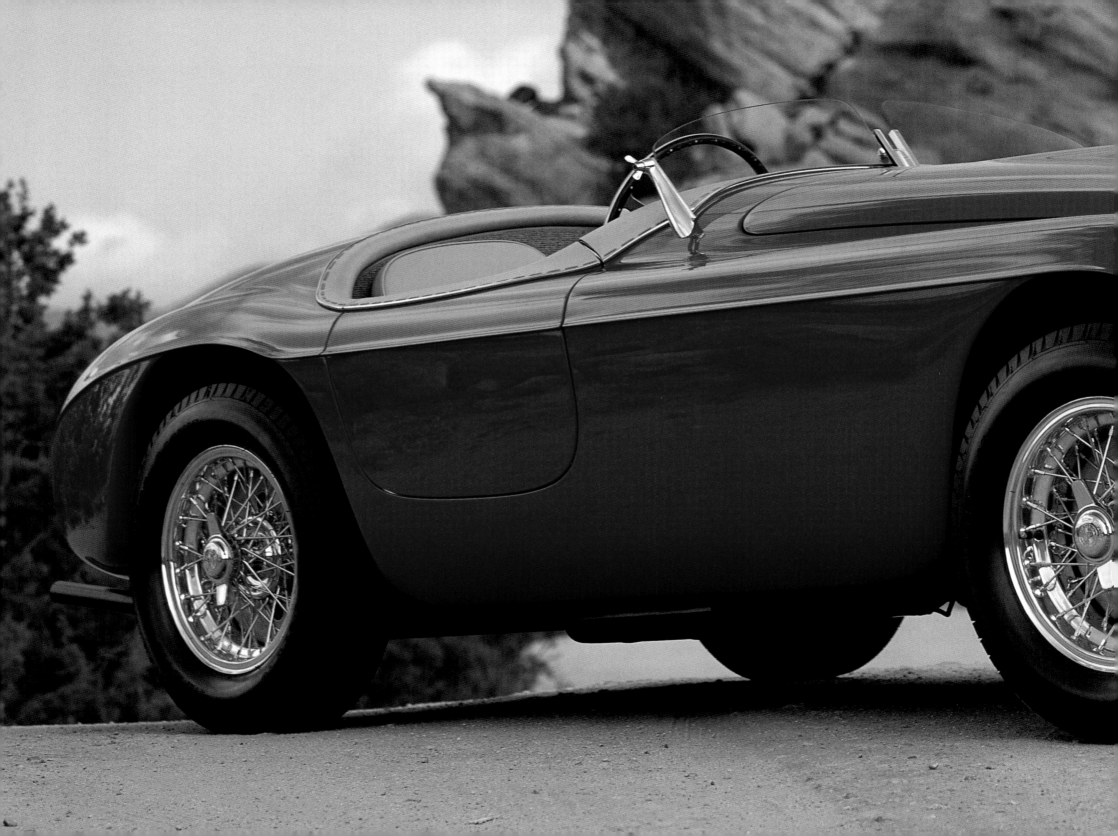

building road cars, but they often paid the bills, and he was willing to let his customers choose their own body designs. In postwar Italy, there was no shortage of panel-beaters to produce custom bodies for Ferrari's V-12 chassis, as mechanically racecars and road cars were still almost one and the same.

Throughout the 1950s, Ferrari models varied from the 212 series (which remained in production until October 1953) to the 340 America (1951–52), 342 America (1952–53), and the 375 America, introduced in 1953. These were the first road cars to successfully carry the Ferrari name beyond Italy, particularly to the United States, where Luigi Chinetti's New York dealership was establishing the marque as the most prestigious line of sports and racing cars in the country.

The first cars built with the American market in mind, and also named America, were the 375 series. They were fitted with stylish coachwork and sold in limited numbers through 1955, by which time Ferrari had developed the most significant sports car of the postwar era up to that time, the 410 Superamerica.

Equipped with the most powerful V-12 engine Ferrari had ever placed in a touring car, the Superamerica delivered an unprecedented 340 horsepower, and later versions built in 1958 and 1959 delivered a breathtaking 400 horsepower. In 1956, the 410 Superamerica was without peer, except for the Mercedes-Benz 300 SL, and then only in styling. In performance and price, the Ferrari was virtually in a class by itself. At the New York Auto Show, the 410 Superamerica was offered by Chinetti at $16,800; the Mercedes-Benz 300 SL was selling through New York importer Max Hoffman's Manhattan dealership for $6,995.

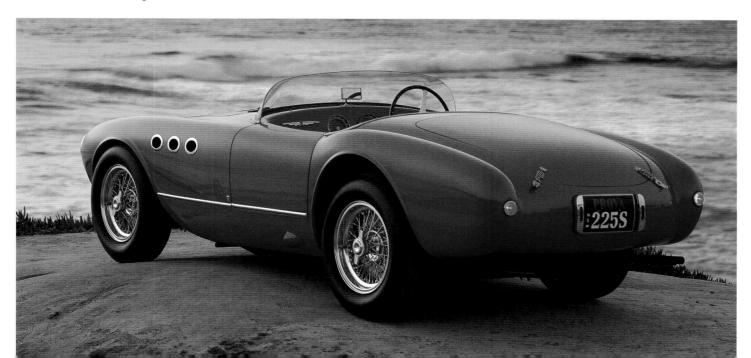

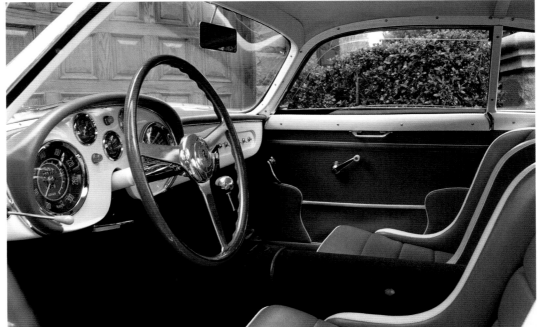

ABOVE: *The unusual double-bubble roofline is the defining characteristic of this Ferrari 250 GT Tour de France model.*

ABOVE RIGHT: *Ugo Zagato's designers often added a "signature" styling cue to their work, and in the rear three-quarter view of this 1956 Ferrari 250 GT Tour de France, it is evident in the "Z" configuration of the rear quarter window and backlight pillar. (David Sydorick collection)*

RIGHT: *Zagato stylists also lent their touch to the Ferrari 250 GT Tour de France interior with a striking color scheme of blue and white contrasted to deep blue carpeting. Interior detail was as important as the exterior styling.*

The styling for the Superamerica, by Battista "Pinin" Farina and his son Sergio, would later become the foundation for Ferrari's 250 GT Berlinetta Tour de France (TDF) racecar, and would strongly influence the styling of the 250 GT PF coupé, 250 GT Cabriolet, and legendary 250 GT Spyder California.

Renowned Ferrari historian Antoine Prunet wrote

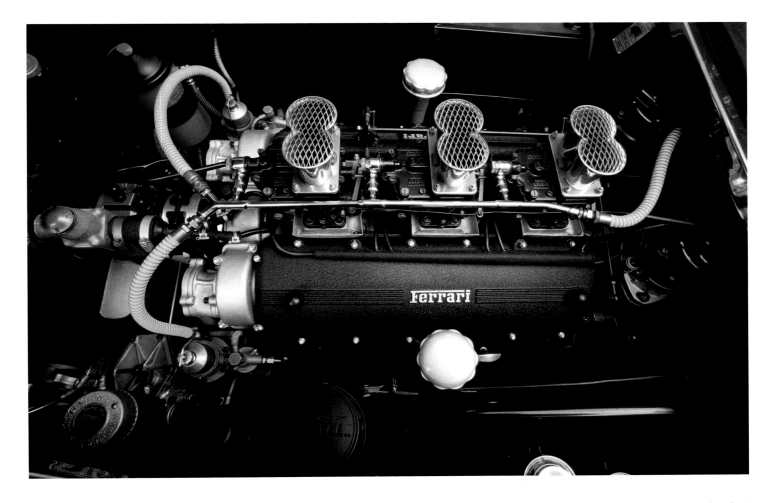

Ferrari's 250 GT engine was one of the firm's most successful and longest-lived designs. In various configurations, carburetion, horsepower ratings, and states of tune, the 250 GT V-12 was found beneath the hoods of nearly 2,500 Ferraris from 1954 to 1964.

that the 410 Superamerica "represented important progress in the design of the engine, the chassis, and the body." Sergio Pininfarina,* who has designed almost every Ferrari road car produced over the last 45 years, says that the 410 Superamerica was his father's favorite design. "This is something unique, a Ferrari between the Ferraris, something extremely refined, extremely good taste, extremely powerful," and with a hint of humor in his voice, he adds, "extremely expensive. The Superamerica is a car which is very dear to my heart." It was dear to the heart of many of its owners too.

*Battista Farina's nickname was Pinin. Over the years he came to be known as Pininfarina, and the family name was legally changed from Farina to Pininfarina in 1961.

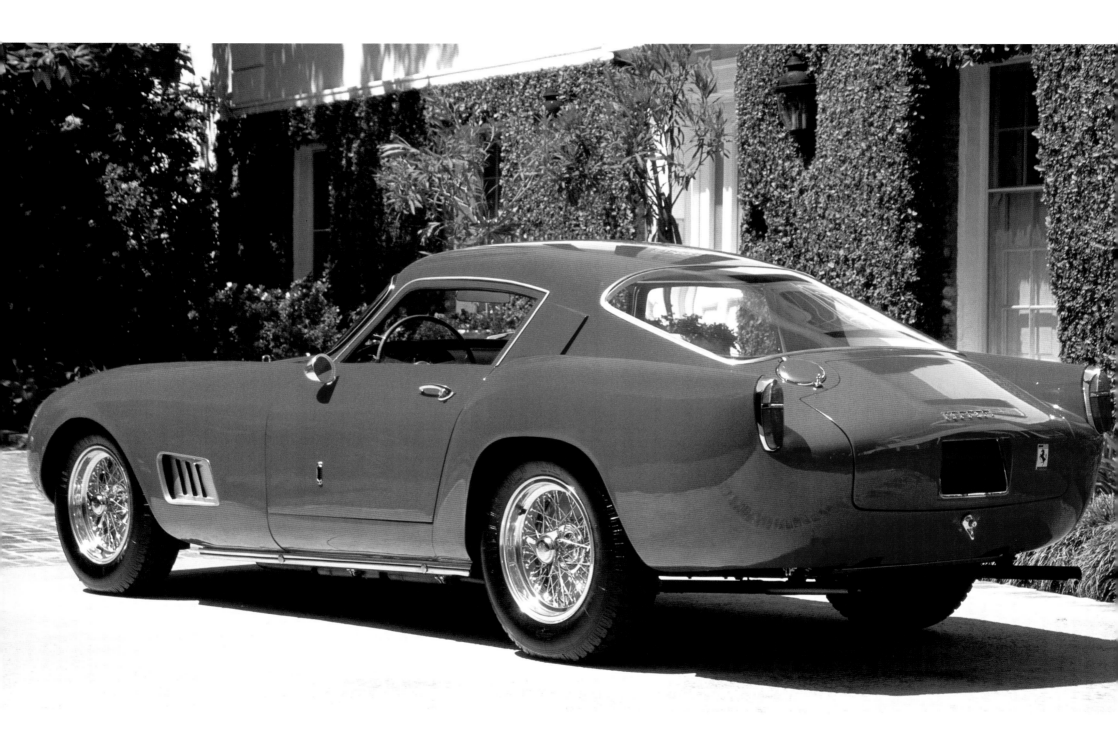

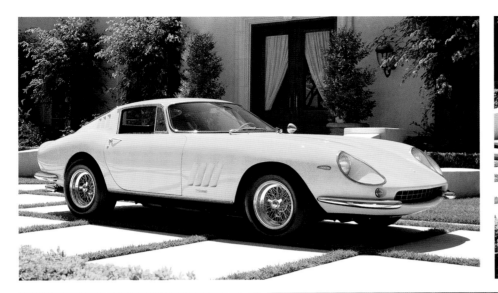

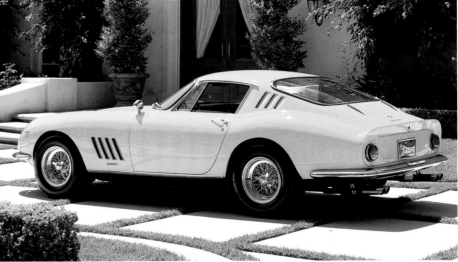

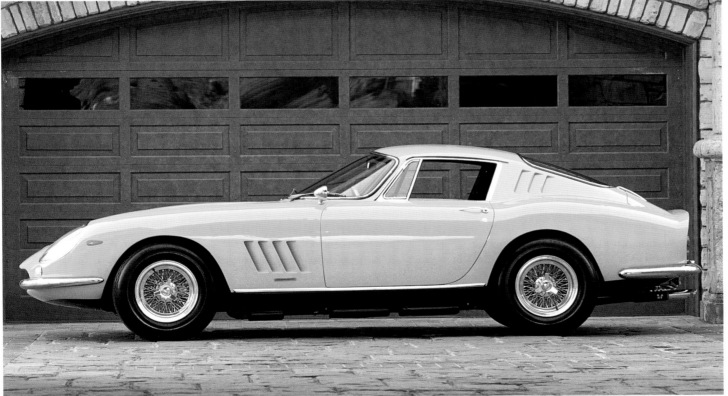

ABOVE LEFT: *Pininfarina improved the design of Ferrari road cars with each successive model, but with the 275 GTB and GTB/4, both the exterior design and engineering took a step forward. They were the first road cars to offer four-wheel independent suspension. The example pictured is a 1968 275 GTB/4.* (Bruce Meyer collection)

LEFT AND ABOVE RIGHT: *The 1966–68 Ferrari 275 GTB/4 combined the best of the racing 250 GTO bodylines with a more contemporary front end and a stunning profile. Combined with the four-cam, 60-degree V-12, delivering 300 horsepower (20 better than the two-cam 275 GTB), this is the most beautiful and best-handling Ferrari ever produced, in the opinion of many.* (Bruce Meyer collection)

N.A.R.T. COMES A SPYDER

In the mid-1950s, Chinetti had moved his dealership from New York to Greenwich, Connecticut, and formed the North American Racing Team (N.A.R.T.) to campaign Ferraris in the United States. The factory had even given Chinetti the right to use the Cavallino Rampante emblem as part of the N.A.R.T. insignia. But in 1966 there arose a difference of opinion between Chinetti Sr. and Enzo Ferrari, one that was never resolved and which created a rift between the two men that they took to their graves.

In 1966, Enzo refused Chinetti's request for a suitable car to replace the 250 GT SWB Spyder California, insisting that he no longer needed to have special cars for his American clientele. In response, Chinetti and his son decided to go out on their own and have the cars they wanted built in Italy at their own expense. They commissioned Carrozzeria Scaglietti to take 275 GTB/4 Berlinettas and convert them into Spyders. Sergio Scaglietti was an artist when it came to fabricating custom coachwork, and the nine 275 GTB/4 Spyders he produced for the Chinettis were flawless. They were sold exclusively through Chinetti Motors in Greenwich as the 275 GTS/4 N.A.R.T. Spyder. Though few in number, and much to Enzo Ferrari's chagrin, the N.A.R.T. Spyders became one of the most coveted Ferrari models of all time.

ABOVE: *The N.A.R.T. insignia incorporated Enzo Ferrari's historic Cavallino Rampante (rampant stallion) emblem, which had been used by Ferrari since the 1930s.*

RIGHT: *The fenderlines of the 275 GTB/4 body lent themselves beautifully to the look of an open car. Both Chinetti Sr. and Jr. knew this but were unable to convince Enzo Ferrari. Thanks to the Chinettis, at least nine were produced. Repainted burgundy, this first N.A.R.T. Spyder appeared in the Steve McQueen film* The Thomas Crown Affair.

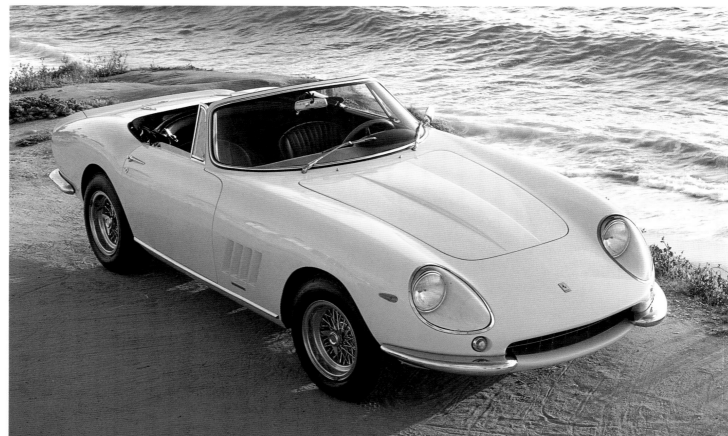

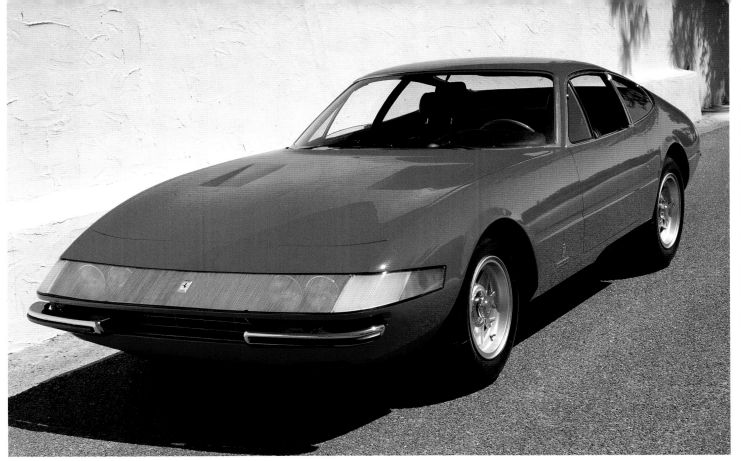

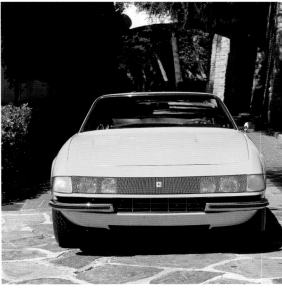

A year after the debut of the Daytona coupé (left), Pininfarina displayed a convertible version. It is ironic that the Daytona Spyder became such a popular model, since the entire theory behind the car was its aerodynamic streamlining, which was completely disrupted by removal of the roof! Sometimes looks were more important.

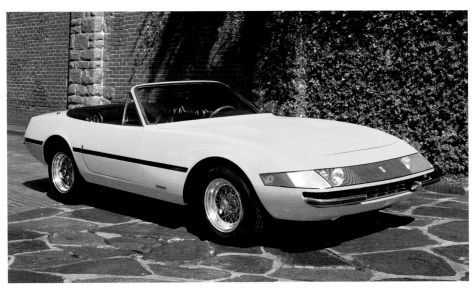

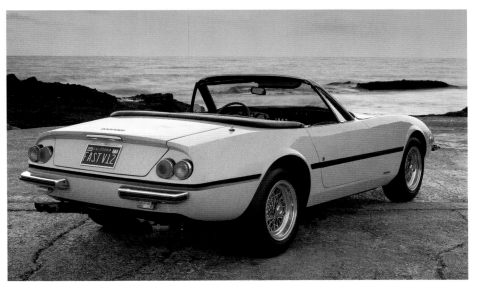

The 1981 Ferrari 512 BBi was a further
development of the 365 GT4 Berlinetta Boxer,
introduced in 1973. The BB series, which
concluded in 1984, was the foundation for an
entire generation of mid-engine models
utilizing a flat 12-cylinder, horizontally
opposed design. The 512 BBi delivered 340
horsepower at 6,000 rpm through a five-speed
gearbox. (Ronald Busuetil collection)

clutch failed. In other events, rallyist Ian Appleyard won the 1950 Alpine in a factory-built ("works") XK-120. Stirling Moss won the Tourist Trophy race in Ireland, and an ambitious 23-year-old race driver named Phil Hill drove an XK-120 to victory at the first Pebble Beach races in 1950.

In Europe, XKs had cut a wide swath through the competition, even at Le Mans, where, although severely outclassed, they still finished a respectable 12th and 15th. The lessons learned in 1950 brought forth an entirely new effort from Jaguar in 1951, and they returned to Le Mans with the remarkable XK-120 C-Types.

Lofty England, who managed the Jaguar Racing Team from 1951 to 1956, said that the XK-120 C-Types were designed to increase the potential of otherwise standard mechanicals—engine, gearbox, and axle unit—but in a lighter, more aerodynamically shaped motorcar. With that combination, England believed Jaguar had a chance of winning Le Mans. In 1951, his team did just that, with a stunning 1-2-3 finish. And Le Mans was not the only success

that year; the Jaguars were also victorious in the Belgian Marathon de la Route, Alpine, Tulip, and RAC Rallies, while Stirling Moss repeated his win in the Tourist Trophy. In America, Jaguars scored wins at Watkins Glen and in Reno. And in virtually every Jaguar dealership!

The following year, England and the Jaguar team faced Mercedes-Benz and watched as their Le Mans title was wrested away from them by the most advanced sports car in the world—the 300 SL, a car that had been completely inspired by the XK-120 C!

Racing continued to dominate Jaguar's focus and strengthen its image worldwide. With Mercedes-Benz retired from 1952 to 1954, Jaguar faced a new challenger at Le Mans in 1953. The C-Types—using disc brakes for the first time—were pitted

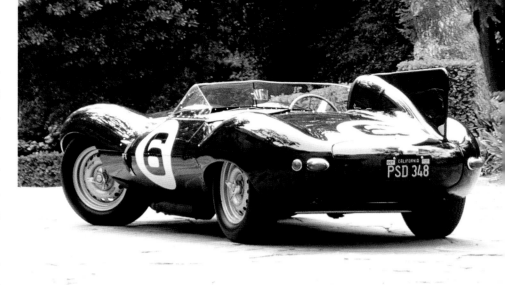

The styling of the D-Type would become the basis for the XK series' replacement in 1961, the Jaguar XKE, possibly the best-looking sports car ever designed. The similarity of design is clearly evident in the hood and fenderlines of this 1955 model. (Bruce Meyer collection)

The D-Type's interior was minimalist as racecars go, with cramped quarters and only essential equipment. It was enough for drivers to win Le Mans three times.

against the new Ferraris and world-champion driver Alberto Ascari. In the end, Jaguar prevailed, with the Tony Rolt/Duncan Hamilton C-Type finishing first, the Stirling Moss/Peter Walker car in second, and the Peter Whitehead/Ian Stewart C-Type in fourth.

The new Jaguar D-Types were introduced in 1954, strictly as "works" cars, and were fitted with a streamlined aluminum body, created by Lyons and Jaguar's aerodynamics specialist Malcolm Sayer. The cars were six inches lower than the C-Type, equipped with improved disc brakes, light-alloy wheels, dry-sump lubrication, and even more horsepower. Unfortunately, it was not to be Jaguar's year. Throughout Le Mans, bad weather plagued the cars. Moss lost his brakes at the end of the long Mulsanne straight and retired on the spot. The second car suffered gearbox failure, while the third, driven by 1953 winners Hamilton and Rolt, fought unsuccessfully to overtake the leader. That year, Jaguar would have to settle for a second place behind Ferrari.

Mercedes-Benz and Jaguar would face each other once again at Le Mans in 1955. Both were counting on their latest cars to win the race. In terms of power and speed, the improved D-Type Jaguar and new 300 SLR Mercedes were equally matched. Both cars had the staying power, and the drivers would decide the race. Mercedes had pinned its hopes on Juan Manuel Fangio, while Jaguar had Mike Hawthorne. The race would end in tragedy.

For the first time, different classes of cars were competing together at Le Mans. Fangio and Hawthorne were in the fastest group, and as they battled it out, they had to pass less powerful cars, which laid the foundation for disaster. At six-thirty in the evening, as the light was just beginning to fade, Hawthorne was approaching the pits when he overtook one of the slower cars, an Austin-Healey driven by Lance Macklin. As Hawthorne passed, Pierre Levegh, driving one of the 300 SLRs, came up right behind him. Macklin later recalled, "Hawthorne passed and then pulled across in front of me. To my amazement, his brake lights came on and I swerved to avoid him." All of this in an instant. Macklin had unknowingly cut in front of Levegh just as the 300 SLR was accelerating, and Levegh slammed into the rear of the Austin-Healey. Macklin said he could feel the

heat of the SLR's exhaust as the car spun around, careening off the rear of the small roadster and into the barrier wall. The Mercedes burst into flames on impact, Levegh was killed instantly, and parts of the car were flung into the crowd, taking the lives of more than 80 spectators. It was the worst accident in the history of motor racing. Mercedes withdrew its remaining cars from the race, which continued, Hawthorne going on to win a sad and hollow victory for Jaguar.

For the next two seasons, the D-Types were virtually unbeatable, with every victory enhancing the company's reputation. Even after Jaguar withdrew from racing in 1956, a private team won Le Mans in 1957. In fact, Jaguar won the great event five times in seven years, with a combination of C-Type and D-Type sports cars.

Competition was not confined solely to the racetrack. Jaguar's victories brought with them an inordinate amount of buyer interest and the likes of BMW and Mercedes-Benz nipping at their heels. Sports cars were in vogue, both in Europe and in the world's greatest marketplace, the United States. Jaguar had to keep pace not so much with performance, but with luxury. Thus came the XK-140, in which some aesthetic purity had to be com-

promised in the name of comfort and style. While production of the XK-120 had lasted six years, the XK-140 gave way to the improved XK-150 in a mere two and a half.

This was the final evolution of the XK-120, similar in appearance, but far more refined, Jaguar's response to the BMW 507 and Mercedes 300 SL Roadster. Production continued through 1960, with the XK-150 and 150S versions, the 150S equipped with a larger 3.8-liter engine tuned to 265 horsepower at 5,500 rpm. As with the XK-120 and 140, there were three body styles, roadster, fixed-head coupé, and convertible, the later two offered with 2 + 2 seating in the 150.

It seemed Jaguar could only go from strength to strength, and in 1961, Sir William Lyons would prove that theory true with the introduction of what has become the most famous sports car in the world.

Jaguar had gone to the parts bin to build the championship C-Types and D-Types. Each engine was essentially a modified in-line six taken from the Jaguar XK-120.

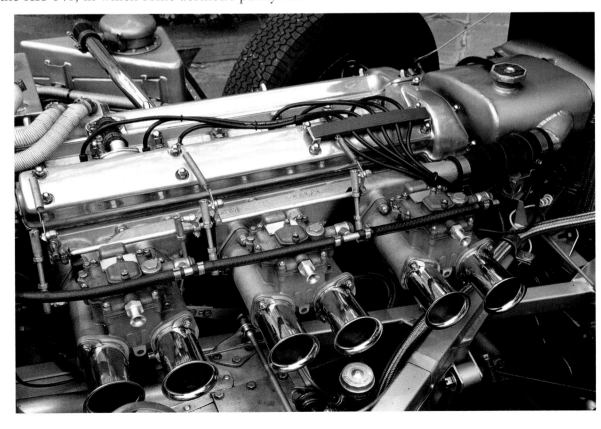

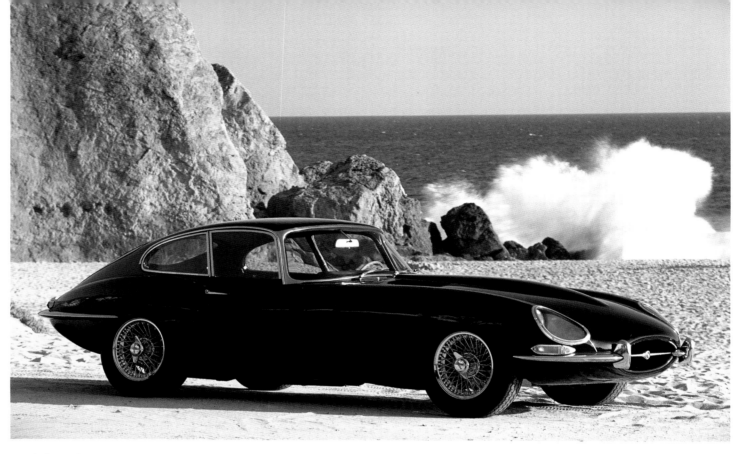

Though 41 years have passed since the XKE's debut in Geneva, the styling is as contemporary as many 2002 models shown at this year's European motor shows. The XKE has never grown old, and if Jaguar were to build it again today, it would still look fashionable. Only a handful of cars in the history of the automobile can make such a claim, none the equal of the XKE.

In designing a successor to the XK series, Lyons once again started on a clean sheet of paper and with one bold stroke reinvented the sports car. As the original XK-120 had been in 1948, the Jaguar XKE was the fastest and most exotic-looking sports car one could buy in 1961.

Though new from the ground up, the E-Type had its design and performance origins well rooted in the Le Mans–winning Jaguar D-Types and roadgoing XKSS versions. The symmetry of line penned by Lyons and Sayer for the XKE was gleaned from the D-Type works car. In translating racecar to sports car, Sayer and Lyons called upon themes that prospective buyers of the new Jaguar model and followers of the company's victories throughout the late 1950s might easily recognize—the large oval grille opening, sweeping front and rear fenderlines, and the

prominent power bulge and hood louvers. For those who had owned and raced the production D-Types and later XKSS variants (some of which were rebodied D-Types), the XKE was the closest anyone had come to building a roadworthy scion.

It took nearly four years to fully develop the XKE. The production E-Types, fixed-head coupé and convertible, had benefited from the D-Type's competition experience. Here was a true race-bred sports car, steeped in tradition and engineered to perform like no other production car on the road. Under its hood was a 265-horsepower, 3.8-liter, six-cylinder engine. This was the same engine that had been used in the later XK-150 models.

The E-Type measured 14 feet 7½ inches from end to end, and 5 feet 5¼ inches in width. The wheelbase stretch was 8 feet, and the track, 4 feet 2 inches. Setting off Dunlop RS5 6.40 tires were the E-Type's stunning 15-inch, 72-spoke wire wheels, the first use of 15-inch wheels on a Jaguar sports car.

The E-Type was an exemplary sports car. One could pile on speed and enter a corner hell-bent without the fear of falling off a rapidly decreasing radius. The steering was neutral except at the limits, where throttle-off oversteer could be induced, and with the XKE convertible's low center of gravity, one could almost transcend the laws of physics before breaking the tires loose. For the average driver, and even the seasoned veteran, the E-Type was the best sports car money could buy, unless of course, one had the financial means to purchase a Ferrari. Few did.

On both road and track, the 3.8-liter six was the mainstay of Jaguar for years. In 1964, displacement was increased to 4.2 liters and paired with an all-synchromesh gearbox. With easier operation, a slight (though not noted) increase in horsepower, and a sizable step-up in torque, 240 lb. ft. to 283 lb. ft., the 4.2 was quicker from a stand to 60, through the quarter mile, and up to 100 mph than its predecessor. An improved clutch, new exhaust system, and more comfortable seats seemed to cure any of the E-Type's ills. It was, for the time, the consummate sports car.

With the new Series 3 V-12 introduced in 1971, the car was at once endowed with Ferrari-like power to reach 60 mph in 6.4 seconds, cover a quarter mile in an average of 15 seconds, and drive the speedometer upward of 135 mph. The V-12 engine was uncommonly quiet, the exhaust note, leaving the four exhaust tips, deep and resonant.

In 1971, *Road & Track* described the V-12 as "a magnificent engine in an outclassed body." Outclassed by contemporary standards perhaps, yet had Jaguar built an all-new car for 1971, the E-Type would have faded from the motoring scene unceremoniously. With the V-12, the XKE went out in a blaze of glory! As a fitting end to the XKE, a pair of 1974 V-12 Jags, running in SCCA Class B Production, won virtually every race in which they were entered.

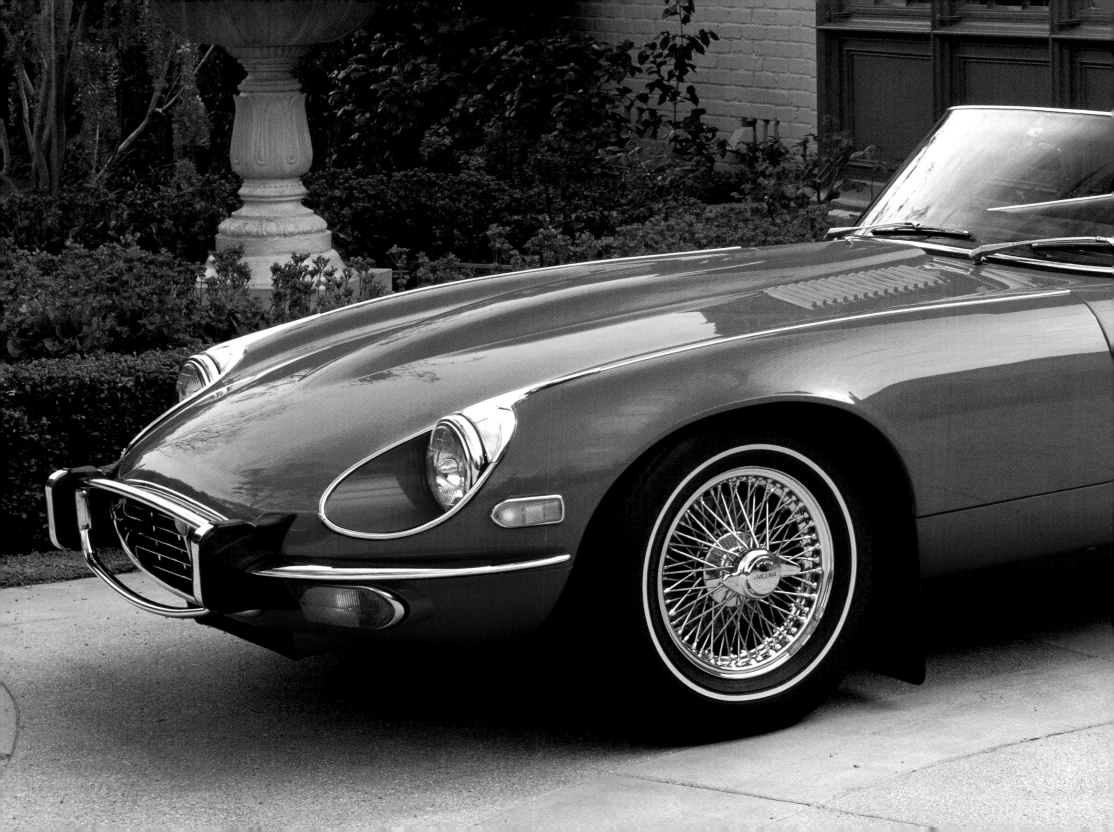

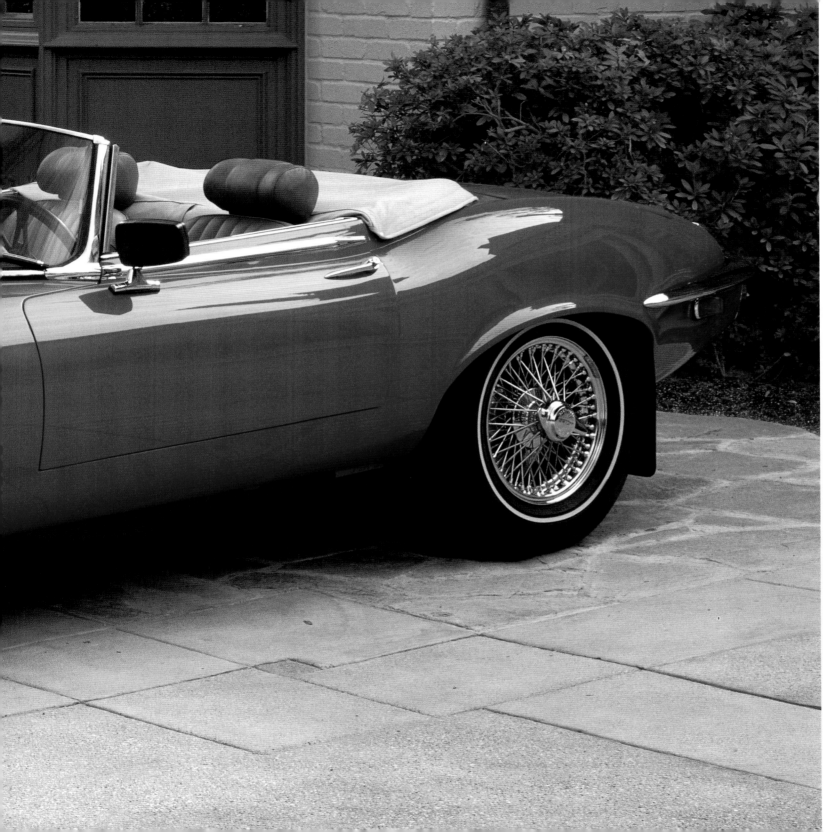

Although there was no direct competition between Jaguar and Ferrari, the new Series 3 Jag V-12, introduced in 1971, was endowed with Ferrari-like capabilities: power to reach 60 mph in 6.4 seconds, cover a quarter mile in an average of 15 seconds, and drive the speedometer upward of 135 mph.

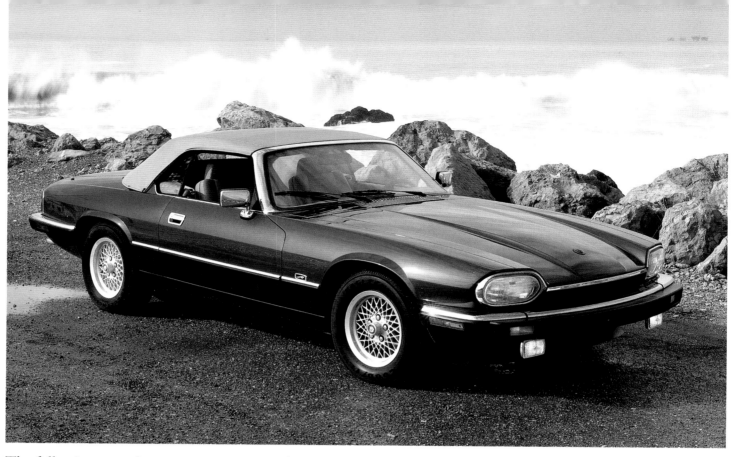

Heir to the XKE legacy, the XJS convertible was introduced in 1988 and remained Jaguar's flagship sports car for nearly a decade. (1993 model pictured courtesy Jaguar Cars. Photo by Dennis Adler)

The following year, the cars were campaigned again, with Bob Tullis and Group 44 ending the season with a victory at Road Atlanta and the championship title.

The E-Type was officially retired from the Jaguar line on February 24, 1975, a car we can look back on 27 years later and still covet.

The sports car image that had been part of Jaguar since 1935 was handed over in 1975 to the V-12-powered XJS, a luxury sports car. Lyons and Sayer had again designed a body that would seem timeless, although not as striking as the E-Type. Drawing from their own past, they built the XJS, like the XK-120, on a modified saloon chassis, in this instance the XJ6/XJ12 platform. A convertible model joined the handsome XJS coupé in 1988, which remained Jaguar's flagship sports car for nearly another decade.

Over the past 70 years, only five major sports car body styles have borne the Jaguar name: SS-100, XK-120, XKE, XJS, and XK-8. Each is dramatically different, yet all were cut from the same cloth, a many-colored fabric woven with threads of victory, innovation, elegance, and grace.

ASTON MARTIN

The Aston Martin is not claimed to be the fastest sports car in production. It is certainly not the cheapest. It is essentially a balanced car in which in addition to outstanding quality and practicality, the aim has been to produce a combination of roadholding, steering, braking and sheer performance, which will be equal to any demand. A considerable stride towards that ideal has been expressed in the DB2-4 Mk III.

—DAVID BROWN, 1957

Named after founder Lionel Martin and a famous piece of English real estate called Aston Hill, Aston Martin had a rather uncertain beginning in 1914. In fact, it would be difficult to refer to Aston Martin as an automaker at all until the

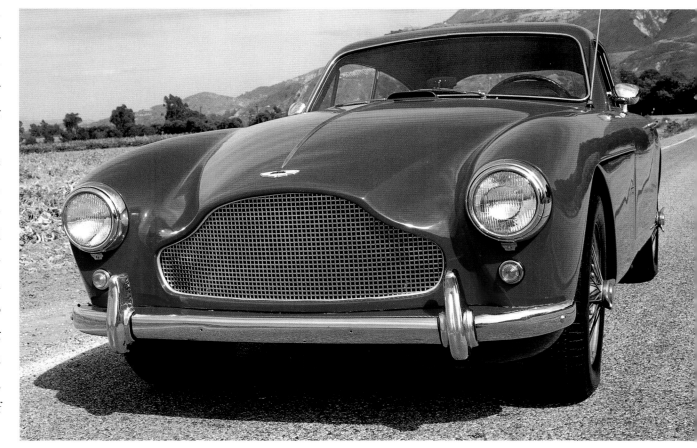

early 1920s, by which time Martin had lost controlling interest and been demoted to technical engineer by his investors. In 1926, Aston Martin was reorganized as Aston Martin Motors, Ltd., with financier Augustus Caesar Bertelli taking control and sending Martin packing altogether.

Under Bertelli's stewardship, Aston Martin rose to prominence in motor racing by the early 1930s, recording a first in the 1931 Brooklands JCC Double-Twelve, a second in the 1931 Tourist Trophy, and a fifth at Le Mans in 1931, 1932, and 1933. Constantly bettering itself, in 1935, Aston Martin won its class in both the Mille Miglia and Targa Abruzzo and improved its standing at Le Mans, finishing third overall. As a result, sales of both competition and road cars were sufficient to keep the Feltham, Middlesex, factory up and running until the start of World War II.

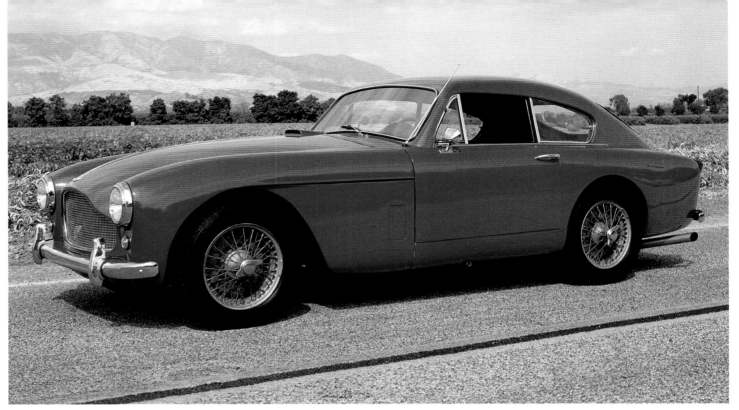

The DB 2 led up to the most beautifully styled model in Aston Martin history, the 1957–59 DB2-4 Mk III. This model laid the foundation for the distinctive DB body styling, establishing the timeless Aston Martin look with a curvaceous grille that has been perpetuated for 45 years.

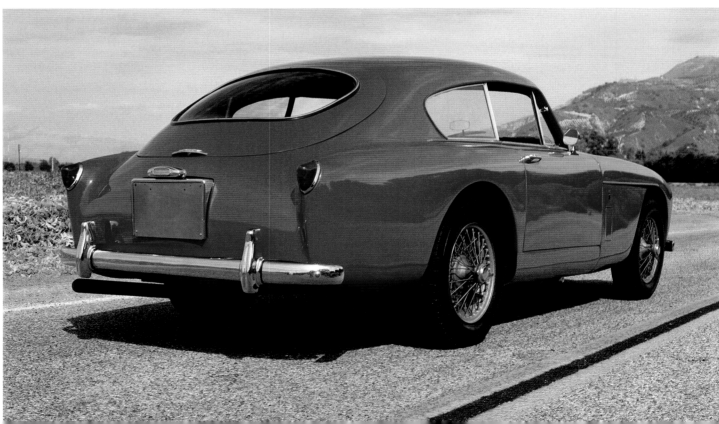

David Brown became owner and director of the company in the same era as William Lyons's XK Jaguars, Enzo Ferrari's incomparable V-12s, and the return to sports car racing by Mercedes-Benz. He regarded motorsports competition as the best means of establishing his new enterprise in the eyes of the public. By 1959, when Aston Martin wrested the World Sports Car Championship from Ferrari, David Brown and his racing manager, John Wyer, had recorded three victories at Goodwood, another trio in the Tourist Trophy, three more at the Nurbürgring 1000 Km, and an overall first at Le Mans in 1959, with a young American driver, Carroll Shelby.

During the same period, David Brown was also building award-winning road cars, which first appeared at the 1948 London Motor Show under the designation DB 1. Within two years, an all-new DB body had been designed, and power for the second series David Brown models improved with the adoption of a Lagonda-Bentley, 2.5-liter dohc six. Making its debut in 1950, the DB 2 series remained in production for nine years, establishing the marque with the most beautifully styled model in Aston Martin history, the 1957–59 DB2-4 Mk III. With this car the foundation was laid for the distinctive DB body styling that continues to this day and includes such legendary models as the DB5, made famous in the James Bond films. Sean Connery's 007 character played no small role in creating an image for Aston Martin that even Enzo Ferrari would have killed for.

The body design was penned by ex–Lagonda* stylist Frank Feeley and manufactured by Salmons/Tickford in Newport Pagnell. Feeley also designed the notchback and drophead coupé versions of the 2-4, and the original 1950 DB 2 model. Feeley's Mk III redo, however, established the Aston Martin look, with a curvaceous grille that has been perpetuated for 45 years.

The Mk III was a true thoroughbred, a sports car capable of speeds in excess of 120 mph with the 5.9-liter Lagonda-Bentley engine turning out 178 horsepower. An improved 195-horsepower version arrived in 1958, nearly coinciding with the introduction of the all-new DB 4.

In 1957, *Motor Trend* wrote of the DB2-4 Mk III, "Driving the Aston Martin is sheer sport, from the moment you switch on the key starter, get on the loud pedal and hear the throaty rumble of the twin exhausts, until you clamp down on the brakes and come to a quick, unswerving stop. The Aston Martin DB2-4 Mk III is one of the world's 10 best cars." Nothing has changed since then.

*The Lagonda Motor Company was purchased by David Brown in 1941 and incorporated into the Aston Martin family.

MG—THE CARS FROM MORRIS GARAGE

For those of modest means, MG was the answer.

The question really wasn't important. If it involved sports car club racing in the 1950s, the answer was almost always MG, built by Morris Garages, Ltd. in Abingdon-on-Thames, Oxfordshire.

In the late 1940s, MG owners virtually pioneered sports car club competition, particularly in northern and southern California. For nearly a decade, the MG was the most commonly raced sports car in America. During the early 1950s, MG TC and TD models were very competitive cars, especially when fitted with special oversize valves, milled heads, domed pistons, and higher compression ratios to extract every trace of horsepower from the small four-cylinder engines. The cars were nevertheless dated and outclassed, if not in engineering and suspension, then certainly in appearance, with styling that had its roots firmly planted in the prewar MG TA and TB models. That was all about to change.

MG was among the last of Europe's major sports car manufacturers to forsake classic-era styling, leaving the look

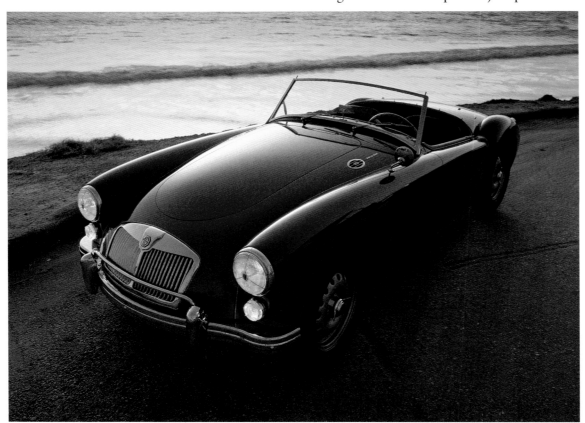

of the 1930s solely to Morgan. In 1955, the company made its first total break from the original prewar, square-rigged styling in favor of a sleek envelope-body that would give MG instant parity with the likes of Austin-Healey, Triumph, Jaguar, and Porsche.

From the time of its debut at the Frankfurt Auto Show, on September 22, 1955, the MGA was lauded by the world's motoring press. In America, *Road & Track* wrote, "Early enthusiasm for its appearance can now be augmented by the knowledge of its very surprising performance. Anybody who likes anything about sports cars will be more than pleased with the new MG." Writing for *Sports Car Illustrated*, Griff Borgeson noted in his usual candid style: "basically safe, friendly, [a] likable car—a genuine well-built sports machine at a price that can't be considered anything but reasonable and fair."

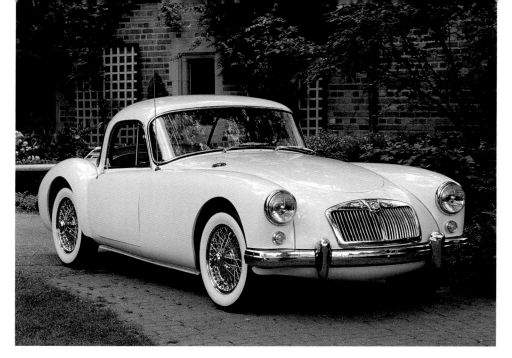

Sports car enthusiasts wholeheartedly agreed, making the MGA the most popular sports car ever built by the time it went out of production in June 1962. Over seven years, MG sold more than 100,000 MGAs, including a limited production run of 2,111 Twin Cam roadsters and coupés, manufactured from September 1958 through June 1960.

The MGAs had a pleasant raspiness to their exhaust note, a firm ride, agile handling, and for the engine displacement and size, spirited performance. It was by design a purebred sports car, but not one purposely built for motorsports competition. The 1500 B series engine in the MGA shared most of its parts with the other BMC products of the time. In the MGA, the engine was modified to increase performance, developing an ample 72 horsepower at 5,750 rpm. Although it was not as powerful an engine as many sports car drivers would have liked, the 1500 series parts were readily available almost anywhere in the world, making the MGA 3-main one of the easiest engines to repair or replace.

Owners had a choice of two gearboxes, the standard four-speed or a close-ratio gear set, based on the MGA competition cars campaigned at Le Mans in 1955. BMC built three cars for the race plus one backup car. MG finished 12th with drivers Ken Miles and Johnny Lockett; the backup car came in 17th, driven by Ted Lund and Hans Waeffler. The second team car was written off after crashing early in the race. It is interesting to note that the body design for the MGA was based in part on a specially built Le Mans racecar produced in 1951—proof perhaps that racing does improve the breed.

The aerodynamic efficiency of the MGA design quickly proved its worth, returning an average increase in top speed of 15 mph over the TF 1500 models, with no increase in horsepower. The

LEFT: *The MGA coupé was introduced a year after the roadster, at the 1956 London motor show. Though the coupé was a bit cramped on the inside, its styling further improved the MGA's aerodynamic profile, allowing the cars to reach the 100 mph mark and become the first normally aspirated production MG to achieve triple digits. (Duane and Pat Van Conant collection)*

BELOW: *Once snugged into the smallish, bucket-type MGA seats, the driver faced a full set of instruments framed by the large, thin-rimmed MG steering wheel. From behind the wheel the gearshift fell right at hand, and all of the controls were within easy reach.*

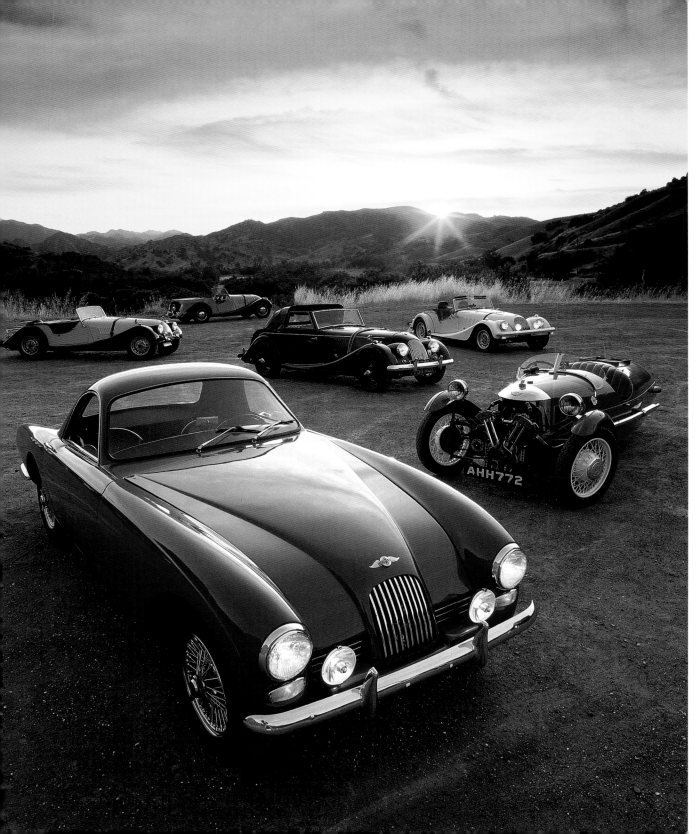

MGAs were so trim that they could maintain a speed of 60 mph on only 16 horsepower.

The suspension utilized an independent front with coil springs and unequal-length wishbones; the rear was a semi-elliptic leaf-spring arrangement. If nothing else, the Le Mans cars had proven the durability of the MGA's underpinnings, utilizing essentially the same components for competition as the production cars.

The MGA was appointed with Connolly leather upholstery, full carpeting, and an efficiently designed instrument panel. The doors contained storage compartments and compensation for the lack of a glove box. The trunk, though small and filled mostly by the spare, still provided enough room for an overnight bag. Anyone seriously considering travel in an MGA ordered the car with an optional trunk rack.

As a J production racer, the MGA Twin Cam was successful, bringing countless victories to MG in the hands of amateur racers the world over. As a limited-production club racer, it was nearly perfect, but for daily driving it was far more difficult to manage than the 1500 and later Mk II 1600s. The standard MGA would ultimately prove to be the better of the two.

Marking an end to the old ways, the MGA was the last model produced with a separate body and

chassis, and the last to be engineered by the prewar Morris Bodies plant. The coachwork utilized steel and aluminum panels—the doors, trunk lid, and hood being of the latter lightweight, rust-free metal. The styling was a cross between the Jaguar XK-140 and, by no small coincidence, an Austin-Healey, another of the BMC products. The new MG had smoothed, flowing lines, arched fenders, and a deliberate absence of chrome trim, even in the door and trunk-lid handles.

In the roadster, headroom was of little consequence unless the top was up or the optional hardtop fitted. In the coupé, however, one had to be slight of build to fit comfortably behind the wheel, even with the car's pronounced bubble roof. The coupé was introduced a year after the roadster, at the 1956 London Motor Show. The first coupé built at Abingdon-on-Thames in more than 20 years, it delighted sports car enthusiasts with an aerodynamic profile that allowed the MGA to surpass 100 mph, making it the first normally aspirated production MG to reach triple digits. No car past or since has captured the pure sports car allure of the MGA, one of the greatest British sports cars of all time.

MORGAN—A FAMILY CARRIES ON TRADITION

In 1906, draftsman and engineer Harry F. S. Morgan decided to end his career with England's Great Western Railway (he was a mechanical engineer, not the guy who blew the whistle or stoked the fire) and open an automobile garage and motor works in Malvern Link. He was 25 years old, and for the next half century H. F. S. Morgan would build one of Great Britain's most famous sports cars.

In 1906, Morgan's personal car was a three-wheel Eagle Tandem, manufactured by Eagle Engineering & Motor Co., Ltd., in Cheshire. It was of a simple design, inexpensive, and powered by a small nine-horsepower, two-cylinder De Dion engine. The Eagle set Morgan to thinking. He could do better.

"It was from his experiences with this machine and a seven-horsepower, two-cylinder car called The Little Star that he had the idea of making his own three-wheeler," says Charles Morgan, grandson of H. F S. Morgan and current managing director of the British firm, the oldest privately owned automobile company in the world.

In 1909, Morgan constructed a lightweight, single-seat, three-wheel cyclecar powered by a seven-horsepower, twin-cylinder Peugeot engine. He used a rigid frame, lightweight body, and an independent suspension. It was as simple as the Eagle but a better design. Although he had built the car for his own interest, as soon as it appeared in public, people began asking where they might obtain one of these wondrous little motorcars for themselves. With a handful of orders and £3,000 borrowed from his father, Morgan added an extension to his Malvern Link garage

The Morgan heritage dates back to 1909 when Harry F. S. Morgan constructed his first lightweight, single-seat, three-wheel cyclecar. Ninety-three years later, the managing director of the oldest privately owned automobile company in the world is founder Harry Morgan's grandson Charles. In the foreground are a rare 1964 Plus 4 Plus Coupé and 1939 Super Sports Trike. Center is a 1964 Plus 4 Drophead Coupé, and in the background from left to right, a 1969 Plus 8 Roadster (yellow car), 1959 Plus 4 four-passenger roadster, and 1987 Plus 8 propane-fueled roadster. (Collections of John Willburn, Michael Hattem, Jim Belardi, Greg Good, John Levins, Don West)

The 1934 Morgan Super Sports is the quintessential three-wheel sports car. This two-seater embodies all the style and unabashed character of the earliest Morgans.

and set up machine tools for manufacturing. Thus was born the Morgan Motor Company.

Morgan soon found himself eminently successful and with more orders than he could possibly fill. He approached several large manufacturers about building the cars, but every one turned him down. And that was fortunate. Morgan expanded his facilities and purchased more machine tools, thereby maintaining complete control of the business.

Being a practical man, Morgan built his cars as efficiently and as inexpensively as possible. One could call his construction methods frugal, but the cars appealed to buyers all the same. The early two-place, three-wheeled Morgans were built atop a simple ladder chassis with lightweight sheet-metal coachwork fashioned around a frame of Belgian ash. This elementary, yet highly efficient layout has become what many motoring authorities consider one of the ten greatest automotive designs of all time!

Interestingly enough, the simplicity of the car, with its Vee-Twin engine perched precariously near the front of the grille, lightweight coachwork, and short wheelbase, endowed the Morgan Trikes with a remarkable power-to-weight ratio and 90 brake horsepower per ton, which enabled the little vehicle to accelerate as fast as any car being produced at that time. Remember Henry Ford's theory that "strength has nothing to do with weight"? Morgans proved virtually unbeatable in their class, on road, track, and in hill-climb competitions. In 1913, Morgans earned more awards for reliability and speed than any other light car in England.

Selling for 85 guineas (approximately $600), the Morgan was not only fast, agile, and affordable, but also fuel efficient. A Morgan entered in the Cyclecar Club's "Fuel Consumption Trial" won the event, averaging 69.4 mpg.

In 1913, the company produced some racing cars with longer chassis, lower seating, and more powerful ohv J.A.P. engines. One of the new three-wheelers was entered in the French Grand Prix at Amiens and handily won against larger four-wheeled European racecars. The competition model became known as the Grand Prix. "Among famous owners," notes Charles Morgan, "was Captain Albert Ball, the English World War I flying ace. He said that driving his Morgan was the closest thing to flying on the ground."

Motorsports victories brought further prosperity to Morgan, and by 1914 production had increased to nearly 1,000 cars a year. Although automobile manufacturing was suspended during World War I, Morgan resumed pro-

duction shortly after the armistice, opening a new facility on Pickersleigh Road in Malvern Link. This is still the site of the Morgan Motor Company.

Although the three-wheelers were still selling in 1935, Harry F. S. Morgan announced that the company would begin to produce a more contemporary "four-wheeled vehicle." The new 4/4, so called to indicate four cylinders and four wheels, was powered by a 1,122cc Coventry-Climax engine, and though not as fast, or as sporty, as the three-wheelers, the new models quickly grew in popularity.

As did most British automakers, Morgan suspended production during World War II, converting the works to manufacture parts for antiaircraft guns. Morgan also produced aircraft undercarriages and performed precision engineering work. Remarkably, the assembly plant on Pickersleigh Road ended the war virtually unscathed, well equipped and ready to resume automobile production in 1945. Though only a few cars were built that year, by 1946 Morgans were being produced at a steady rate and almost exclusively for export.

In the flourishing international market, the new 4/4 was in demand. The three-wheelers, however, did not fair as well. There was little export market for the Trikes since other countries did not offer the same tax concessions on smaller vehicles as Great Britain. By 1950, sales were dwindling even in the home market, and in February 1952, Morgan produced its last three-wheeler, marking the end of a 40-year tradition.

Almost any of the three-wheel Morgans is worth collecting today. Even though their values are not remarkable, the fun quotient more than compensates for any lack of appreciation, and Morgan Trikes make great vintage racers.

The new Morgan line of 1952 consisted of the Plus 4 model, which had replaced the 4/4 in 1950, utilizing a 2,088cc Standard Vanguard engine. In 1955, Morgan reintroduced the 4/4, powered by a Ford engine, as a cheaper (although much slower) alternative to the Plus 4, which used a Triumph TR2 motor. By now you have probably realized that Morgan never built its own engines.

The two model lines in both two- and four-passenger versions remained in production through 1968, the Plus 4 moving through Triumph's TR3 and TR4 engines and the 4/4 keeping pace with Ford developments up to the 1600GT engine.

When H. F. S. Morgan passed away in 1959, control of the company passed to his son Peter. Under his guidance, Morgan Motor Co. Ltd. continued to prosper and in 1962 achieved the most prestigious competition honor in the firm's history, scoring a remarkable class win in the 24 Hours of Le Mans with a Plus 4 Super Sports model driven by Christopher Lawrence and Richard Shepard-Barron.

Under Peter Morgan's leadership, the company also saw the brief production of the most exotic of all Morgans, the Plus 4 Plus Coupé, which had an aerodynamic fiberglass body mounted on a Plus 4 chassis. This has become the rarest of all Morgan variants.

From the front, the Plus 4 Plus resembled the early Aston Martin DB2-4, but this changed drastically in profile as the body took on a sleeker shape accentuated by the high, curved roofline, short rear overhang, and tapering deck. As a purebred sports car, the Plus 4 Plus lived up to the Morgan tradition. The coupés were built on a 96-inch-wheelbase chassis utilizing Morgan's typical Z-section frame with sliding-pillar front suspension, Triumph TR4 engine, and Moss nonsynchro first gearbox. With its smooth exterior lines and approximately 2,000-pound curb weight, the Plus 4 Plus could easily exceed 100 mph.

To those who were not Morgan traditionalists, the Plus 4 Plus seemed a very modern car, although underneath it was as dated as a standard Plus 4. Morgan folk, however, thought it too untraditional and sales were less than rewarding. It turned out to be a moot point. After 26 bodies had been manufactured, a fire at E. B. (Staffs) Ltd., which produced the fiberglass coachwork for Morgan, destroyed all of the drawings and body molds.

Later Morgan models followed the Plus 4 design but were powered by a Buick-based, 3.5-liter Rover V-8. Despite its archaic design, the Plus 8, like all Morgans before it, was a true sports car, capable of 0 to 60 sprints in 6.7 seconds and a realistic, although frightening, top end of more than 120 mph. For competition, the Plus 8 could be special-ordered from the factory with a lightweight, all-aluminum body. Morgan produced a total of 19 alloy-bodied Sports Lightweight models from October 1975 to January 1977.

In production to the present day, its classic 1930s styling still defining it as a purebred sports car, the Morgan is equally at home on a country road or in a vintage road race.

TRIUMPH ON ROAD AND TRACK

Looking back in time along the tree-shaded Coventry lane from which the Triumph TR series emerged in the 1950s, one sees a line of sporty two-seaters that achieved outstanding recognition in a comparatively short time.

The first Triumph TR model was introduced at the Geneva Motor Show in 1953. Named the TR2, it gave the impression of being the second car in the series, and in a certain sense, it was. The production TR was based on the experimental Triumph 20TS prototype exhibited in 1952 at Earls Court. The 20TS was subsequently renamed TR1, *after* the TR2 was introduced!

The cars that built Triumph's early postwar reputation in America, the sporty little TR3 (right) and TR3-A. Triumph virtually dominated E-Production racing in the 1950s, and much of the American sports car market. By July 1953, TRs represented half of Triumph's production, and after 8,600 TR2s were built, the TR3 took over, followed by the further improved TR3-A in 1958, combining to total over 75,000 cars, nearly two-thirds of which were sold in the United States! (John Krause collection)

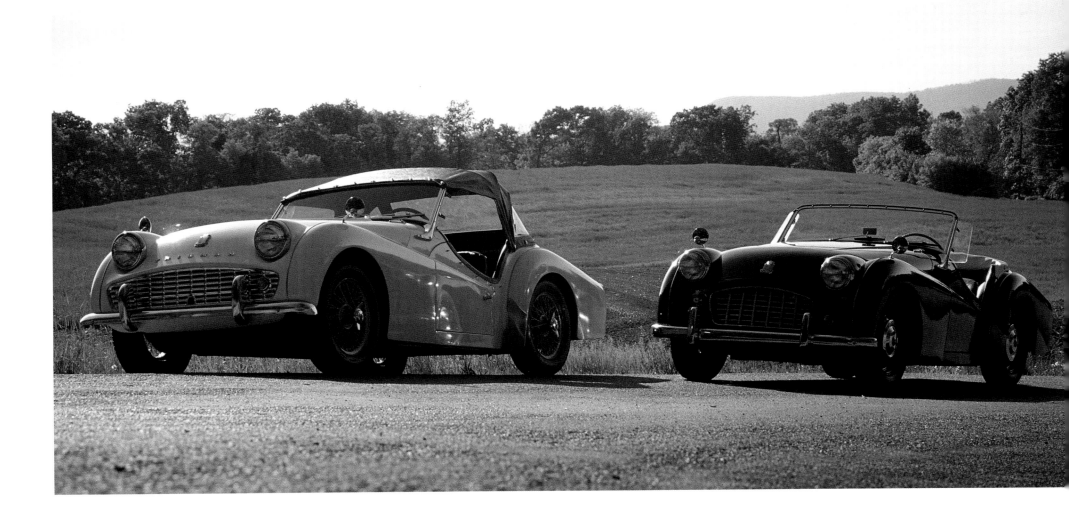

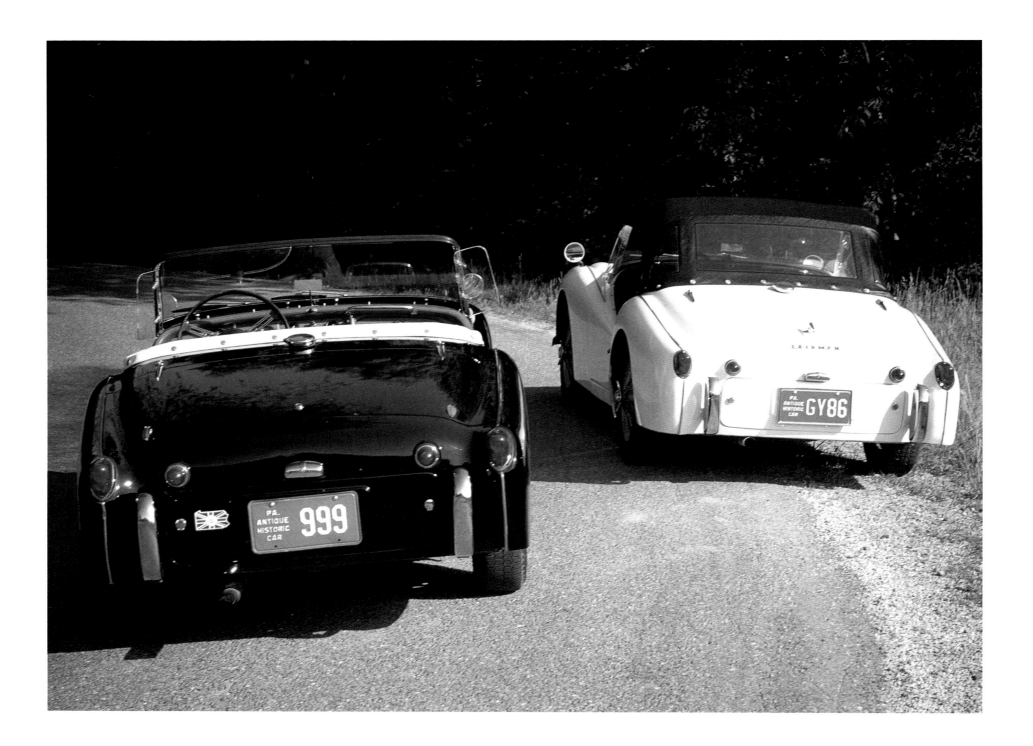

Triumph's concept for the sporty two-seater was racecar driven—put as large an engine as possible into as small and light a car as possible. Anyone who has slipped behind the wheel of an early TR knows the Coventry firm handily accomplished that feat, and it did so with little expense, drawing from many of its existing parts to create the lightweight roadsters.

Triumph had been building cars since 1923 and had pioneered a number of styling breakthroughs in British sports car design. From the very beginning, Triumph had set itself apart by concentrating on the production of compact specialist sports saloons and high performance sports cars for the individualist. Throughout the 1920s and 1930s, the company built a variety of small sports and touring cars, highlighted by popular models such as the 1928 Super-Seven Two-Seater Deluxe, the dashing 1936 Southern Cross two-seater, and one of the greatest prewar Triumph sports cars, the 1934 Dolomite SS Roadster, which, by no small coincidence, resembled the dazzling Alfa Romeo 2.3.

By the beginning of World War II, Triumph had firmly established itself as a builder of fine, reasonably priced sports cars, but was by no means a raging success in Great Britain.

After the war, Triumph quickly began to break away from the classic, squared-off styling themes MG, Morgan, and other British automakers were still using in the early 1950s. The first great success for the company was the Triumph TR2, with its rounded and shapely front end, upswept fenderlines, partly buried headlamp pods, and bold, hollow grille cavity. At the midsection, the rear fenders kicked upward from just behind the car's rakish cut-down doors, then swept back into a sloping tail, discreetly accented with four small tail lamps, a tidy little trunk, and just a hint of bumper at either corner.

The TR arrived at a turning point in automotive history, the dawning of the 1950s sports car boom, led by MG, Austin-Healey, and Jaguar, but followed by countless other cars of European and American lineage. Within a year of its introduction, the TR2 had established itself among sports car enthusiasts and club racers, picking up the rather catchy epithet Tiny Rapid. And that it was. Until the advent of the more powerful AC Ace, which was moved up to Class D in 1960, Triumph's little four-cylinder TR2s and later TR3s virtually dominated E-Production racing, along with a good share of foreign sports car sales in the United States, earning Triumph its place in the history of the sports car.

RIGHT: *The Austin Motor Company merged with MG in 1952 to form the BMC conglomerate and that same year introduced the spectacular Austin-Healey 100, the undisputed star of the London Motor Show. Graceful but sturdy and competitively priced, the 100 became an instant sensation. The model pictured is a 1958 100-6. (Bob Denton collection)*

BELOW: *The visual relationship between the Austin-Healey 100 and the 1955 MGA is unmistakable, as MG greatly benefited from the 1952 merger with Austin. The more sporting of the two marques, the Austin-Healey models 100, 100M, and 100-6 were popular on both road and track throughout the 1950s. (Bob Denton collection)*

OPPOSITE: *Measuring 13 feet 1½ inches in overall length, the Austin-Healey 100-6 was built atop a 92-inch wheelbase. Weighing 2,478 pounds, the trim two-seater was a mere 4 feet ¾ inches at the windshield and 5 feet ½ inch wide. Zero to 60 mph could be achieved in 12.9 seconds, and the standing quarter mile was clocked at 18.8 seconds. And it could do this while maintaining an average fuel economy of 23.3 mpg!*

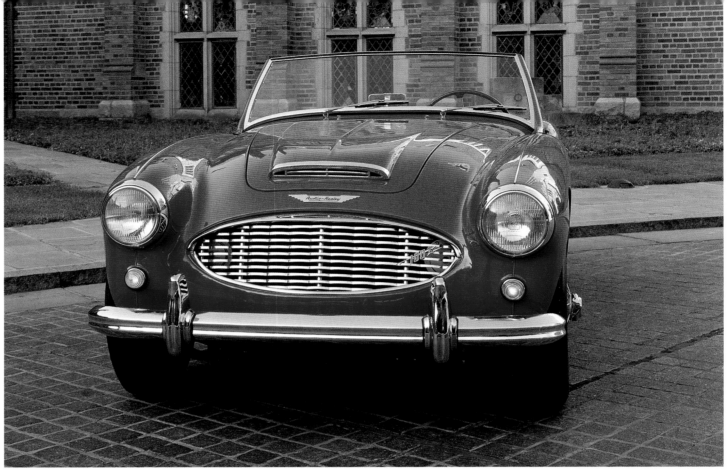

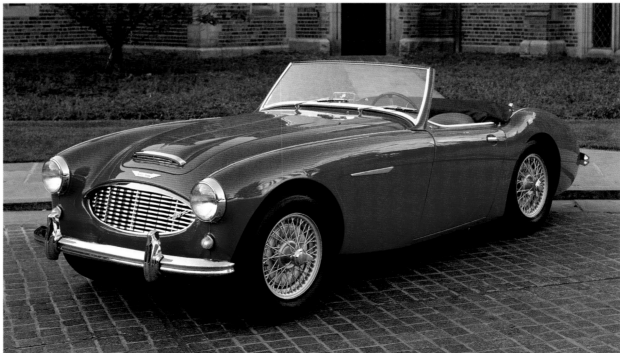

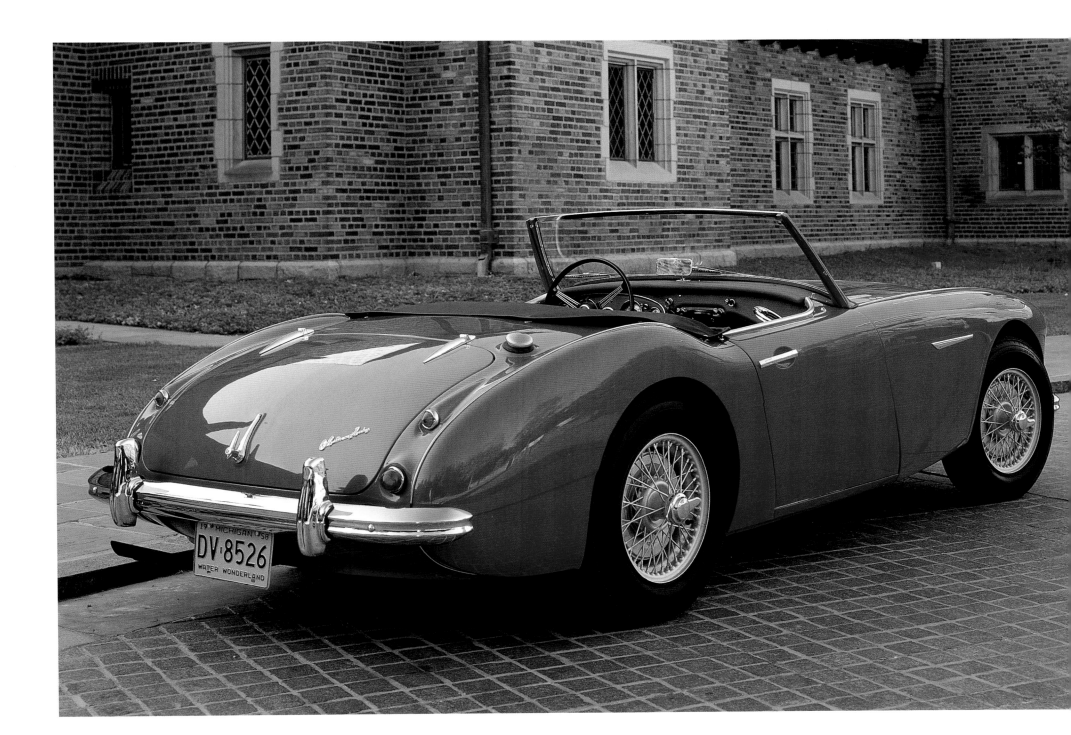

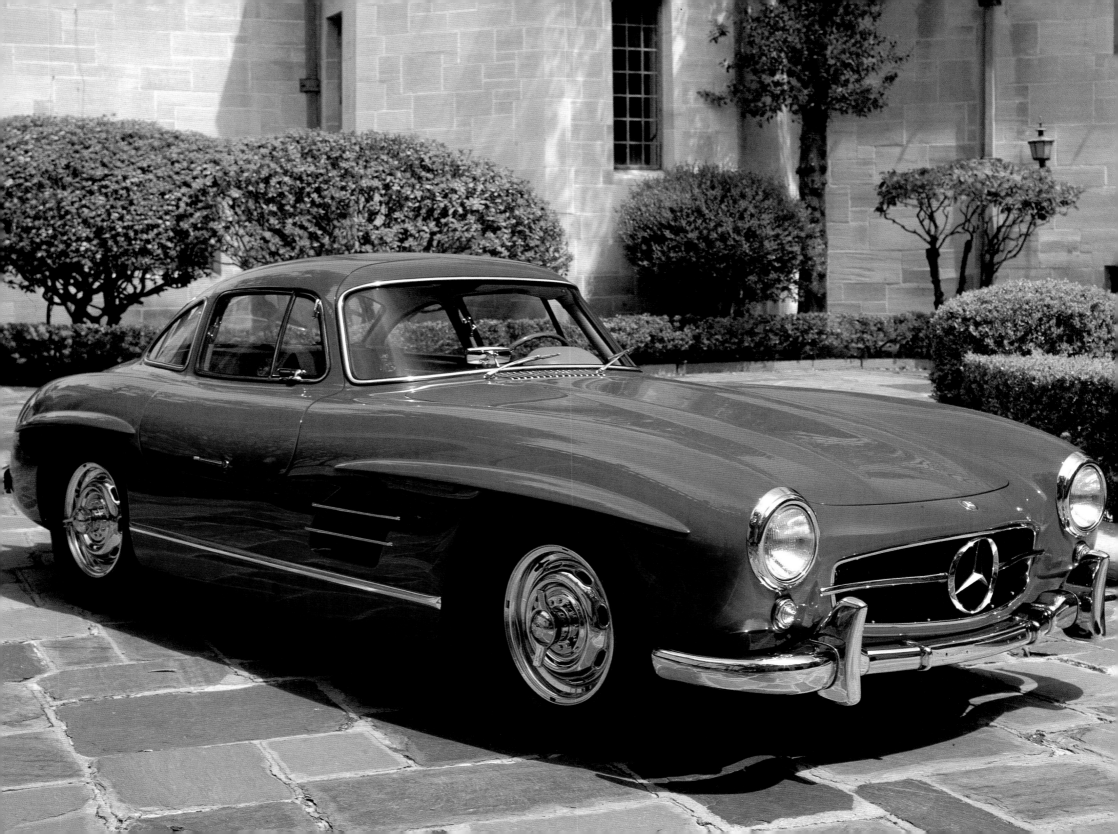

THE GERMAN EQUATION

Mercedes-Benz and BMW in the 1950s

T HEY HAD REACHED AN IMPASSE. IN 1952, MERCEDES-BENZ CHIEF ENGINEER RUDOLF UHLEN-

HAUT, TECHNICAL DIRECTOR FRITZ NALLINGER, AND STYLIST KARL WILFERT HAD DESIGNED THE

MOST AERODYNAMIC SPORTS CAR IN THE COMPANY'S HISTORY, WITH ONLY ONE MINOR

FLAW . . . THERE WAS NO WAY FOR THE DRIVER AND CODRIVER TO GET INTO IT! • THE

INNOVATIVE 300 SL RACECAR WAS BUILT AROUND A MULTITUBE SPACE FRAME, WHICH,

THOUGH WEIGHING A MERE 181 POUNDS, WAS STRONG ENOUGH TO SUPPORT THE

ENGINE, TRANSMISSION, AND REAR AXLE. HOWEVER, THE DESIGN CREATED

A HIGH, WIDE SILL THAT SURROUNDED THE PASSENGER COMPARTMENT AND

The production 300 SL coupé, introduced in 1954 and based on the 1952 racecars, has become one of the benchmark automotive designs of the 20th century.
(Bruce Meyer collection)

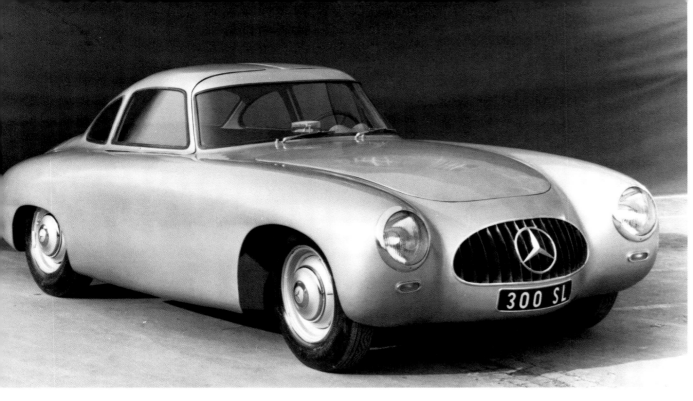

The 300 SL racecar was a masterpiece using essentially off-the-shelf parts from the 300 series sedans. A tubular space frame, supporting the engine and the suspension taken from the production 300 model, was surrounded with an aerodynamic sports car body that literally rewrote the book on automobile design. This is the 1952 racing prototype.

made the use of conventional doors impossible. The solution, as Wilfert later remarked, was to allow form to dictate function. Entry would literally be "through the roof," using large panels hinged at the top that could be lifted straight up, allowing driver and codriver to step over the sill and into the car. The raised doors would later be described by the automotive press as "looking like the wings of a gull."

The 300 SL was principally the work of Rudi Uhlenhaut. The son of a German bank director and an English mother, he was born July 15, 1906. Educated in Great Britain and Germany, he earned a degree in mechanical engineering in 1931 from the Munich Technical Institute and began his 41-year career with Daimler-Benz that same year, as a passenger-car test engineer.

His easygoing manner and reputation for finding creative solutions to engineering problems helped him to advance within five years to technical director in charge of racecar construction and testing. At the time of his appointment in 1936, Daimler-Benz racecars were being trounced so badly that the company had withdrawn from several events. Uhlenhaut was given the task of turning the situation around in as little time as possible. He did it in less than a year! By the 1937 racing season, Mercedes-Benz had returned to the competition forefront with the W125 Grand Prix car. The W125s won the Tripoli, German, Monaco, Swiss, Italian, and Masaryk Grands Prix. Uhlenhaut and his team later guaranteed Daimler-Benz dominance of Grand Prix racing for the rest of the decade, with the W154 and W163 GP cars.

Not only was Uhlenhaut a gifted engineer, he was also a highly skilled driver. By 1939, he was as fast as anyone else on the Mercedes-Benz team and would often investigate complaints about a car's being down on speed by carefully analyzing its performance from behind the wheel! Unfortunately, World War II was to put a temporary halt to both his engineering and his driving.

As Mercedes-Benz began to rebuild itself in the late 1940s, Uhlenhaut was appointed chief of the experimental department. As head of research and development, he was also responsible for the factory's new racing program along with his prewar colleague the legendary Alfred Neubauer, who resumed direction of the works' race team in 1951.

Uhlenhaut was facing a difficult challenge in his new position, that of repeating what he had done for Daimler-Benz in the 1930s with the W125, only this time he had little more than production car engines and spare parts at his disposal. Even as late as 1951, Mercedes-Benz was working with fundamentally prewar designs, and its 300 series flagship models were in many respects the last vestiges of a bygone era.

Having watched Jaguar dominate the French 24-hour, day-into-night marathon at Le Mans in 1951, Uhlenhaut, along with his close associate Daimler-Benz technical director Fritz Nallinger, reasoned that they could do essentially the same with Mercedes-Benz 300s that William Lyons had done with the XK-120 Jaguars. Raid the parts bin! The XK-120C had been little more than an aerodynamic body covering a slightly modified suspension, lighter frame, and moderately tuned version of an off-the-shelf engine. In Jaguar's case, it had been the dohc XK-series six; in Daimler-Benz's, it would be the sohc six from the Type 300 and 300 S. Uhlenhaut and Nallinger also decided that the racecars could utilize other 300 S components for competition, including the rear axle, transmission, front and rear suspension, even the same wheels and tires.

While Uhlenhaut extracted 170 horsepower from the 300-series engine without increasing its displacement, the success of the car would rely as much on engineering as on sheer horsepower. In addition to a modified engine, the racecar would require a lightweight frame and a streamlined body to become a winner. Uhlenhaut and Nallinger already had the weight problem solved with the birdcagelike space frame, and chief stylist Karl Wilfert was applying his experience in aerodynamics to the creation of a sleek, streamlined body. All that remained was to fit the pieces together like some elaborate jigsaw puzzle.

The sleek, rounded contours of the body were a perfect fit for Uhlenhaut's tubular space frame. Slipping through the air, the 300 SL carried no superfluous trim—no chrome-plated bumpers, door handles, outside rearview mirrors—

BELOW AND FOLLOWING PAGE: *Rudolf Uhlenhaut came up with the 300 SL's design after watching Jaguar win at Le Mans in 1951. A year later, Uhlenhaut and his staff delivered what was to become the most successful one-year wonder in racing history. In 1952, a trio of 300 SLs started at Le Mans and 24 hours later two of them streaked across the finish line in first and second place.* (DaimlerChrysler Classic collection)

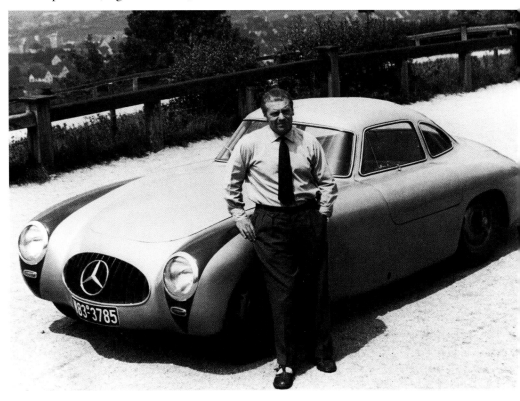

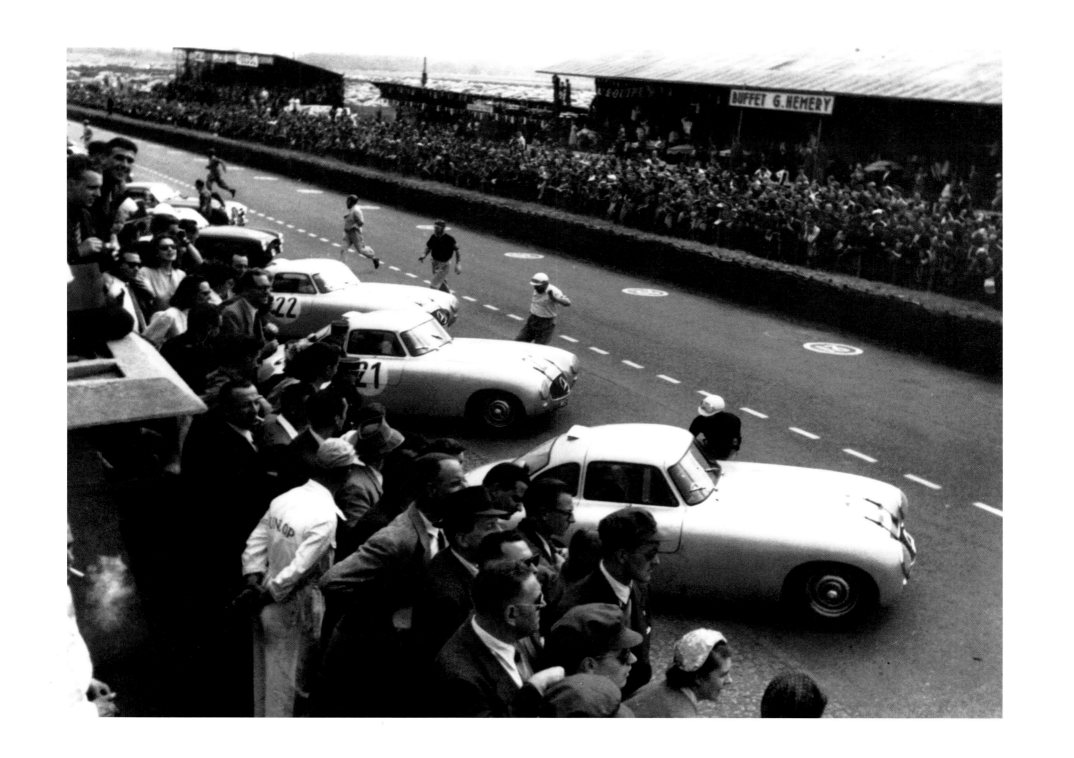

nothing that might increase resistance. The wind tunnel revealed a drag coefficient of 0.25, a figure that auto manufacturers still find challenging 50 years later!

The factory campaigned the 300 SLs for only one season, in which they finished first and second in all but their maiden race, the Mille Miglia, where they finished second—just four minutes behind Giovanni Bracco's winning Ferrari. From then on the Mercedes-Benz team was first across the finish line. At the Grand Prix of Berne, they completed the race in order—first, second, and third; at Le Mans, they finished first and second; and at the Nürburgring, the 300 SLs streaked home first through fourth!

Having proven themselves virtually unbeatable in Europe, the 300 SL team concluded the 1952 season on the other side of the Atlantic, competing in the grueling Mexican road race, the Carrera PanAmericana. Untried in the desert and fraught with bizarre problems from the start (on the first leg from Tuxtla Gutiérrez to Oaxaca, a buzzard crashed through the windshield of Karl Kling's 300 SL and landed in his codriver's lap!), the Mercedes-Benz team managed a remarkable 1-2 finish, moving through the desert at such a velocity that racing manager Alfred Neubauer's chartered DC-3 spotter plane could barely keep up. After 1952, the racecars were retired. Most of them are now displayed at the Mercedes-Benz Museum in Stuttgart.

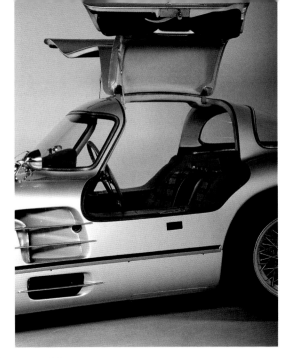

ABOVE AND BELOW LEFT: *The 300 SLR coupé combined the styling of the production 300 SL introduced in 1954 with the Formula 1 configuration of the factory racecars campaigned in 1955. Of two coupés built (the racecars were all roadsters), this one was Rudolf Uhlenhaut's personal car, which he drove frequently.*

BELOW: *The interior of the 300 SLR was pure racecar but executed in a style that would have been suitable for a production car. The noise inside the SLR, however, was deafening, as the car had no insulation.*

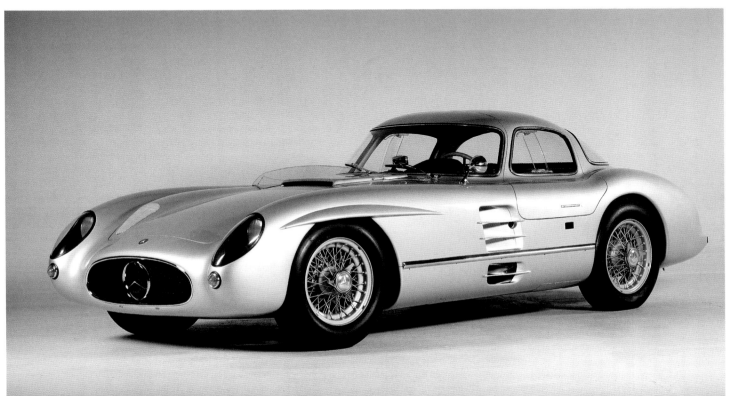

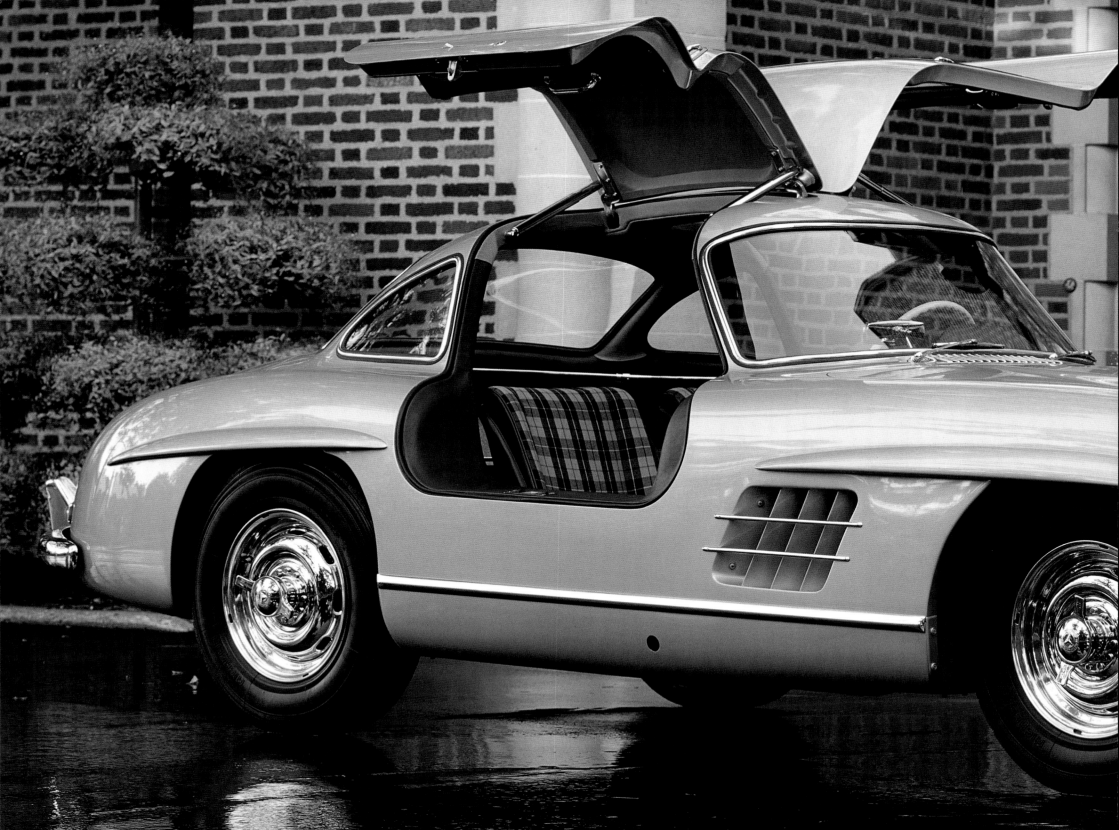

Toward the end of 300 SL's production, roughly 1,000 cars had been sold in the United States, and American importer Max Hoffman queried Mercedes-Benz regarding a roadster model, which he believed would be better suited to the tastes of American drivers. Unknown to Hoffman, or anyone outside Rudolf Uhlenhaut's design studio, a roadster version of the 300 SL had been on the drawing board since 1954; thus, in 1957, the Gullwing was replaced by the new 300 SL roadster.

While there has always been great speculation surrounding the Gullwing's demise, it was the opinion of Heinz Hoppe—the Daimler-Benz executive who established Mercedes-Benz of North America in April 1965—that the decision was in part a reaction to comments made to Daimler-Benz management by Hoffman. "A vast majority of the cars went to the States, and Maxie Hoffman told us time and again that his pampered customers wanted a bit more comfort, a larger boot, and a bit more fresh air," recalled Hoppe. "In addition, we didn't know how long customers—who can be pretty choosy in this price range—would accept a car so similar to the racing version with all its compromises. That's why we started considering a roadster offering that extra creature comfort American customers like so much." Whether or not Hoffman prompted the decision, in 1957, the last 70 Gullwings were delivered to customers, and by year's end, 618 roadsters had already come off the assembly line.

Most of the problems associated with the Gullwing were remedied in the new convertible roadsters—ventilation and headroom being the biggest—while an improved rear suspension made the cars more manageable. The coupé had used a conventional swing axle with two pivot points outboard of the differential. If driven on trailing throttle through a tight curve, the camber change tended to lift the inside rear wheel and induce sudden oversteer, the same problem the race drivers had encountered. This was manageable for professionals, but difficult for those less skilled, so the roadster was fitted with a new swing axle, utilizing a single low pivot point, thereby improving the car's cornering behavior and predictability. A horizontal compensating spring included with the new axle also gave

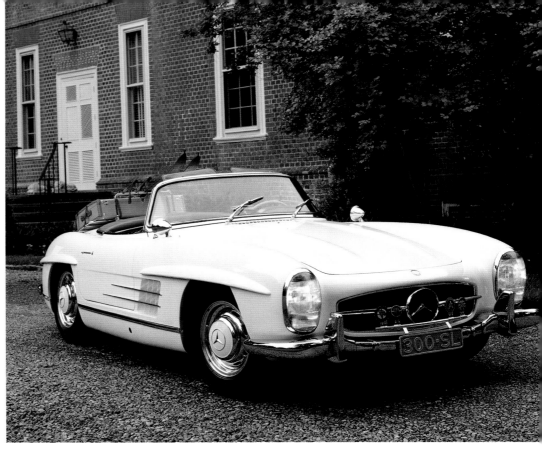

OPPOSITE: *A rare and controversial model, this is the 300 SL roadster prototype featured in an October 1956* Collier's *magazine article by David Douglas Duncan. It was later used to prototype the design for two SLS racecars campaigned in SCCA by American race driver Paul O'Shea. It has been restored to the latter configuration, a decision around which much controversy still exists.*

ABOVE: *The European-style headlights (shown) were better looking than those required to meet U.S. standards, and many 300 SLs have been retrofitted with the original European lenses first seen on the 1956 roadster prototype. (Dr. Frank Spellman collection)*

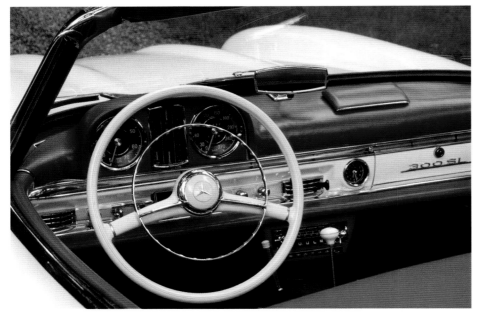

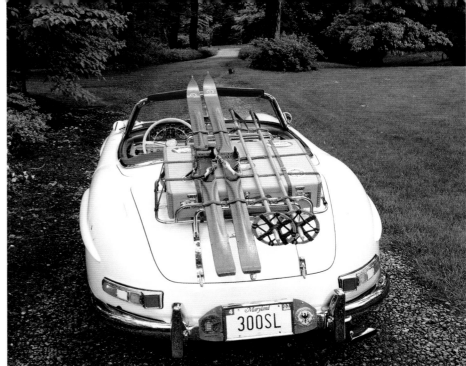

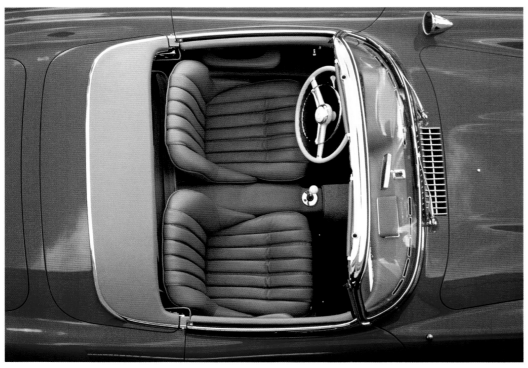

the roadster a somewhat gentler ride. Improvements in the engine compartment, including a standard-equipment sports camshaft—increasing output to 235 horsepower—made the roadster a better-handling and faster car than its predecessor, despite a 200-pound increase in weight.

Though not seen as often in competition as the Gullwing, the roadster was the more comfortable and practical of the two 300 SL models. With the addition of Dunlop disc brakes in March 1961, and an optional removable hardtop, the roadster reached its pinnacle—the final evolution of the cars that had come from the parts bin and from the imaginations of Uhlenhaut, Nallinger, and Wilfert. When production ceased in 1963, a total of 1,858 300 SL roadsters had been built. Most were sold in the United States.

BMW—ON THE WRONG SIDE OF THE WALL

On May 8, 1945, when World War II came to an end in Europe, Germany's leading automakers found themselves surrounded by rubble. But few companies suffered greater devastation than BMW. What remained of their production facilities was situated on the wrong side of the line dividing Germany into East and West. By the late 1940s, when Mercedes-Benz was rebuilding, BMW was all but out of business.

During the years 1945 to 1950, the company rebuilt itself by manufacturing motorcycles, which had been the foundation of BMW in the post–World War I era. Originally a manufacturer of aircraft engines, BMW was banned from aviation by the Treaty of Versailles and, in an effort to increase business, began manufacturing innovative, flat-twin, shaft-driven motorcycles in 1923.

One of Mercedes's biggest competitors today, BMW was actually created by Daimler's independent Austrian partner to assemble Daimler aircraft engines during World War I. After the war, the Bayerische Motoren Werke became a separate company under the direction of Austrian engineer Franz Josef Popp. In the years between the wars, BMW became one of Germany's most promising automakers with models like the Type 328. They were also close to perfecting a jet engine for the Luftwaffe by 1944! But precise bombing raids by the Allied forces and a line of demarcation on a map had changed BMW's history by 1945.

OPPOSITE ABOVE RIGHT:
The 300 SL roadster became a more popular car than the Gullwing. This is the fourth from the last to be built in the model's final year of production. All four final cars were identical—white with red interiors. Owned by Chevy Chase, Maryland, physician Frank Spellman, this is the only example extant equipped with the optional rear luggage rack and additional Mercedes suitcase.

OPPOSITE ABOVE LEFT AND
OPPOSITE BELOW: *The 300 SL roadster's interior eliminated many of the Gullwing's shortcomings, headroom and ventilation being foremost. More comfortable seating, improved suspension and handling, along with a revised instrument panel, featuring two round gauges with a vertical grouping in between, gave the roadster a considerable advantage over its predecessor.*

LEFT: *The BMW 503s were more conservative sports models than the 507s, but they gave up little when it came to performance and handling. Both the 503 Coupé and Cabriolet were introduced at the 37th Frankfurt Motor Show alongside the 507 Sport Roadster. Over a three-year production run, from 1956 to 1959, 302 Coupés and 110 Cabriolets were built.*

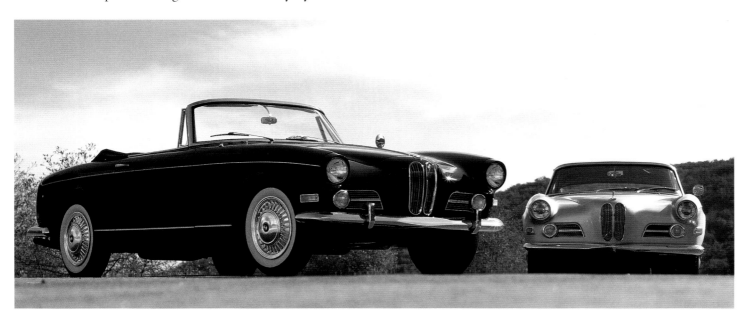

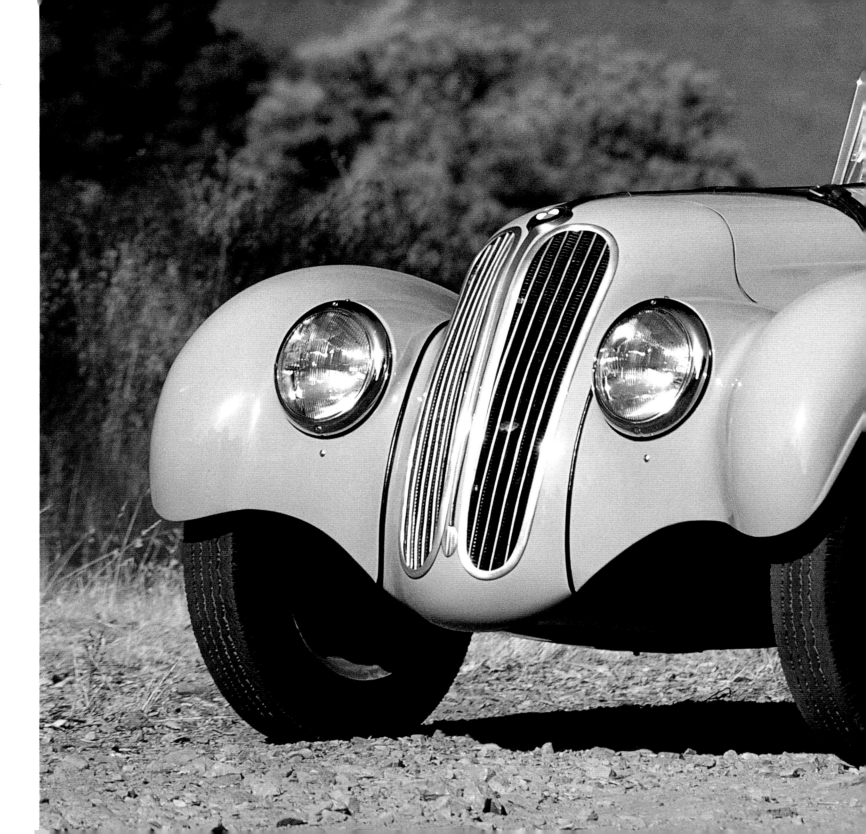

Sometimes you get it right the first time. The 1937 328 Sport Roadster was the first sports car BMW built. In its brief history, 1937–39, the 328 models recorded more than 100 victories in European competition. (Randy Cowherd collection)

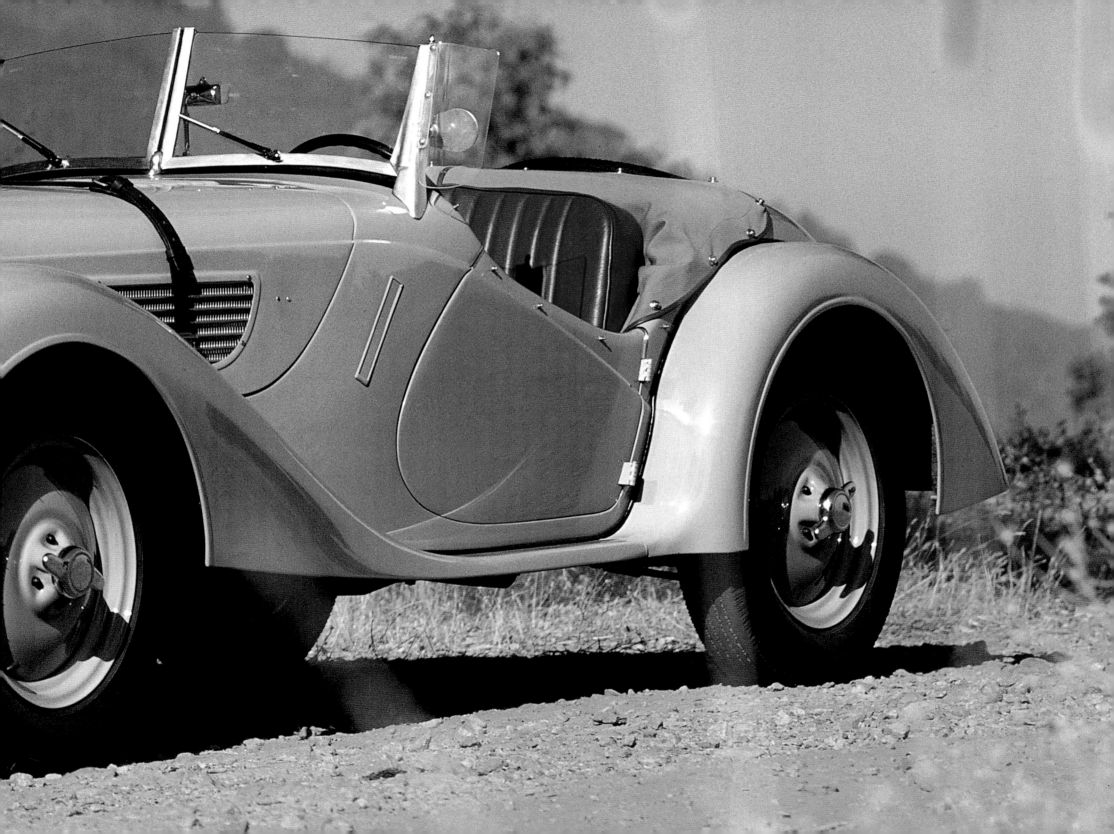

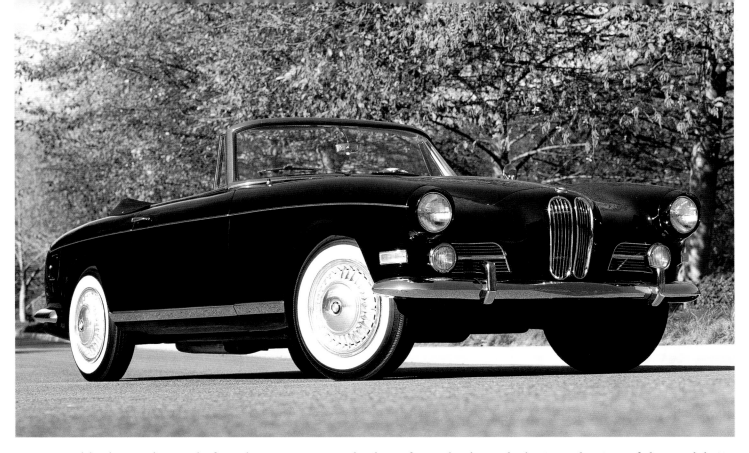

It would take until 1951 before the company was back on four wheels, with the introduction of the model 501 sedan powered by a prewar six-cylinder engine. The following year, a new 2.6-liter V-8 was introduced, along with an improved 502 series and two new models, a sporty two-door Cabriolet and two-door Coupé.

Competitive with the Mercedes-Benz 220 series (and some say the 300 S and Sc), the BMW models were attractively styled and arguably better-looking cars. Still, what BMW needed more than anything was an image builder, a sports car to rekindle the history of the great prewar-era BMW 328 Sport Roadster.

The 328 Sport Roadster had been the company's first attempt at producing a true sports car, one that was suited both to the road and to competition. In Germany, Mercedes-Benz was the leader in sports car design throughout the late 1930s, and BMW management was uncertain about how to debut the 328. Their solution was bold, if not unique. Rather than choosing a traditional motor show introduction, they entered one of the 328 prototypes in the June 14, 1936, Eifelrennen at the Nürburgring. Campaigned in the class for unsupercharged cars up to two liters, the lightweight BMW was victorious in its first outing. By 1937, the 328 had

THE ITALIANS
In Ferrari's Shadow

"In 1947 my father designed the best car he ever did, the Cisitalia," says Sergio Pininfarina. "This set the pace for the design of sports cars throughout the 1950s." Indeed, it is virtually impossible to look at any European sports car from the early postwar era and fail to see a resemblance to the Cisitalia. (Car courtesy Caballerzia, Inc. collection, Steve Tillack, and the Petersen Museum)

IT BEGAN HERE. IN THE PAST. IN WHAT WAS ONCE THE SOUL OF EUROPE'S BLOSSOMING AUTOMOTIVE CULTURE. ITALY. • THROUGHOUT THE FIRST HALF OF THE 20TH CENTURY, THE AUTOMOBILE AND ITS DEVELOPMENT HAD CAPTIVATED THE FRENCH, THE GERMANS, AND THE BRITISH, BUT IT HAD CONSUMED THE ITALIANS. DRIVING AND RACING BECAME SUCH A NATIONAL OBSESSION THAT DURING THE DEPRESSION, THE ITALIAN GOVERN-MENT WENT SO FAR AS TO PURCHASE SHARES OF ALFA ROMEO TO ENSURE THE COMPANY'S SOLVENCY! IT WAS A MATTER OF NATIONAL PRIDE—ALFA ROMEO WAS ITALY'S MOTORSPORTS CHAMPION—FOUR-TIME WINNER OF THE VINGT-QUATRE

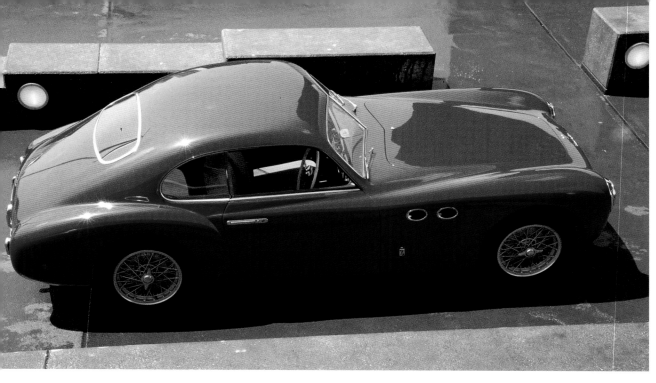

Heures du Mans, and the victors in 10 consecutive Mille Miglia challenges.

This national passion for motor racing drew a wealthy Italian industrialist named Piero Dusio into the sport. He made his fortune selling war materials to the Italian government. Even being on the losing side had been profitable for Dusio. In 1946, he bankrolled the development of an entire class of single-seat racecars, named after the Consorzio Industriale Sportivo Italia, gracefully shortened to Cisitalia.

Dusio hired a talented Fiat engineer named Dante Giacosa, who designed a simple, Fiat-based racecar that could be produced profitably in reasonable numbers.

OPPOSITE ABOVE LEFT AND RIGHT: The streamlined body of the Cisitalia blended hood, fenders, greenhouse, and rear deck into one continuous form. The groundbreaking Pininfarina design would become the fountainhead for almost every sports car produced in the 1950s.

OPPOSITE BELOW:
The Cisitalia's interior was simple in design but elegantly rendered, accented by beautiful instrumentation and a purposeful arrangement of controls. All of the cars were right-hand drive.`

Dusio also employed former Fiat experimental engineer Dr. Giovanni Savonuzzi to put the car into production. None other than the great race driver Piero Taruffi, whom Dusio also put on his payroll, tested the first example. By August 1946, Cisitalia had produced seven of the new Type D46 Monopostos. In their debut race, the Cisitalias took the first three places, and in 1947, legendary race driver Tazio Nuvolari drove a sports version of the Cisitalia to a second-place finish in the Mille Miglia. Orders for the D46 began to roll in, but Dusio was already off on another venture, the development and production of a Cisitalia sports car.

THE FIRST MODERN SPORTS CAR

In the late 1940s, England, France, and Germany were still reeling from the destruction wrought by six years of war. Italy, however, being a country motivated by its love of wine, automobiles, and motorsports, was among the first to resume production. Thus inspired, Signor Dusio failed to notice that the lire he was spending so rapidly had begun to deplete his fortune. He spent the equivalent of 1 million francs in 1946 to help liberate Ferdinand Porsche from a French prison, and the grateful designer repaid the favor by creating the scintillating four-wheel-drive Cisitalia 12-cylinder Formula 1 Grand Prix car. Dusio's coffers were further drained by endless developmental costs for his racecars and production of the 1947 and 1948 Cisitalia 202 sports cars. The 202

was to become the most important automotive design of the mid-20th century.

For the Type 202, Savonuzzi had completed a preliminary layout at Dusio's request, but it was Battista Pininfarina who finalized the architecture of the body and built the first two Cisitalia 202 coupés. When the 202 appeared at the 1947 Villa d'Este Concours d'Élégance, the automotive world was astounded both by the simplicity of its design and its fresh approach to sports car styling. Not only did the Cisitalia send every automobile designer in the world back to the drawing board, it turned Pininfarina into the postwar era's most renowned stylist on both sides of the Atlantic. In the 1950s, he would become the first Italian to design cars for American automakers, including the magnificent 1951 Nash-Healey, the first American sporting car to have a chassis and suspension engineered in England (by Donald Healey) and a body designed and built in Italy.

In 1930, Battista Pininfarina, the youngest of the Farina brothers, whose family had founded one of Italy's premier

carrozziera, the Stabilimenti Farina, decided to set out on his own. From the late 1930s well into the postwar era, his company produced bodies incorporating highly innovative features, such as angled windshields and horizontal radiator grilles. The Cisitalia 202 was the finest expression of Pininfarina's highly personal style, one that was both simple and functional, in contrast to the then-current French design idiom that overstated every line of a vehicle with coachwork, which Pininfarina thought was as complex as it was irrational.

The Cisitalia's design ignited the granturismo movement within Italy; the car's body was reconceived as a single profile, rather than as a construct of separate panels—the traditional prewar blueprint of hood, fenders, body, and trunk being individual components. The sleek, envelope styling exemplified by the Cisitalia gained momentum throughout the 1950s, particularly in the realm of high-performance sports car design, with smoothly flowing bodies that satisfied both the eye of the customer and the ideals of the engineer.

The Cisitalia Granturismo Berlinettas produced in 1947 and 1948 were built atop simple Fiat 1100S mechanicals, but one could overlook the languid four-cylinder, in-line monoblock engine beneath the hood and the Italian automaker's ordinary underpinnings when they were surrounded by the swept-back, handcrafted steel body that made the Cisitalia one of automotive history's most influential designs.

The oval grille opening was another Cisitalia styling cue taken up by most every sports car designer in the 1950s.

Although the little Fiat engine developed a mere 50 horsepower, the aerodynamic lines of the Cisitalia allowed the car to cheat the wind and reach a top speed of 100 mph. Thus the Cisitalia became the symbol of the enveloping body, a concept of design that would be emulated throughout Europe for the next two decades.

As for Piero Dusio, by 1949 the Consorzio Industriale Sportivo Italia was broke. Dusio sold the remains and departed for Buenos Aires, along with the Grand Prix racecar. All that was left of the short-lived enterprise was a handful of stunning Cisitalia 202 Berlinettas. Several attempts by others to revive the marque in the 1950s would end in failure, leaving behind a trail of forgettable little cars unworthy of the Cisitalia name. Dusio's legacy was the creation of the first modern sports car.

The significance of the Cisitalia is exemplified by its selection for the 1951 New York Museum of Modern Art exhibit *Eight Automobiles*. It came to be regarded as the perfect example of sports car design. In 1972, Carrozzeria Pininfarina donated a 202 to MOMA's permanent collection, where the legendary Cisitalia now serves as an example of machine art.

THE RETURN OF ALFA ROMEO

The roar of the destroying war had just ceased from the skies but down on earth a new roar is rising, this is a song of revival and announces that peaceful men are at work again. The works, which still bear the war scars, are already teaming with new life, and the new Alfa Romeos are fanning out towards the roads of the world, which again will be paved with their victories. Every trial is a hard test for new formulas, through which the most modern technique proves its superiority. The Sports and Super Sports models of the latest Alfa Romeos will prove to be the highest product of such a technique. A snappy, yet gentle engine, high speed, low consumption, sturdiness and elegance, a perfect suspension, ensuring road holding at all speeds, smooth driving and powerful braking: these are the main contrasting features, which our technicians have been able to blend together, these are the features which make the new 6C 2500 Alfa Romeo 2nd series an unsurpassed car. By this car the renowned Alfa Romeo works offer proof of the reviving Italian industry as well as an ingenious combination of mechanical perfection, the result of the long and splendid series of victories which they have won all over the world.

—ALFA ROMEO, 1946

With these words, Alfa Romeo rededicated itself to the manufacture of automobiles after World War II—producing the spectacular Pininfarina-bodied 6C 2500 Sport and Super Sport cars, which marked the end of one era and the beginning of another. The first models built by Alfa after the war, the 6C 2500s were a second generation of the great prewar 6C 2500 series, fitted with new, more aerodynamic bodies.

Although the postwar Alfas were never intended for competition, the 6C 2500s won innumerable rallies and road races throughout the late 1940s and early 1950s. Not only did this car become the prestige automobile among Europe's café society, it also reaffirmed Alfa's guiding principle, that their racecars should be suitable for the road and their road cars suitable for racing.

Back in 1939, the 6C 2500 had replaced the 1936 Tipo 6C 2300B. The new model offered greater performance than its predecessor, through increased output and higher gearing. The new engine was a race-proven 2,443cc, six-cylinder, double-overhead camshaft design, with seven main bearings, and hemispherical combustion chambers, which were first employed by Alfa in 1927.

Used in the 106-inch-wheelbase Super Sport model, the engine developed 105 horsepower at 4,800 rpm, with a

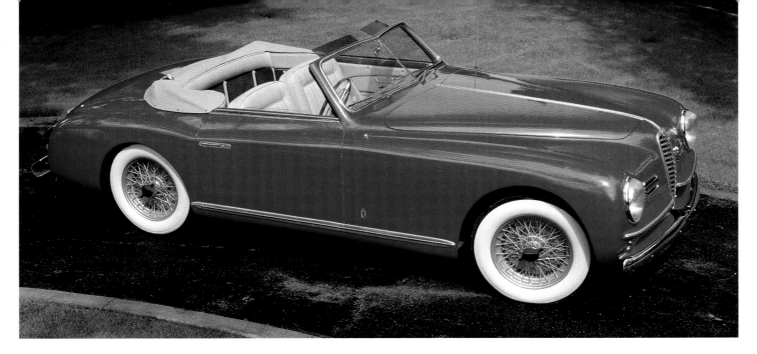

72mm × 100mm (2.8 inch × 3.9 inch) bore times stroke and 7.5:1 compression ratio. Fuel for the Super Sport engine was metered through three horizontal, single-barrel carburetors, while the larger 118-inch-wheelbase 6C 2500 Sport model used a single two-barrel carburetor and a lower 7.0:1 compression ratio, and produced 90 horsepower at 4,600 rpm. The car's four-speed synchromesh gearbox was built in-unit with the engine block and operated by a column-mounted shift lever. The column shifter was chosen over the ordinary floor shift to allow three-passenger front seating.

Alfa produced a total of 2,594 6C 2500s from 1939 to 1953, with the postwar models carrying striking new Pininfarina coachwork similar to that of the 1948 Cisitalia.

The majority of 6C 2500 chassis were divided between the Sport, with 1,440 cars built from 1939 to 1953, and the Super Sport, of which only 458 were produced from 1939 through 1951. The factory also built three *competizione* chassis in 1948 with a short 98-inch wheelbase. The engines for these cars used three two-barrel Webers, a higher 9.2:1 compression, and developed 145 horsepower at 5,500 rpm. Driving one of them in the 1949 Mille Miglia, Franco Rol came in third, and in 1950 Juan Manuel Fangio did the

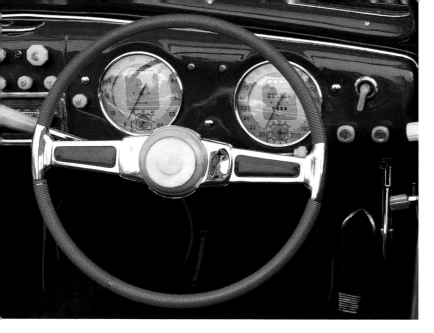

same. Rol placed second in the 1949 Targa Florio, and the Bornigia brothers placed first in 1950. A pair of 6C 2500 Sport models also earned a place in motorsports history, finishing fourth and eighth overall in the first Carrera PanAmericana de Mexico in 1950.

While the number of chassis produced by Alfa Romeo may have been limited, the selection of coachwork available for the 6C 2500 most definitely was not. As the last Alfa with separate frame, coachbuilders found it to be an adaptable and respected platform upon which to practice their old-world skills. Most of the cars were produced in the bare chassis form and bodied by Italy's leading coachbuilders: Ghia, Boneschi, Stabilimenti Farina, Allemano, Balbo, and Bertone. The majority, however, were produced by the two largest Italian coachbuilders of the day, Carrozzeria Touring and Pininfarina. Both houses produced bodies for the 6C 2500 in limited numbers of 20 to 40 cars. Simple, uncomplicated lines and a low, wide stance, with the power of the body gathering at the wheels and fenders, characterized the Pininfarina models. The headlights and traditional Alfa grille were distinguishing features, with front and rear bumpers often reduced to mere chrome strips. Nearly all of the Pininfarina bodies produced for the Sport and Super Sport chassis were cabriolets. Carrozzeria Touring, which created roughly one-fourth of all 6C 2500 coachwork, concentrated mainly upon berlinetta bodies.

Every 6C 2500 was lavishly appointed with rich, hand-sewn leather, plush carpeting, ornate instrumentation, and decorative Ivorlite control knobs. With few exceptions, all 6C 2500 models were right-hand drive.

The 1939 through 1948 6C 2500 Alfas are among the handful of postwar European cars recognized by the Classic Car Club of America, while the Milestone Car Society accepts the 1949 through 1953 models. For Alfa Romeo, another triumph.

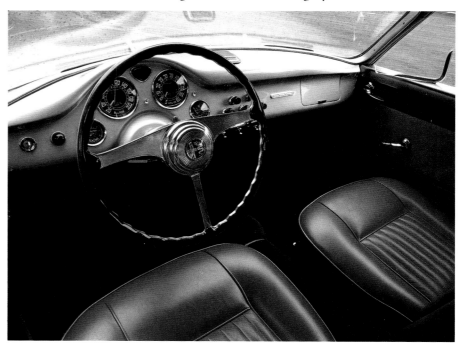

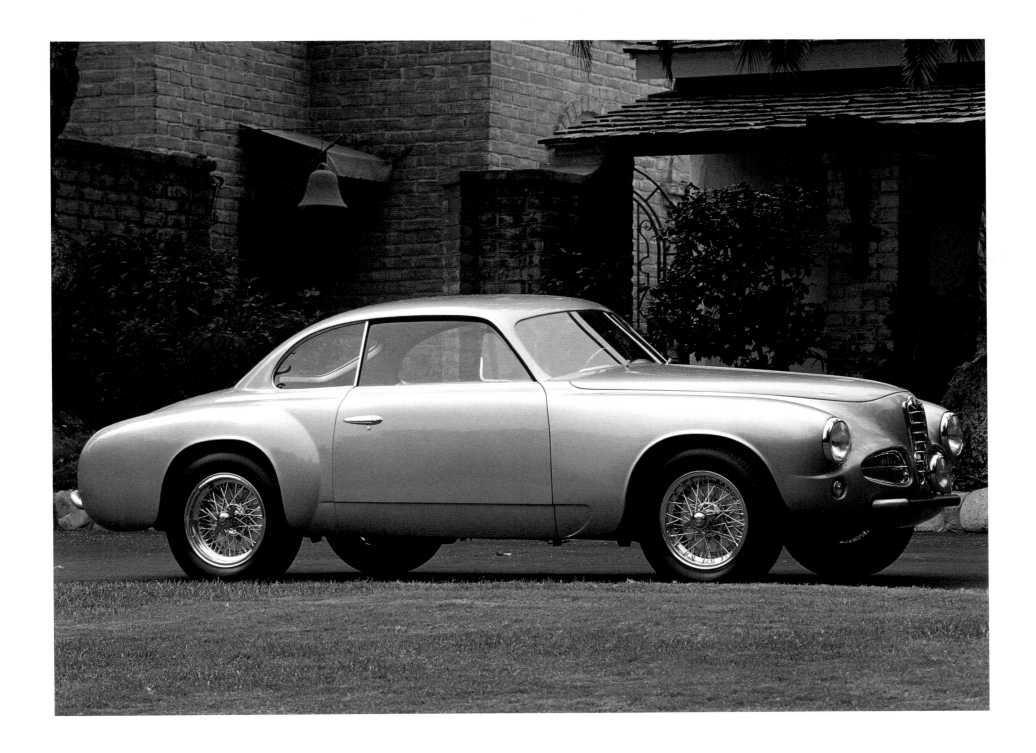

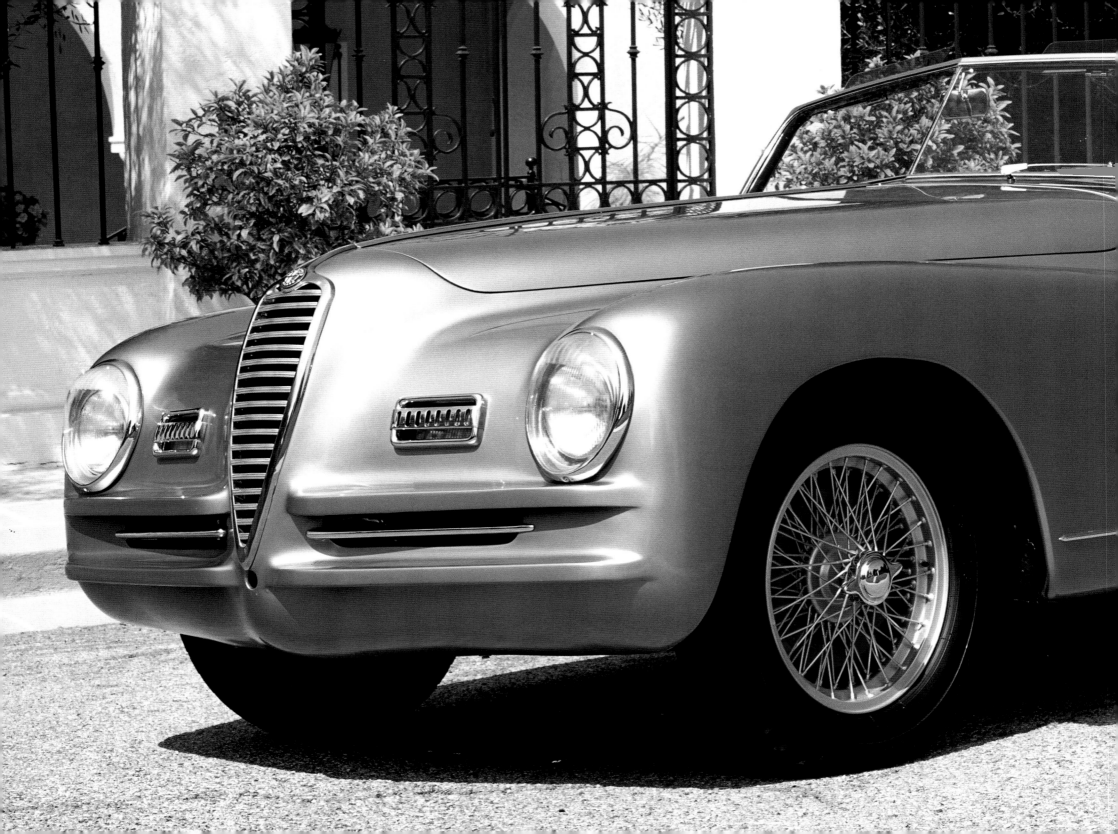

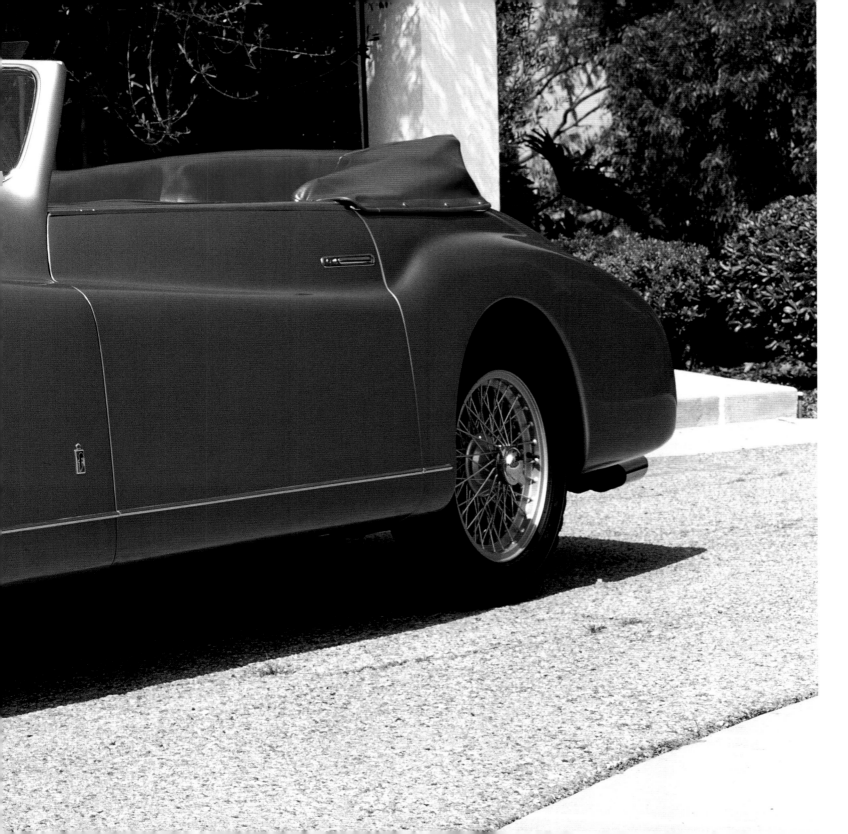

The Alfa Romeo 6C 2500 Sport was a larger version of the Pininfarina-designed cabriolet and was capable of seating three across the front seat, while two additional passengers could cozy up in the narrow rear seat.

FIAT'S UNSUNG SPORTS CARS

While not highly regarded in the United States, Fiat is the Italian equivalent of General Motors. It is the country's largest automaker and today includes Alfa Romeo, Lancia, and Ferrari among its various holdings. There was a time, however, when American sports car enthusiasts of average means could go down to their local Fiat dealer and buy a jazzy little Pininfarina-built Fiat 124 Spider. But that came to an end years ago when Fiat withdrew from the U.S. market.

Throughout the Turin automaker's 103-year history, it has occasionally flirted with greatness, and one of the high-water marks was the company's collaboration with Enzo Ferrari on the 1967 Dino. The venture resulted in the fastest and most expensive sports car that Fiat had ever built. It has since become one of the most desirable "Ferrari models" produced, even though the Dino is technically a Fiat, not a Ferrari.

More than a decade before the Dino, however, Fiat had another benchmark design, one that is little remembered today, the 1952–54 Otto Vu. The name, when pronounced with just the right inflection—oh-toe-vu—has that inexplicable Italian charisma that makes a car sound interesting, even if it isn't. Fortunately, the Otto Vu was.

While not terribly poetic, the name came about as the result of a misinterpretation of international copyright laws. When Fiat and Siata, the Società Italiana Applicazione Automobilistiche, jointly designed a new two-liter V-8 engine in 1952, they were under the misconception that Ford Motor Company owned the international copyright to the name V-8. Reluctant to dispute what they believed to be the law, Fiat management simply decided to transpose the *V* and the *8* and call their new engine Otto Vu . . . 8-V.

At the heart of this design was an innovative two-liter V-8 engine with a 70-degree angle between its banks, utilizing a three-main-bearing crank and a single camshaft, operating overhead valves through short pushrods and rocker arms. Conventional enough, but the engine had an oversquare bore and stroke (72×61.3 mm) that was quite advanced for the day. It was also small enough to fit in the narrow engine bay of a Fiat. The two-liter displaced 1,996 cc and developed

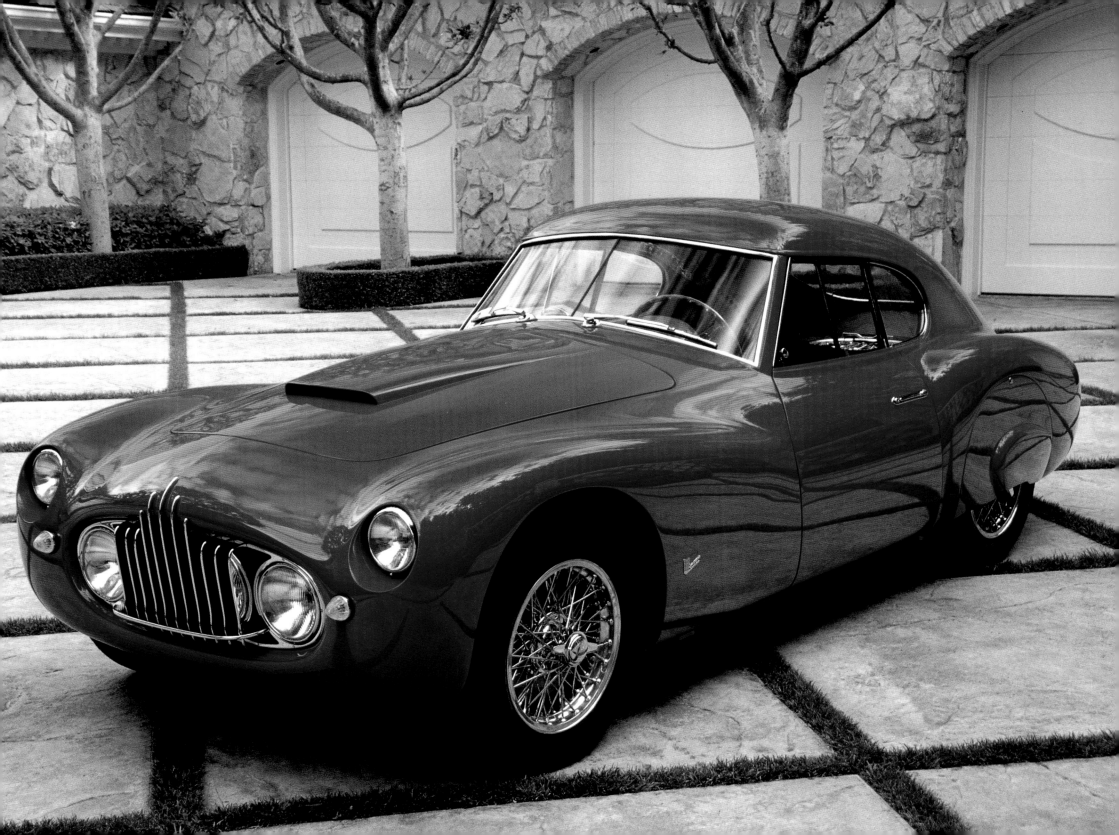

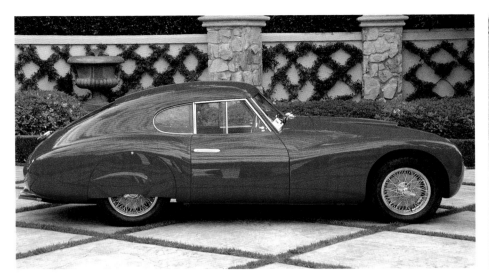
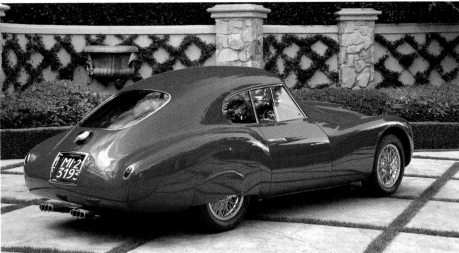

While appearances can be deceiving, the Otto Vu coupés resembled the aerodynamic Adler racecars that came to Le Mans in the late 1930s, at least from the rear, with their fast-back contours and full fender skirts covering the knockoff hubs.

105 horsepower at 6,000 rpm, assisted by a pair of Weber 36DCF dual downdraft carburetors. Siata's subsequent reworking of cams and elevation of the compression ratio from 8.5:1 to 8.75:1 produced a 115-horsepower version and later 127-horsepower model for racing—impressive statistics for a small car. The drive was taken to the rear wheels through an off-the-shelf floor-shift, four-speed Fiat gearbox bolted to the back of the engine.

The Otto Vu chassis was rudimentary, comprising two oval tubes with modest crossbracing fore and aft connecting the suspension members and engine mounts, while the rigid body was welded into a real monocoque. In contrast to the chassis, and a significant breakthrough for Fiat, was the use of a fully independent suspension, with four shocks in the rear, coil springs, and antiroll bars at both ends. In 1952, this was on the cutting edge. Completing the car's sporty appearance were large-diameter, finned drum brakes, clearly visible behind the wire spokes of Borrani-built, Rudge-Whitworth, center-lock wire wheels.

On a wheelbase of just 94.5 inches, and with a front and rear track of 50.8 inches, the average model weighed in at only 2,200 pounds, could accelerate from zero to 100 mph in 35 seconds, and reach a top speed of 119 mph. Pretty remarkable for a two-liter production car in the early 1950s.

Had Fiat built these cars ten years later, they would have been an outstanding success. However, in 1952 nearly every Ferrari was a racecar, as were most Maseratis and all OSCAs. The Otto Vu, despite its respectable performance and eye-catching coachwork, was just not competitive in its intended market. A costly, almost custom-built Fiat sports car was a hard sell, even in America, where the asking price was $6,000.

The majority of Otto Vu bodies were coupés with somewhat odd-looking aerodynamic coachwork. The man behind the 8-V's styling was Dante Giacosa, who had been involved in the conception of the Cisitalia Gran Sport coupé in 1947. In the early postwar years, Fiat's chief task had been to provide Italy with bread-and-butter vehicles. Giacosa thought the Fiat engineers deserved a chance to stretch their creative horizons with the 8-V. To optimize the model's aerodynamic shape, a great deal of time and money was spent in the wind tunnel of the Turin Polytechnic Institute developing the body contours. Each 8-V was handcrafted in the experimental studios of Fiat, at Ghia or Zagato, and intended for enthusiasts who had no interest in a run-of-the-mill car from the production line yet could not afford a Ferrari or an Alfa Romeo.

By 1954, both Fiat and Siata had discontinued the Otto Vu as a result of insufficient sales. Although the total was less than gratifying for a company the size of Fiat, had this been Ferrari, 114 cars in three years would have been terrific.

Rarely seen or even heard of today, the Fiat Otto Vu and its beautiful little gem of an engine are considered by many to be the best-performing and the most beautiful of all postwar Fiats, if one discounts the Dino.

BELOW LEFT: *The interior of the Fiat Otto Vu coupé was as unusual as the exterior, with a protruding pod blended into the metal dashboard. This placed the speedometer and tachometer directly behind the steering wheel and in the driver's direct view.*

BELOW RIGHT: *In 1954, Carrozzeria Vignale built two one-off models, a sleek aerodynamic coupé and a matching roadster on the Otto Vu chassis. The two Vignale models pictured, along with another 112 production versions of varying body styles, were named after their innovative Fiat-Siata–designed 70-degree V-8 engine.*

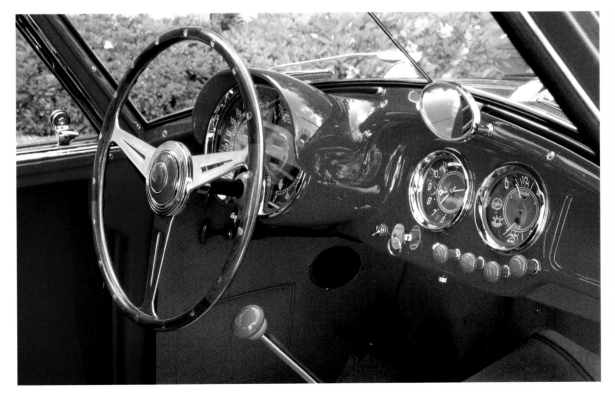

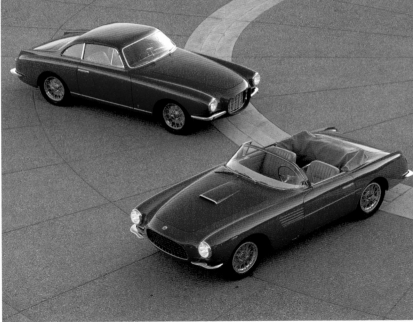

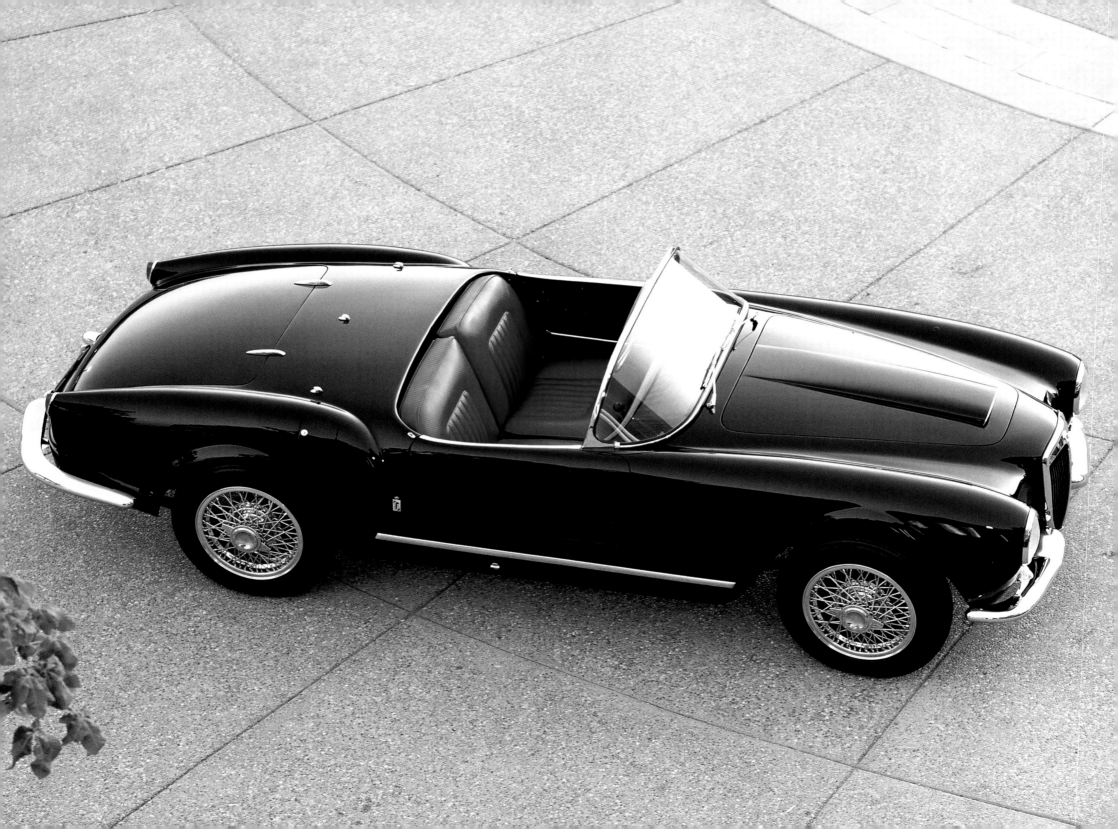

LANCIA—A LEGENDARY ITALIAN MARQUE

While almost everyone has heard of Fiat, Lancias are about as well-known in mainstream America as Kaiser Manhattans are in Turin. Mind you, Lancia bears no blame for this; their cars have always been among the finest built and most technologically advanced to come from Italy. Unfortunately, not every car that was imported to the United States met with the success of Mercedes-Benz, Porsche, or Ferrari. Even so, in later years there were numerous attempts to sell Lancias in the United States, and when Fiat had its own American distribution network, Lancias were imported and sold through select dealerships across the country. But like Fiat, Lancia never established a strong enough dealer and service network in the United States to remain profitable. We can add to that illustrious list MG, Triumph, Jensen-Healey, Citroën, Renault, Peugeot, and Alfa Romeo, all of which have over the years withdrawn from the United States (Alfa Romeo is planning a comeback, and now that BMW owns Mini, there are sporty little Mini Coopers dashing around American roads once more).

Aside from having too few dealers, little or no advertising, and only modest coverage in automotive publications, Lancia also had to live in the shadows of Ferrari, Alfa Romeo, Mercedes-Benz, and Porsche, whose racing accomplishments were known worldwide and highly regarded by American sports car enthusiasts.

A talented young automotive engineer and race driver named Vincenzo Lancia established the company in 1906. Born in 1881, he was the youngest child of a wealthy family, and from his earliest years Vincenzo was fascinated with transportation. His first job was as bookkeeper to Giovanni Ceirano's bicycle import business in Turin. When Fiat took over Ceirano in 1899, he became chief inspector to the new company and subsequently started a successful racing career with the Fiat factory team. Count Carlo Biscaretti di Ruffia, one of Fiat's founders, encouraged Lancia to go out on his own in 1906 and helped him purchase a small factory. Within a year, Lancia & Cie, Fabbrica Automobili, had completed its first prototype automobile. Unfortunately, a fire destroyed the car in February 1907, before Lancia even had a chance to run it. Undaunted, seven months later he completed the first motorcar to bear his family name. The car was a success, as were all that followed for the next 30 years.

Throughout the 1920s and 1930s, Lancia developed an array of technologically advanced automobiles that led up to the landmark 1937 Aprilia, Vincenzo Lancia's last design; a heart attack in February 1937 claimed the 56-year-old Lancia before the new model was put into production. Following Lancia's death, management was taken over by his son, Gianni, who remained at the head of the firm until 1955.

Among the last models to be built under the Lancia family banner was the 1955 B24S Spider Aurelia. Derived from the Aurelia Gran Turismo model, which first appeared in 1951, the sporty B24 convertibles utilized integral chassis-body construction. Carrozzeria Pininfarina hand-built the sleek bodywork for the B24S Spiders.

In the early postwar era, Lancia, like so many Italian automakers, was anxious to produce an all-new model, but it would take five years before the company was able to introduce its first completely new car, the Aurelia. Designed by Gianni and former Alfa Romeo engineer Vittorio Jano, the Aurelia made its debut in 1950. The new model was powered by the world's first production V-6, developed by Francesco De Virgillo, who had joined Lancia in 1939. The 1,754cc, overhead-valve V-6 was coupled to a four-speed gearbox integrated with the rear axle.

Like so many models before it, the Aurelia was teeming with innovations: the V-6; the first use of a semitrailing arm system for the rear suspension; a rear clutch and aluminum transaxle with inboard brakes; an aerodynamic, pillarless unibody; and the first use of Michelin X radial tires as standard equipment. The Aurelia was initially available only as a sedan, but in 1951 the 1,991cc B20 coupé was added. One of the most stylish sports coupés of the postwar era, it enabled Lancia to make a successful return to racing. With engine displacement increased to 2,266 cc and finally to 2,451 cc, the Aurelia B20 was successful in racing and rallying between 1951 and 1955. This encouraged Lancia to set up a competition department, which fielded teams of sport racing coupés and roadsters at Le Mans, the Targa Florio, and the Mille Miglia. The D20, D24, and D25 models, powered by V-6 engines of 2.6 to 3.7 liters, scored victories in the 1953 Carrera PanAmericana, the 1953 and 1954 Mille Miglia, and the 1954 Targa Florio.

In 1954, Lancia entered the big leagues, Formula 1 racing, with the D50, 2,487cc four-overhead-cam V-8 Grand Prix car. The company's fortunes rested in the hands of legendary driver Alberto Ascari, who had already won the 1955 Turin and Naples Grands Prix titles for it. What had begun as a very successful season for the Turin automaker ended tragically in May when Ascari was killed at Monza while driving a borrowed Ferrari. The loss of Ascari, combined with the financial burden that the racing program had put on Lancia, brought an end to the factory's Formula 1 efforts. A demoralized Gianni Lancia sold the entire team of D50 Grand Prix cars, their spares, tools, and drawings to Ferrari. Jano, who had lost his position as Lancia's chief designer, went to Ferrari as well. The cars appeared later in the year under the name Lancia-Ferrari and had a very successful 1956 season, with Juan Fangio winning the Driver's Championship.

Although a succession of checkered flags had brought fame to Lancia's doorstep in the early 1950s, the flow of red ink generated by the factory competition department was not offset by increased sales. The rising cost of manufacturing convinced Gianni and his mother, Adele, that the time had come to put the company on the market. Lancia found a buyer in millionaire industrialist Carlo Pesenti, who modernized production and established new headquarters with a 16-story office block in Turin. The street where this building sits today was renamed Via Vincenzo Lancia.

Among the last models to be built under the Lancia family banner was the B24S Spider Aurelia. Derived from the much respected Aurelia granturismo model, which first appeared in 1951, the B24 utilized integral chassis-body construction. Pininfarina created the sleek bodywork for the B24S Spider, but retained the familiar shield-shaped Lancia radiator grille, giving the car a dynamic front appearance. Another interesting styling touch was a split front and rear bumper.

The B24 Spider was primarily intended for export sale in the United States. Like Ferraris and Alfas, the Lancia was an expensive car with exquisite attention to detail, luxurious leather upholstery, and a coachbuilt body. The price when new ranged from $5,475 to $7,000 for a fully accessorized model, more than twice that of a new Corvette in 1955. They were so expensive because each had a hand-beaten, hand-welded unibody. Combined B20 coupé and B24 Spider pro-

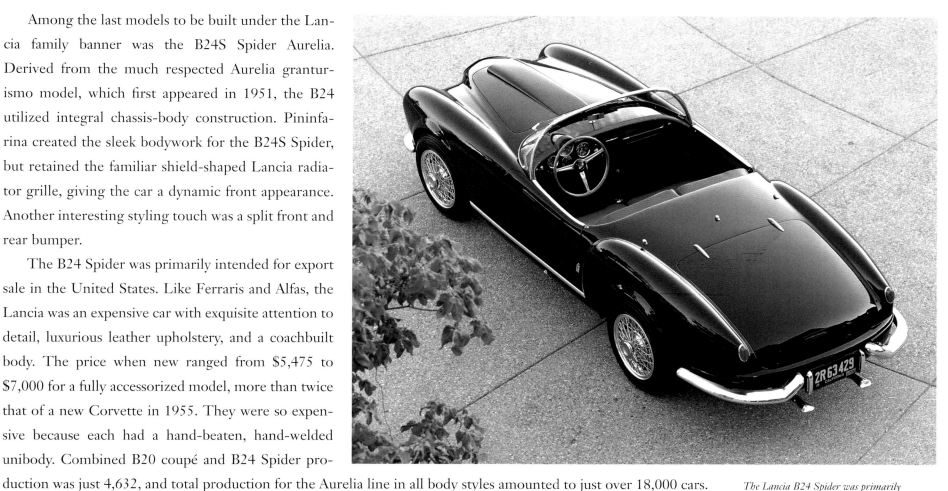

The Lancia B24 Spider was primarily intended for export sale in the United States. Like the Ferrari, the Lancia was an expensive car with exquisite attention to detail, luxurious leather upholstery, and a coachbuilt body. The price when new ranged from $5,475 to $7,000, more than twice that of a new Corvette in 1955.

duction was just 4,632, and total production for the Aurelia line in all body styles amounted to just over 18,000 cars.

Under Pesenti, Lancia's fortunes rose and fell, and he finally sold the company to Fiat in 1969. As a division of Fiat, Lancia flourished once again, both on the road course, with the famed Lancia Stratos rally cars winning 14 World Championship Rallies and 68 other international events throughout the mid-1970s, and on the showroom floor, where Lancia prospered with models like the Monte Carlo coupé, the later Lancia Beta Scorpion coupés, (which were sold in the United States), and the very successful Lancia Thema.

None, however, could re-create the Italian magic of the 1950s, or the character of the coachbuilt Aurelia B20 coupés and B24 spiders that had rolled out the doors of the old Turin factory in 1955. For the pure of heart, they were the last true Lancias.

Singer and actor Dean Martin originally
owned this 1967 Lamborghini Miura.
Notes present owner Jay Leno, "The Miura
has a definite sense of style, one man's idea of
what a sports car should look like."

LAMBORGHINI—ITALY'S RAGING BULL

A decade later, a new Italian sports car was turning heads, the Lamborghini Miura. It was as radical a departure from traditional design as one could imagine, as was its introduction at the Turin Motor Show in November 1965, where the P400 chassis was shown, without a body!

World-renowned Italian coachbuilder Nuccio Bertone was so impressed with the naked chassis that he proposed to drape it in proper garments to make a real car. Ferruccio Lamborghini, who had established his company only two years earlier in the city of Bologna, accepted Bertone's offer, and the stunning result was completed in time for the Geneva show the following March.

The audience was so smitten by the audacity of the Lamborghini's engineering and the beauty of Bertone's coachwork that the problem suddenly became how to get the Miura built quickly enough to meet the sudden demand for this revolutionary new sports car.

Rushed to market, early versions lacked some refinements expected by the buyers. The untinted windshield sloped back so far that the occupant sat in brilliant Italian sunshine. Conveniences, such as air-conditioning and a radio, were never considered since the mechanical uproar generated by the chain-driven camshafts in the mid-engine two-seater would have made a radio impractical, and air-conditioning would have drawn power from the engine. Other excitements included a peculiar latch (for the rear body section covering the engine) that didn't always latch. But the fundamentals were glorious. Getting off the line was really startling. Climbing modest hills in top gear was no trick at all; and the mechanical music never stopped. As subsequent versions were brought to market, the various flaws were corrected, amenities appeared, and the Miura achieved a stature unchallenged in its time.

Crooner and film star Dean Martin originally owned the 1967 model pictured. Notes present owner Jay Leno, "The Miura was sort of the catalyst for the era. It began an entire generation of rear-engined [amidships] designs from Italian automakers. The Miura was never quite a finished car, so not everything was thought out. For example, you throw it into a left- or right-hand turn at speed and the oil pressure drops"—Leno laughs, wrinkles up his face, and shakes his head in mock horror—"but they fixed that on the later models. There was also a tremendous amount of front-end lift at high speed, but it was a car built as much for styling as anything else; that's the way Bertone designer Marcello Gandini wanted it. This was probably the best-looking car Lamborghini ever built, but when the first Countach came along around 1973, everybody got excited and the Miura quickly faded from popularity.

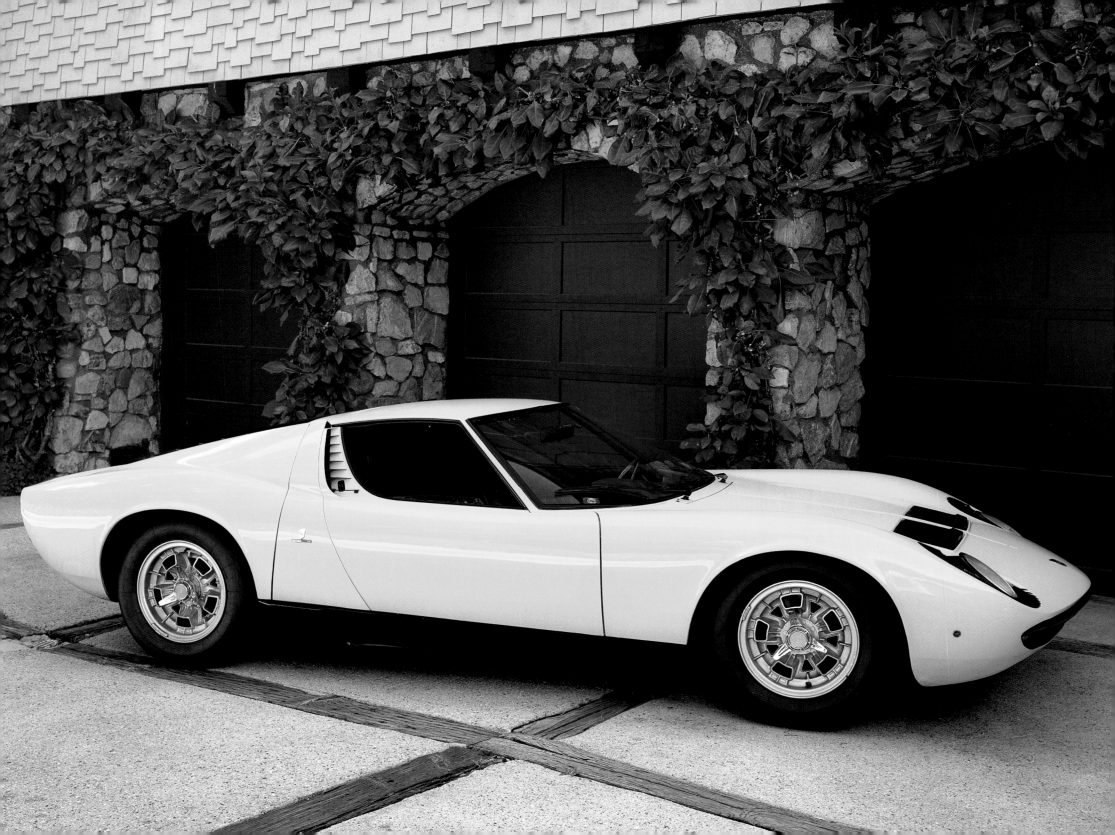

"I like the Miura more than the Countach. I like a car where all four wheels are the same size, from the standpoint of how the car sits. The Miura has a definite sense of style, one man's idea of what a sports car should look like as opposed to wind-tunnel tests and all that, which is probably a better way to do it, but you just don't see many sports cars like the Miura, cars that were styled with no outside influences. It was made to look good, and that's that."

THE POSTWAR-ERA MASERATI

The reaction to the Maserati A6G 2000 Frua Spyder is always the same from all but the most knowledgeable Maserati aficionados. After spying the large, gold-plated trident in the center of what may be the most beautiful grille to grace any 1950s-era Italian sports car, and confirming that it is, in fact, a Maserati by a quick glance at the small blue enamel badge on the nose, people always ask, "What model is this?" After being told it is an A6G 2000 Frua Spyder, made between 1955 and 1957, people predictably say, "I've never seen one of those before." It would be surprising if they had. One of the most captivating sports car designs of the 1950s, no fewer than nine, and no more than a dozen, A6G 2000 Spyders were bodied by Pietro Frua of Turin.

A quick glance through any Maserati book will produce a picture or two of the Frua Spyders, but the car doesn't really jump off the page at you. It almost has to be seen in person to notice the subtle details Frua designed into the body, a type of subtlety that is hard to capture in a profile or three-quarter front view. While most of these cars are believed to still be in existence in one form or another, only a handful have been restored or are well maintained, and these are mostly in museums or private collections, where they rarely see the light of day.

The final reason these cars are such a well-kept secret is that they were not outstanding in their specifications and probably represent little more than a footnote in Maserati's long history. Today, Ferrari manages the company, but it was once one of Italy's premier independent sports and racing car builders. Founders Carlo, Bindo, Alfieri, Ettore, and Ernesto Maserati were all involved in Italy's flourishing turn-of-the-century automotive industry. Carlo was a race driver and engineer for Fiat, Bianchi, and the Torinese firm Junior. Alfieri, Bindo, and Ettore all began their careers working for Isotta-Fraschini in the early 1900s, and Alfieri was their factory test driver until 1913. The following year he opened Alfieri Maserati S.p.A. in Bologna. It was essentially a tuning shop for Isotta-Fraschini.

During World War I, the brothers founded another company, for which they would become famous and wealthy—Maserati spark plugs. During the postwar era, the Maserati brothers produced a number of successful racing cars, culminating in 1929 with the legendary Sedici Cilindri, a 16-cylinder racecar clocked at better than 155 mph.

Following Alfieri's death in 1932, Ernesto became company director. America's Great Depression was taking its toll on Europe, and export sales were falling as the world economy slowed to a crawl by the mid-1930s. The small, family-owned business was in financial trouble for the first time in its history, and for it to survive, Ernesto was forced to take in a partner, Adolfo Orsi, whose empire ORSI SAS made machine tools, controlled several railway and bus systems, and by no small coincidence, also manufactured spark plugs. Acquiring Maserati would bring its spark-plug business under the ORSI umbrella. A deal was struck that made the Maserati brothers "privileged" employees with a 10-year contract.

They built racecars until the start of World War II and resumed production in 1947, but when their contract expired in December 1947, Ernesto, Bindo, and Ettore left ORSI. They formed a new company, Officini Specializzata Costruzione Automobili, abbreviated to the well-known acronym OSCA, which became another legendary Italian marque.

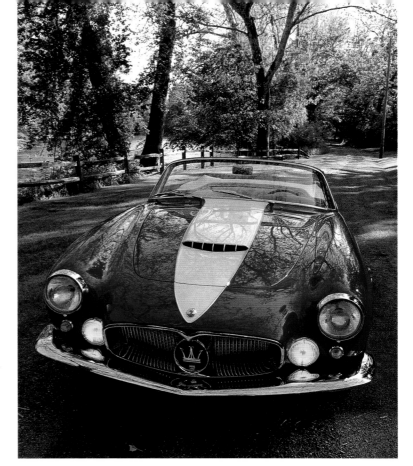

As for Maserati, Orsi continued to run the company, and quite well, developing a superb series of sports and racing models in the 1950s, including the legendary 250F, which Juan Manuel Fangio drove to his second Grand Prix World Championship in 1954. (Fangio would win the title five times between 1951 and 1957.)

With its design heritage deeply embedded in Maserati's successful 1953 A6GCS 2-liter *competizione*, the A6G 2000 Frua Spyder should have been one of the most successful Italian sports cars of the era. That it was not lies not only in the number of cars produced, just 59 examples in all body styles, but in the harsh fact that Ferraris were simply better cars, at least in terms of performance. In spite of the lighter weight of the A6G 2000, less than 2,000 pounds, and 150-horsepower dohc six, the Maserati gave up a lot to its V-12-powered crosstown rival.

When this Frua Spyder, serial number 2197, was produced in late February of 1957, Maserati was about to embark on a racing season that can at best be described as bittersweet. Fangio had won the Grand Prix World Championship for Maserati in the

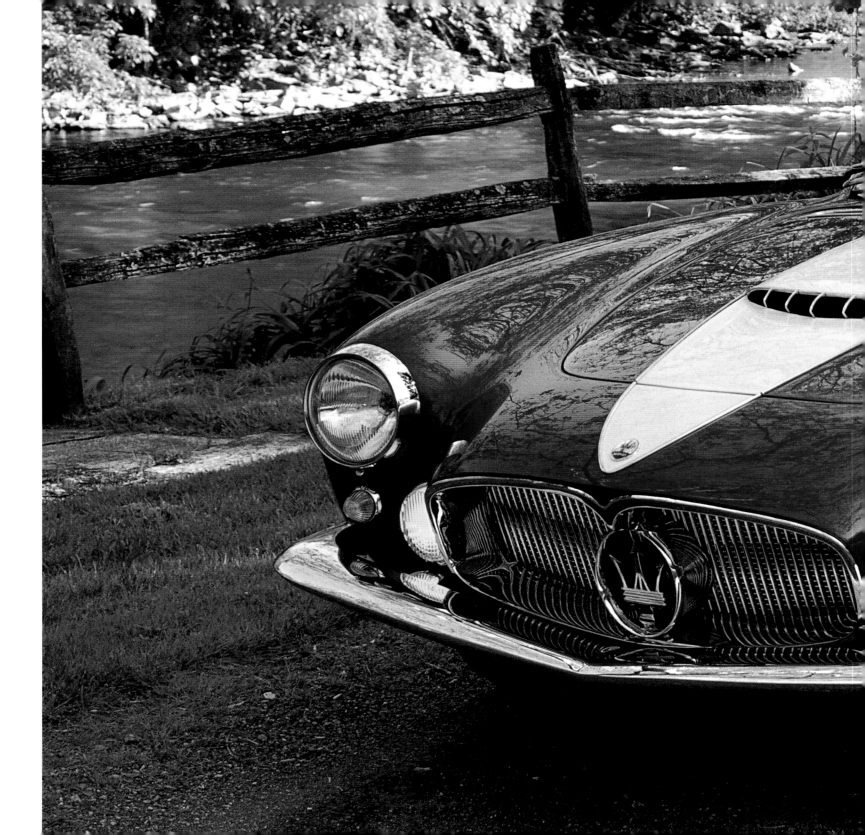

The Maserati A6G 2000 Spyder, bodied by Pietro Frua of Turin, was a limited-production, hand-built sports car. Tracing its lineage to the successful 1953 A6GCS two-liter competizione, the A6G 2000 had the earmarks of a winner, but the V-12 Ferraris completely overshadowed these spectacular road cars. (Jay Jessup collection)

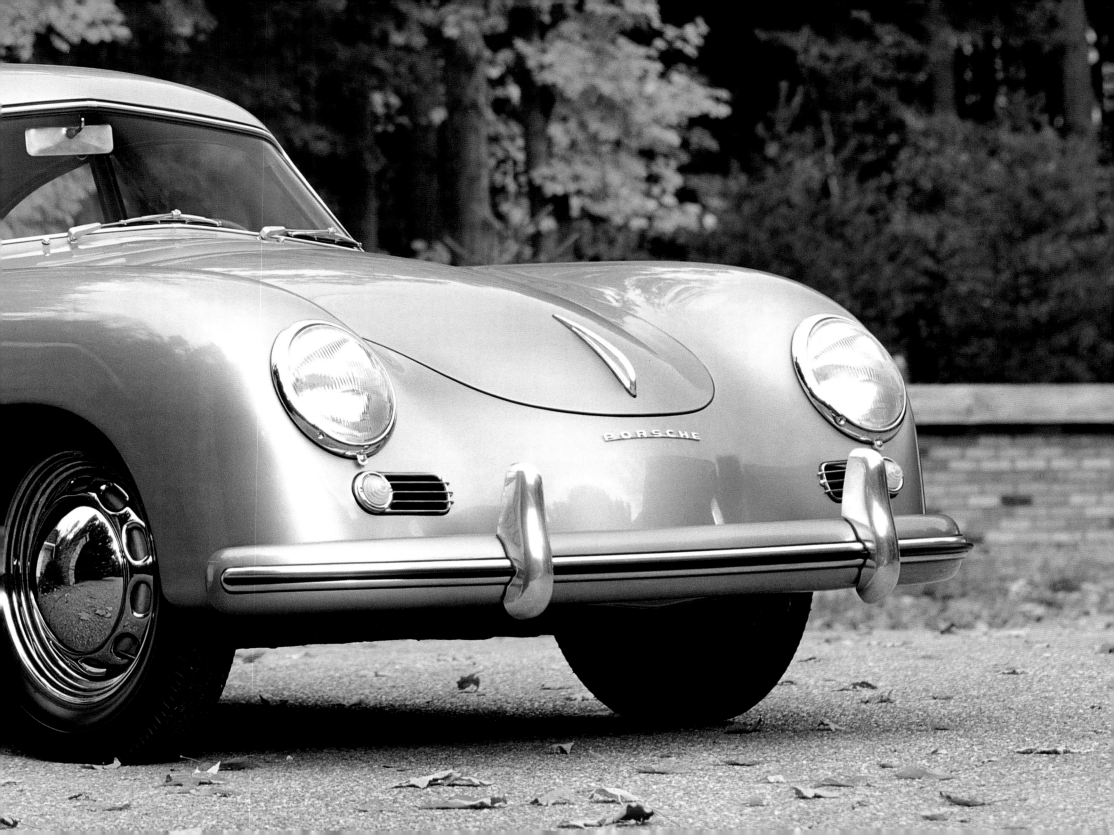

Built for both road and track, the America could easily be stripped down for competition. The windshield was removable—and replaced by a small, curved plastic aeroscreen. The canvas top was simply sprung into place by two pins, and even the bumpers could be unbolted in minutes. By additionally removing the baggage compartment, jack, tool kit, and wheel covers, a total weight reduction of more than 100 pounds could be achieved. On the track, a stripped America could overtake an XK-120 up to around 70 mph and easily outcorner and outbrake anything in the genuine sports car line anywhere near its price.

Production of the America was so limited—in total just 16 cars were bodied for Porsche by Gläser of Weiden—that they were never formally cataloged by the factory and were totally unpublicized in Europe. The market for the car was chiefly the United States and specifically Hoffman, who would ultimately purchase and sell all of the cars but one. Today, the few remaining examples are considered among the rarest of all Porsches, even though Porsche barely recorded their existence. Of course, the methods of documenting serial numbers and keeping track of bodies were less than ideal before Porsche was permitted to move back into Werk I (the original Zuffenhausen facility) in 1955, this on the eve of the company's 25th anniversary.

If one looks back at the early 1950s and the vast number of Porsches competing in sports car club events across America, the 356 appears to have been a very raceable car. Still, with the exception of the America Roadsters, and then only in a modest way, Porsche was not building genuine racecars like Ferrari, but road cars that could be raced. In the right hands they were undeniably competent for rallying and amateur competition, but the 356 was in no sense a real racing car, a term that to Porsche implied a very different type of machine, a design that evolved into the Porsche 550 Spyder, possibly the best-known racecar of all time. It was behind the wheel of a 550 that actor James Dean lost his life on September 30, 1955, forever bonding the Porsche 550 Spyder name to Hollywood history and lore.

OPPOSITE: *The 1600S Speedster was a 100-mph-plus car, and the model most associated with Porsche in the 1950s. Austere in layout, with the minimum of comforts and a top that barely kept the wind out, it was a more tractable car, one capable of being raced on Sunday and driven to work on Monday.* (Bruce Meyer collection)

RIGHT: *America Roadsters would go to amateur racers such as Briggs Cunningham, Richie Ginther, Phil Walters, John Bentley, Jack McAfee, and John von Neumann. The lightweight, aluminum-bodied racers were to become the legitimate forerunner of the famed 356 Speedster.* (John Paterek collection)

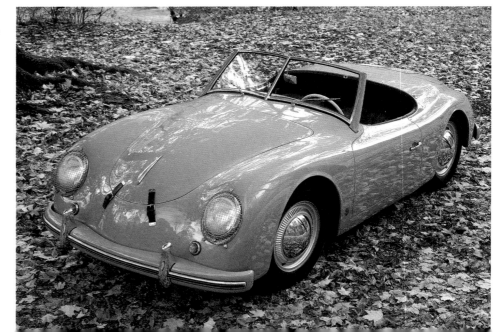

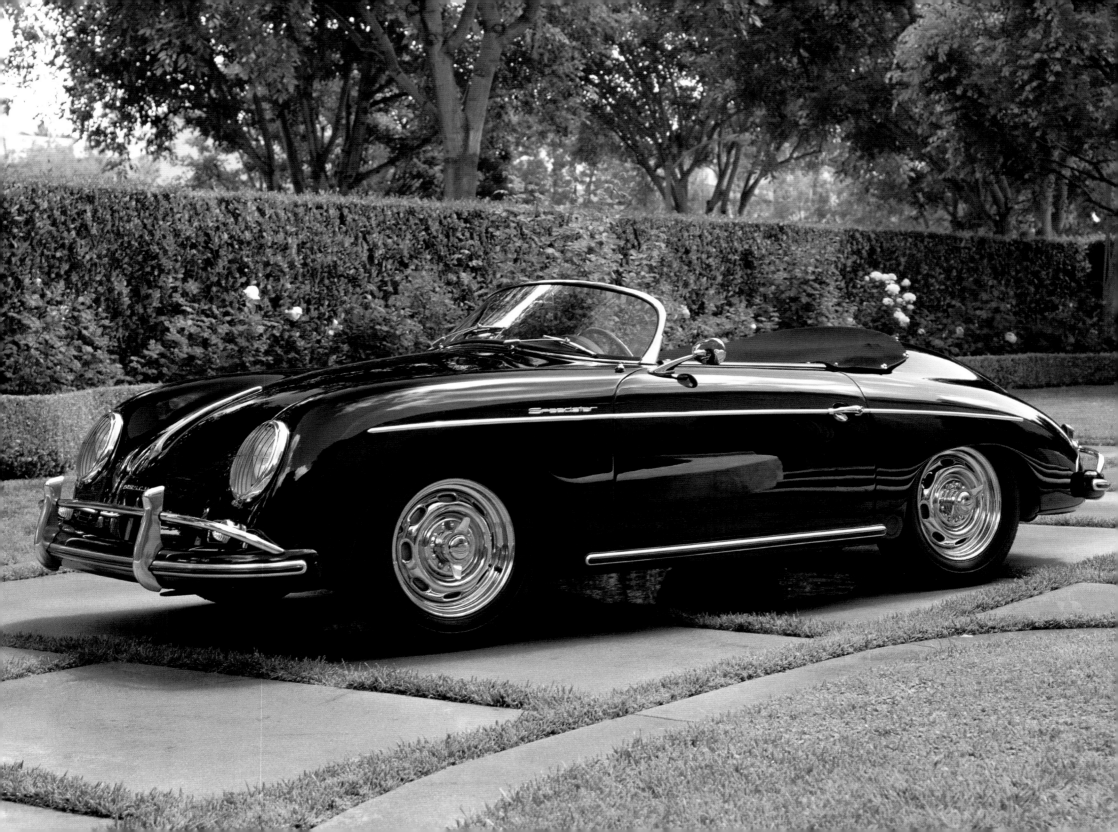

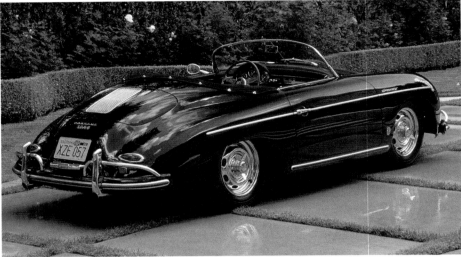

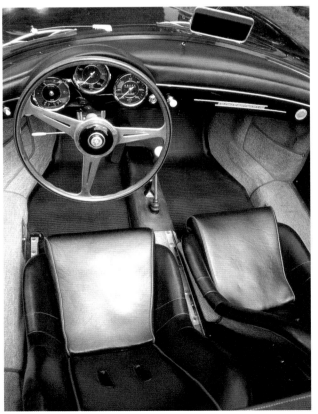

Around 1954, a clamor arose among Porsche owners for a more powerful 356 model, something closer to the performance of the competition 550. Bowing to the wishes of its clientele, late in 1955 Porsche introduced a four-cam 356 Carrera engine at the Frankfurt auto show along with the all-new 356A model line. The new Type 547/1 engine was almost identical to those used in Porsche's championship 550/1500RS racecars, with the exception of a lower compression ratio and adjustments to allow mounting of the engine in the rear of the car, rather than amidships, as in the 550. Based on the earlier air-cooled, four-cylinder motor developed for the 356, the Carrera engines had, in addition to dual overhead cams, a Hirth's built-up crank, twin choke Solex carburetors, dual ignition, dry sump lubrication, and the added performance buyers had requested.

Although it was a far more difficult engine to build and maintain, Porsche offered the four-cam as an option on all 356A models in 1955—coupé, cabriolet, and Speedster, each signified by the gold Carrera script on the front fenders and rear decklid. The name was taken from the famed Carrera PanAmericana, which Porsche had first won in 1953. *Carrera*, which means "race" in Spanish, has been used by Porsche ever since.

The four-cam models displayed dual exhaust pipes and a rousing increase in performance compared with the pushrod 356s. The Carreras were further distinguished from the 356 model line beginning in 1956–57, with the application of twin grilles on the rear decklid.

Beneath the otherwise inconspicuous 356A bodywork, Carreras were equipped with modified suspensions utilizing stronger stabilizers, more vertical shock mounts, improved track rods, a hydraulic steering damper, a wider track, and larger 15-inch wheels. Although the new 356A Carrera was a heavier car by about 100 pounds, it had more responsive handling than the standard Zuffenhausen fare and could exceed 125 mph.

To Porsche's dismay, after the first year of Carrera production, customers were not only dissatisfied with the cars but also divided on whether they were any more suitable for the road than a 550. Arguably, the first Carreras had been a compromise, neither light enough for racing nor luxurious enough to be considered a touring car. With Solomon-like wisdom, Ferry Porsche solved the problem in 1957 by introducing two versions—the Deluxe, equipped with a full leather interior and every luxury feature that would fit into the car; and the GT, a full competition model available in Speedster and coupé body styles only, with bucket seats, plastic windows, lighter bumpers, a Nardi wood-rimmed aluminum steering wheel, and 60mm spyder front brakes. The GT models were the perfect foil for those who decried the luxury of the Carrera Deluxe. No creature comforts were afforded the GT at all—not even a heater! The Carrera was now an eligible GT racer and in competition surpassed many production racecars of the era.

Among the most popular and exciting of all 356A models was the Speedster, a mixed metaphor on wheels. It was the very embodiment of the Porsche ideal, yet it was also the least luxurious and most scarcely appointed model in the

OPPOSITE ABOVE LEFT: *The 1600S Speedster engine delivered a rousing 75 horsepower. To get more, one had to opt for a Carrera Speedster, which delivered 110 horsepower.*

OPPOSITE ABOVE RIGHT: *The Speedster was the embodiment of the Porsche ideal, a road car and racecar in one. It was intended for the pure of spirit, individuals who wanted nothing more than the sound of the engine for entertainment and the open road for inspiration. In 1958, the 1600S Speedster was the fastest production car you could purchase from Porsche without stepping up to a Carrera. (Bruce Meyer collection)*

OPPOSITE BELOW: *The Speedster interior was simple, straightforward stuff, no fancy trim, save for the Porsche name on the dashboard. Sport seats, instruments, shifter, and floor mats—that's all that Speedster owners required. (Bruce Meyer collection)*

LEFT: *The 1958 models were the end of the line for Zuffenhausen's austere 1600S Speedsters. In August, the lightweight ragtops were superseded by the all-new and luxuriously appointed 1959 356B, originally named the Speedster D (D for "Drauz," which was the body builder). By the time of its introduction, Porsche had renamed the new model Convertible D in order to make a clean break with the Speedster. (Gene Epstein collection)*

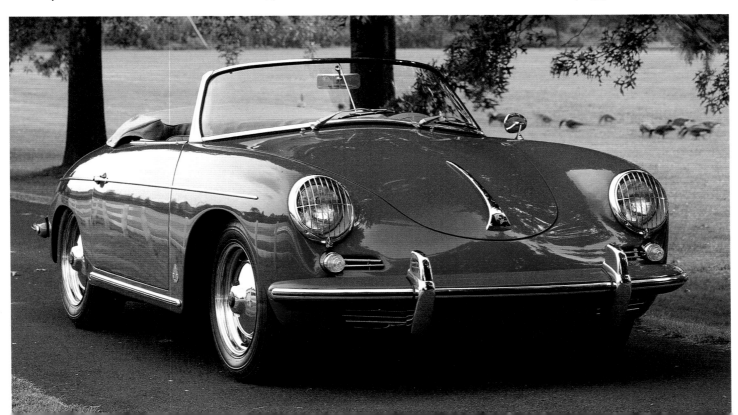

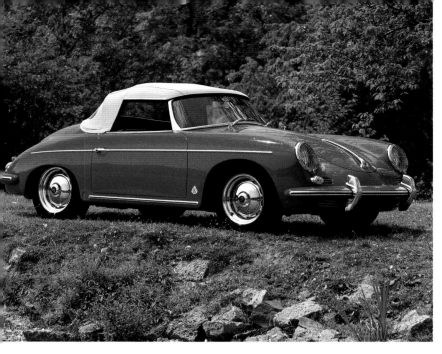

356A line. The average Porsche buyer wanted performance without the sacrifice of comfort or luxury, and for that Zuffenhausen produced the 356A Cabriolet and Coupé. The Speedster was intended for purists, those indomitable individuals who threw caution to the wind (quite literally in a Speedster) and gave not a damn for anything that wasn't purposeful. Aside from the higher-performance, four-cam Carrera Speedster, the 1958 1600S was the fastest production car you could purchase from Porsche. This was a true 100 mph sports car, and it endowed the 356A Porsche with qualities that were uncanny for the 1950s. Most drivers were surprised to find the "tail heavy" feeling of the old 356 all but absent. The Speedster was a more tractable car, one capable of endowing average drivers with seemingly above-average abilities, a fact bemoaned by those who had mastered the unpredictable handling characteristics of earlier models. "Now," wrote Uli Wieselmann, editor of Germany's prestigious *Auto Motor und Sport* magazine, "Even dear Granny can take a turn faster with a Porsche than with an average car." We're not sure how many grannies ordered Speedsters.

In 1959, Porsche introduced the most luxurious of all 356A Carrera models, the 1600 GS. Weighing 2,100 pounds, somewhat heavier than its predecessor, the 1959 models were equipped with an improved 115-horsepower, 692/2 four-cam, plain-bearing engine. A very limited-production model, only 47 Carreras were built.

In 1960, the emphasis returned to competition, and 1959 marked the end of the luxury Carrera Grand Sport models. The 1600 Carrera GT was replaced the following year by the new two-liter 2000 GS series—the fastest 356 road cars ever built by Porsche. By the time Zuffenhausen was prepared to introduce a new generation of cars, the 356 and Carrera names had left an indelible imprint on motorsports and sports car enthusiasts the world over.

Throughout its existence, Porsche had maintained a simple tenet, to make no change for the sake of change alone. Even the latest designs from Porsche AG, however different in their mechanical execution or appearance from the past, are irrefutably linked to the 356 and its successor, the 901/911, designed by Ferry's son, Ferdinand Butzi Porsche III.

In his book *Excellence Was Expected*, author Karl Ludvigsen pointed out Butzi's concerns over designing a car that would replace the company's *only* product. As was not the case at Ford or General Motors, where an unsuccessful model could be swept under the carpet, a miscalculation by Porsche would have been fatal. The problem Butzi Porsche faced was one of tradition and image: "Must you build a new Porsche just like the old one?" In many respects, the answer was

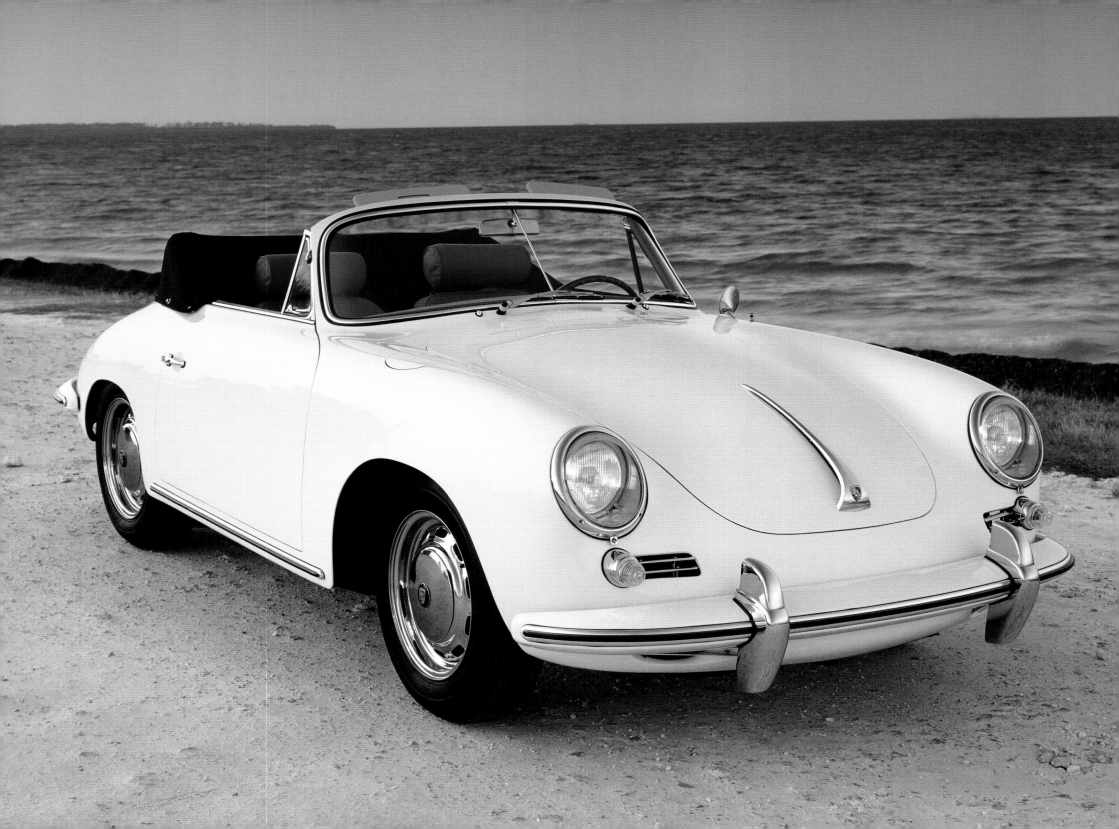

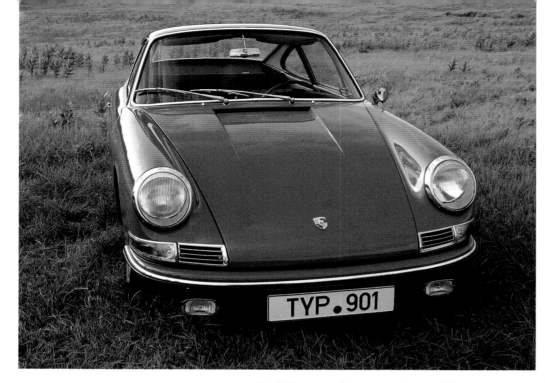

The source Porsche, the 1964 Type 901/911 prototype. This is one of only four built and the only known restored example in the world. In essence, this is the oldest 911 in existence! The new model, penned by Ferdinand "Butzi" Porsche III, incorporated more changes than the company had ever before made. (Don Meluzio collection)

yes, but Butzi wrote, "It should be a new Porsche . . . as good or better than the old, and in the same pattern, but not necessarily the same form." A bit enigmatic perhaps, but one has only to compare an early 911 with a late-model 356 to understand Butzi's philosophy of design. The 911s were an extension of the 356—longer, sleeker, more powerful perhaps, but unmistakably Porsches.

In an August 1963 press release announcing the introduction of a new model to replace the venerable 356, the company explained the theory behind the design and development of the 901/911: "For years Ferry Porsche and his team of engineers have racked their brains as to how to keep the Porsche motto 'Driving in its purest form' both up-to-date and in tune with the constantly changing conditions of modern traffic."

Building on the reputation of the 356—a model that had proven incredibly versatile as both road car and racecar—the press release went on to state, "Porsche engineers were the first to build a comfortable and sporting automobile in quantity, and this more than ten years ago. The most powerful horse in the Porsche stable today is the Carrera 2000 GS; proving that Zuffenhausen has not strayed from the line it began."

Porsche's goal in creating a successor for the 356 was to design "a car with hardly larger outside measurements than the present one, and yet one with more interior room. It should have an engine that can cope without strain with today's traffic jam . . . yet possess the performance of the Carrera—lightning acceleration to a maximum speed of over 200 km/h (120 mph). Apart from that it should have an easily accessible luggage compartment. To that should be added the roadholding of a sports car plus the comfort of the Gran Turismo for the long journey. Equally necessary was a Porsche synchronized, properly spaced, five-speed gearbox, as well as the highest-quality bodywork and all this within a reasonable price." The 901/911 met all of these goals.

The new model embodied as many changes as the company had ever made in a single car, from the body and interior right down to the final suspension layout and new overhead-cam, six-cylinder engine—the foundation of every 911 motor to the present day. The new power plant retained Porsche's established air/oil-cooling system and horizontally opposed (boxer) layout, but now had overhead camshafts driven by double-row roller chains. The two-cam

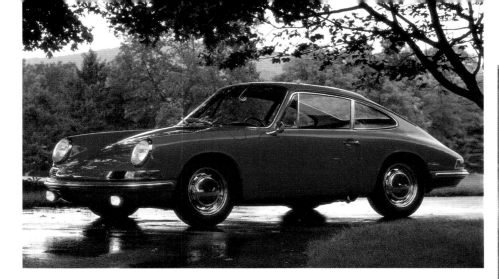

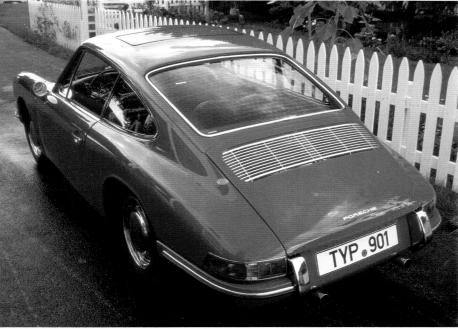

901/911's 128-horsepower output matched that of the four-cam Carrera 2, without the requisite mechanical complexity. A new five-speed gearbox completed Porsche's development of the 901/911 driveline.

The new car continued to utilize the 356's torsion-bar suspension but modified its execution. Up front, MacPherson struts replaced double trailing arms, with the front torsion bars sent lengthwise instead of transversely, inside the A-arm, allowing more trunk space. The 901/911 engineering team moved the steering mechanism—now a rack-and-pinion design—toward the center of the car, utilizing an offset double-jointed shaft.

The 901/911 was both a larger and a smaller car compared with its predecessor. The wheelbase was some 104 mm longer, to provide additional footroom and larger rear seats—although rear accommodations were never seriously considered appropriate for anything but a short drive. The 901/911's greater wheelbase did allow one notable advantage, longer doors, which allowed easier entry and exit. The upper body was wider to increase hip and shoulder room, while the passing of the 356's "bathtub" physique allowed the 901/911's exterior to decrease in width by almost three inches. In addition, from end to end, the new car was some five inches longer.

The production version was originally badged just as the prototype, 901, and the lower-priced four-cylinder model was named the 902. How they became the 911 and 912 is a story few people outside of Porsche actually know. The facts, though not nearly as romantic as some of the stories that have been told, are nonetheless intriguing.

First, the designation 901 had nothing to do with the car's design, as is often suggested. In the early 1960s, Porsche was more closely integrating its sales and service with Volkswagen (the controlling families of both concerns were inter-

twined through marriage, as Dr. Piëch was married to Ferry Porsche's sister, Louise), and Porsche simply needed parts numbers that would be compatible with VW's. The next available series at Volkswagen began with 900; thus the new model would be 901. It would have remained so but for an unexpected encounter with Peugeot in September 1964.

One of the 901 prototypes was on exhibit at the Paris Auto Salon, and much to Porsche's surprise the company was contacted by a Peugeot representative and told that they could not use the number 901. It seemed the French automaker had been utilizing three-numeral designations for all of its passenger cars—two numbers with a zero between them—since 1929! The Porsche designation conflicted with French trademark regulations granting Peugeot exclusive rights to use 901 in France. A quick solution was reached, and Porsche simply renamed the car 911 and the four-cylinder model 912. An interesting aside is that the 904 through 909 number sequence used by Porsche for its racecars was never protested by Peugeot!

Throughout the 911's 38-year history (the longest of any automobile series) racing has played a significant role. Some eight years into production, Porsche encountered its first real problem with the 911. Approaching 150 mph speeds in competition, the cars hit a theoretical wall, the body having reached aerodynamic limits that the 2.4-liter 911S engine and suspension were capable of exceeding. The result was Porsche's development of the aerodynamically styled Carrera Renn Sport or RS series, which began in 1973 with a 2.7-liter car available in two production versions, Touring, which offered standard 911S features, and Sport, a lightweight model honed to competitive perfection and devoid of anything that wasn't purposeful. Porsche had simply applied the 356 Carrera Deluxe and GT theory to the 911. However, this time there was also a third variant—the M491 conversion or RSR—which was a factory-built, out-of-the-box racecar manufactured to order by Porsche's Werk I. In their first season, RSRs won the Targa Florio, the 24 Hours of Daytona, and the 12 Hours of Sebring, earning Porsche the Manufacturers and IMSA Drivers Championships for 1973.

In 1974, the 2.7 gave way to the RS and RSR 3.0, even faster and more aerodynamic versions that put Porsche on the cutting edge of design and performance technology. These cars formed the starting point for Porsche's decade-long domination of production-based GT racing.

Porsche's winning ways also led to an even greater demand from enthusiasts for faster and more agile road cars. In 1974, the factory introduced the first of its legendary Turbos, the 930. The car was initially exclusive to the European market but within a year had made its way to America as the new 911 Turbo Carrera. The Turbo established a new standard of performance for Porsche, and an equally impressive record for price. The 911 Turbos, distinguished

by their now famous *bürzel*, or "whale tail," and generously flared fenders, set owners back a tidy $26,000 without options. A used one commands nearly the same price 28 years later!

Having been around for 38 years, the 911 has become the basis for countless variations on a theme, but every rear-engine Porsche, no matter how modern it may appear, is still rooted to the first 356 models built in Gmünd, Austria, in 1948.

The first Carrera Renn Sport or RS series began in 1973 with a 2.7-liter car available in two versions: Touring, which offered standard 911S features, and Sport, a lightweight coupé (pictured in traditional Grand Prix white and blue), honed to competitive perfection and devoid of anything that wasn't purposeful. (Michael Furman collection)

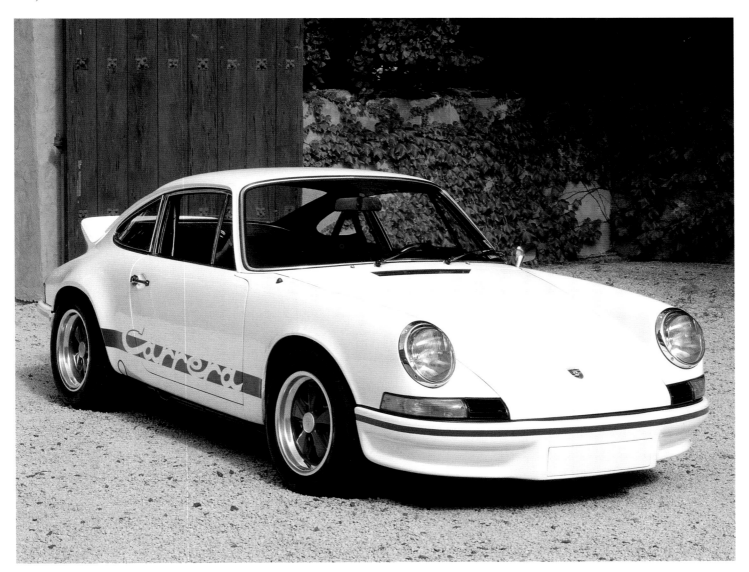

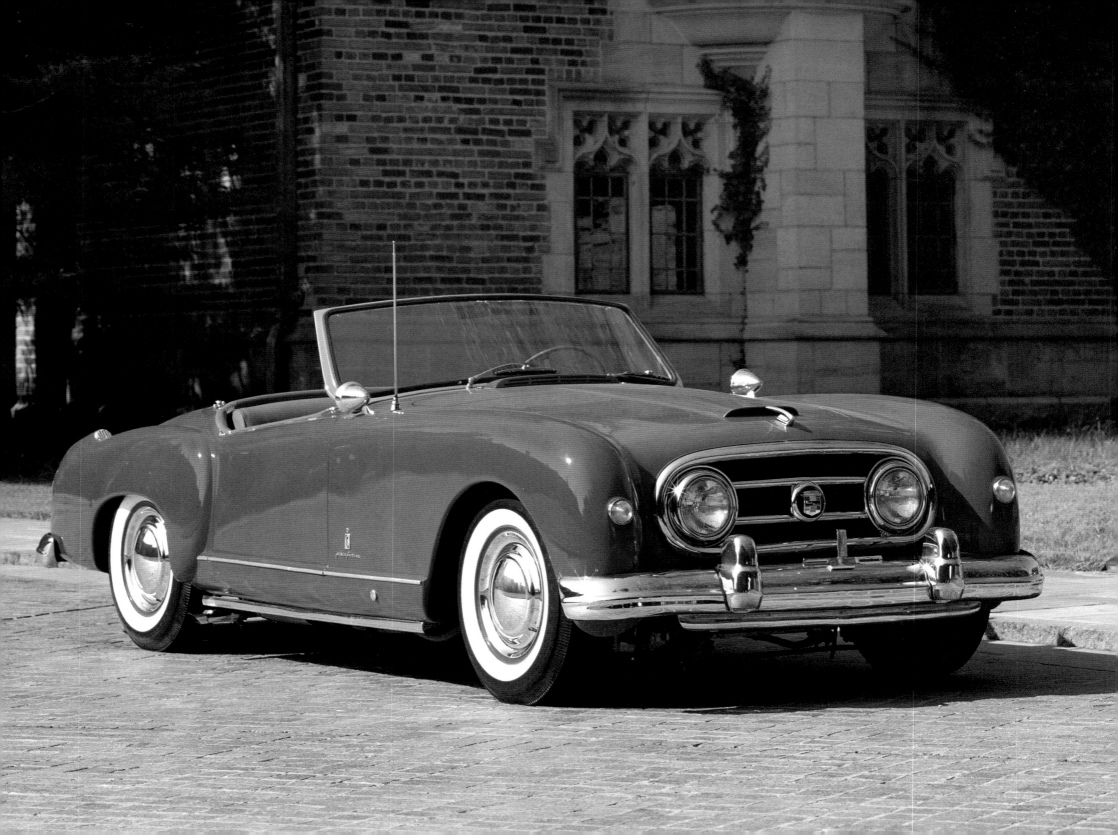

DETROIT'S CONTRIBUTION

Corvettes, Cobras, Mustangs, 'Cudas, and Thunderbirds

T HE EUROPEANS HAVE ALWAYS FAVORED ALPHANUMERIC DESIGNATIONS FOR THEIR SPORTS

CARS—XK-120, DB2-4 MK III, 250 GTO; BUT AMERICANS LIKE ANIMALS, ALL KINDS OF ANIMALS—

COBRAS, MUSTANGS, BARRACUDAS, EVEN MYTHICAL THUNDERBIRDS. NAMES PEOPLE CAN

REMEMBER. CARS PEOPLE CAN IDENTIFY BY SIGHT TWO BLOCKS AWAY, OR JUST BY THE

SOUND OF AN ENGINE. • AFTER WORLD WAR II, SPORTS CARS WERE STILL SOMETHING

The sporty contours of the 1952 Nash-Healey, while very Italian, were toned down around the grille and headlights to impart a more "Americanized" look, closely resembling the Nash Ambassador and Statesman. (Al Ruckey collection)

OF A CURIOSITY IN THE UNITED STATES. IN FACT, IN 1952, A TOTAL OF 11,199 NEW

SPORTS CARS WERE REGISTERED IN THIS COUNTRY. THIS AMOUNTED TO AN

INSIGNIFICANT 0.27 PERCENT OF CAR REGISTRATIONS FOR THE YEAR. AMONG THAT

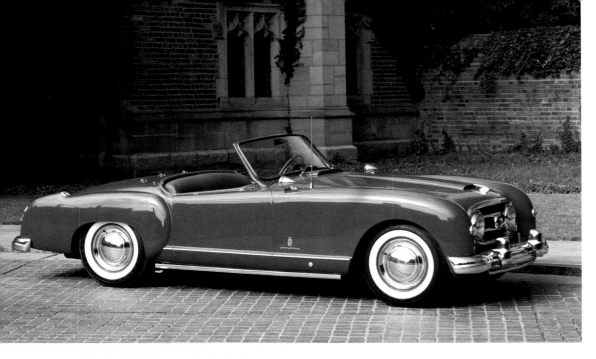

Battista Pininfarina was the first Italian stylist hired by an American car company to design a new model. His first efforts for Nash were the 1952 Ambassador and Statesmen models built in Wisconsin. The Nash-Healey coachwork, however, was assembled in Italy on the Healey-supplied chassis, then shipped to the United States to be completed by Nash. (Al Ruckey collection)

tally were a handful of innovative, hybrid sports cars engineered in England by Donald Healey, designed and bodied in Italy by Battista Pininfarina, and powered by a Nash six-cylinder engine built in Kenosha, Wisconsin. Manufactured for Nash and sold exclusively through Nash dealerships across the country, the Nash-Healey made its U.S. debut in February 1952 at the Chicago Automobile Show and became America's first production postwar sports car, beating the Corvette to market by a full year!

The Nash-Healey quickly established itself with sports car enthusiasts by scoring a class victory in the 1952 Le Mans 24-hour marathon, and by placing third overall behind a pair of Mercedes. More importantly, the sporty new Nash had beaten Ferrari, Aston Martin, Jaguar, and Talbot!

Following the car's sensational racing success, Nash launched an advertising blitz that cost, according to Donald Healey, more than the entire investment in the Nash-Healey project! The company even hung the Le Mans label on the Ambassador and Statesman sedans (also designed by Pininfarina) when equipped with the dual-barrel "power pack" carburetor used in the Le Mans–winning Nash-Healey.

Although the cars were a success, Nash president George Mason never intended them as a high-volume model. Peak production in 1953 was limited to just 162 cars, and between 1952 and 1954 a total of only 506 were built. When Nash merged with Hudson in 1954, creating the American Motors Corporation, there was no place in the new combined product line for the Healey, and America's first sports car was gone in 1955. A true benchmark in early postwar sports car design, a restored 1952–54 Nash-Healey is a rare find.

DETROIT STEPS UP TO THE PLATE

The sports car was an unknown quantity in the early postwar years, at least from an American perspective. Nearly all of the great pre–World War II marques were gone—Duesenberg, Auburn, Marmon, Mercer, and Stutz—and with them, the rakish, sporty boattail speedsters they had made famous in the 1920s and 1930s. What remained of the American automotive industry after the Great Depression and World War II were Detroit's dreadnoughts—General

Motors, Ford Motor Company, Chrysler, and to a lesser extent, Packard, along with South Bend, Indiana, automaker Studebaker, and a handful of struggling independents such as Nash, Hudson, and Kaiser. None of them had a sports car in 1950. Henry J. Kaiser and Howard "Dutch" Darrin teamed up to build the Kaiser-Darrin, a fiberglass sports car that came out in 1954 and was out of production by the end of the model year. Nash offered the striking Nash-Healey, imported from England, and of course, Max Hoffman and Luigi Chinetti were importing a variety of European and British sports cars. But an American sports car did not exist, not before 1953 when General Motors made a bold and ambitious move with the introduction of a "dream car" at the 1953 GM Motorama in New York City. The innovative new model was called the Corvette. From that moment on, America would have a sports car.

The first 300 Corvettes were built at GM's St. Louis assembly plant. All 300 were polo white with sportsman red interiors. The 1953 model shown was one of the earliest built and is in all-original condition. (Chip Miller collection)

Most of the excitement surrounding the Corvette's debut was due to its sleek, sporty body styling and unique fiberglass construction. In this concept car, GM had used fiberglass simply for convenience, but when demand for the car arose from every corner of the nation as the Motorama toured the country, the Chevrolet division planned to tool up and produce the car in steel, after a limited run of 300 special fiberglass Corvettes identical to the Motorama show car. To GM's surprise, the public was totally intrigued with fiberglass, and the fledgling plastics industry was so willing to help produce the car that Chevrolet was persuaded to forget about a steel body. The accountants were pleased too. The use of fiberglass saved GM millions of dollars, since the tooling already existed to build fiberglass bodies.

Designed by the legendary GM stylist Harley Earl, the Corvette was a stunning design, but beyond its looks the car was a pretender to the throne. The Corvette was sporty, but it was no sports car. Despite its low-slung, European-inspired profile, the car quickly drew criticism from both buyers and the automotive press.

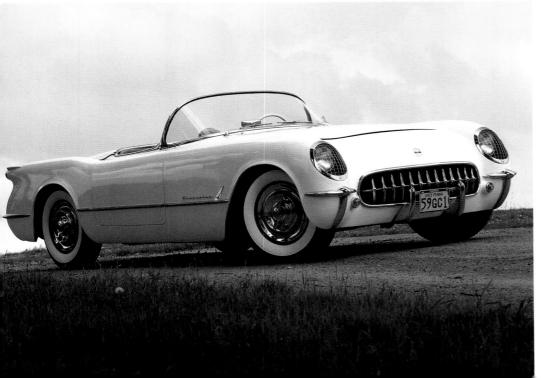

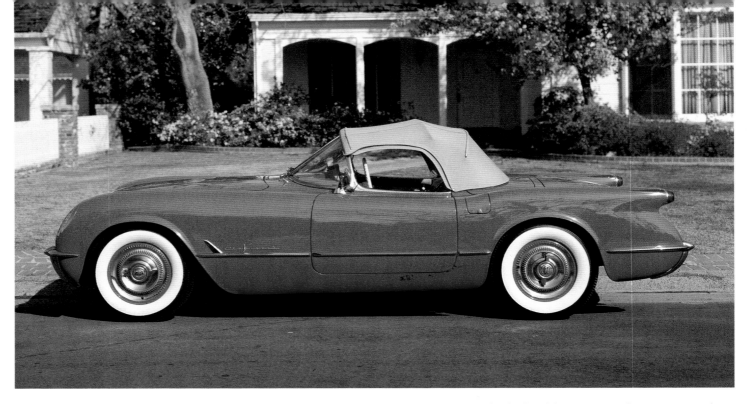

That most people misunderstood the features of the Corvette, or rather the lack of features, such as exterior door handles, roll-up windows, or a weatherproof convertible top, was not GM's fault. The company's error lay in the execution of their concept, not in the concept itself. Harley Earl had based much of his design on the Jaguar XK-120, a car that seemed to appeal to American sports car enthusiasts. The problem with the Corvette was that GM didn't follow through with the concept. Budget limitations had dictated that engineers use an off-the-shelf engine and transmission, and what the sporty two-seater got was an overhead-valve six from the passenger car line, coupled with an inadequate two-speed automatic transmission. Sports car enthusiasts who might otherwise have purchased the car in droves turned a cold shoulder to such an engine, with its mere 150 horsepower.

Historically, the road to success is littered fender-deep with ideas that didn't work, cars that after a few short years tumbled from lofty reverence as innovative concepts into the ominous shadows inhabited by the also-rans. This was nearly the Corvette's fate. By late 1954, nearly half the cars built for the model year were collecting dust on Chevy showroom floors and on back lots. The 300 cars produced in 1953 had sold out because they were a novelty, but by 1954 the word was out. Chevy had a problem.

The 1953–55 Corvettes were underpowered, even when a V-8 was added in 1955, because the automatic trans-

mission was still inadequate, as were the handling and braking capabilities. As a sports car, the Corvette fell well short of expectations. Zora Arkus-Duntov, who had joined the GM engineering staff in 1953, spearheaded a complete redesign that would firmly establish the Corvette as a true sports car by 1957.

With planning under way for an all-new Corvette to debut in 1956, Chevrolet's styling department made substantial changes to Harley Earl's original body design. Every detail was altered and refined. The 1953 Corvette had been greatly influenced by the Jaguar XK-120, but the second time around designers were enamored of the Mercedes-Benz 300 SL. Recalled Bob Cadaret, who worked as a stylist on the Chevy design staff, "From the windshield forward, the 300 SL was the predominant influence on the styling of the 1956 Corvette."

In addition to the Mercedes, the greatest influence on the new Corvette body was another GM concept car, the 1955 LaSalle II roadster. The LaSalle featured contrasting coved panels on the front fenders that curved back into the doors. The Corvette design staff saw this as a perfect way to draw the fenderline back into the doors and, at the same time, give the car a narrower "pinched-in" look at the waist. The rest, as they say, is history. The 1956 Corvette emerged as one of the best-styled cars of the postwar era.

With the 1956 models, output from the Chevy V-8 was increased to 210 horsepower, with 225 horsepower available through an optional dual four-barrel carburetor. With a suspension improved by chief engineer Zora Arkus-Duntov, the Corvette was finally an honest sports car. But there was more to be done.

Now that Duntov had given the car a new body style, convertible top or removable hardtop, locking doors, roll-up windows, and more comfortable interior, improved performance was next on his list. For the 1957 model year, he added fuel injection, increasing engine output to 283 horsepower (1 horsepower per cubic inch with the top-of-the-line 283 V-8), a four-speed manual gearbox, and optional positraction rear end. After road-testing the fuel-injected 1957 model, Duntov was finally satisfied with the Corvette.

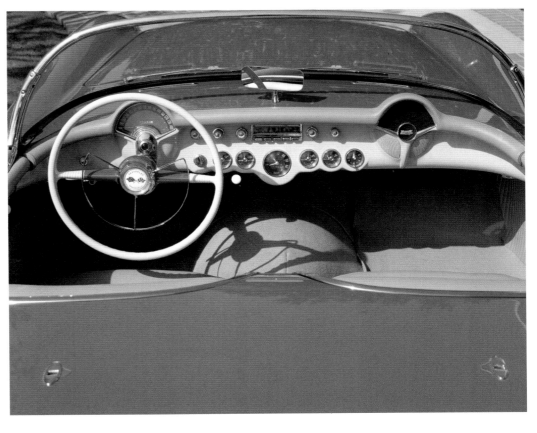

The 1953–55 Corvettes had a simple interior based on British sports car design, but they did not meet with the general approval of customers, who wanted roll-up windows, door locks, and other basic amenities.

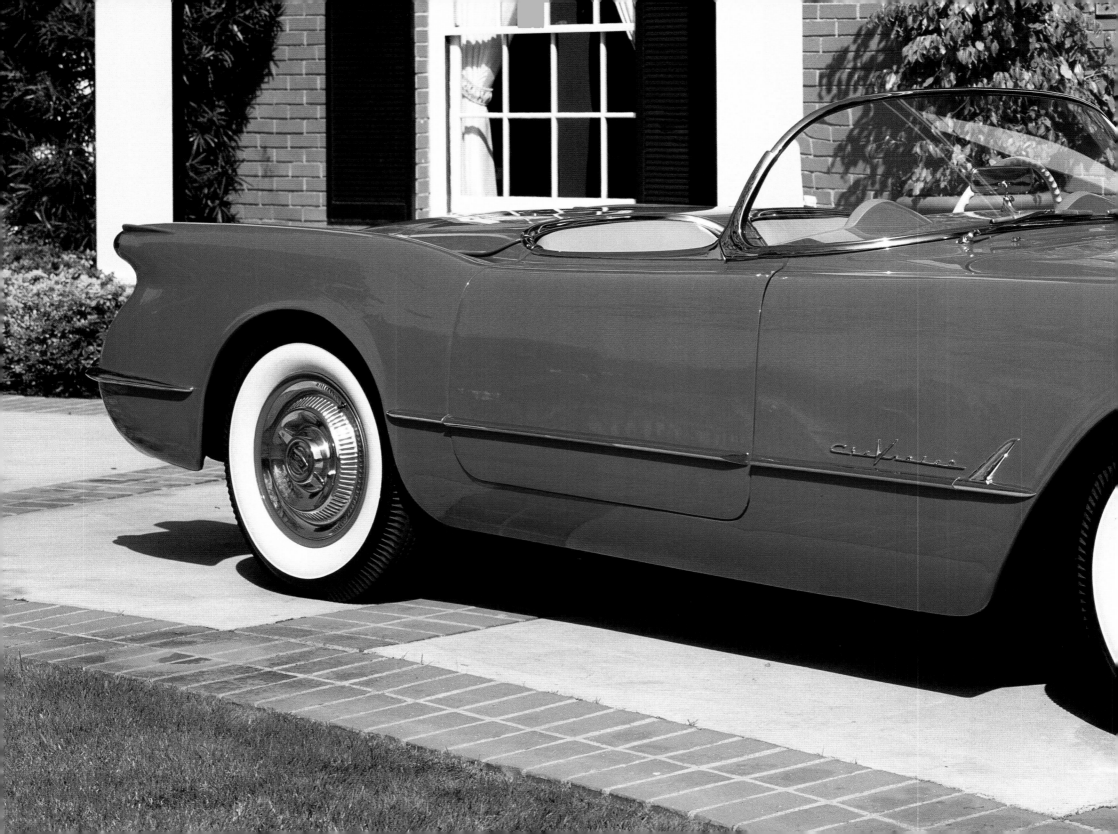

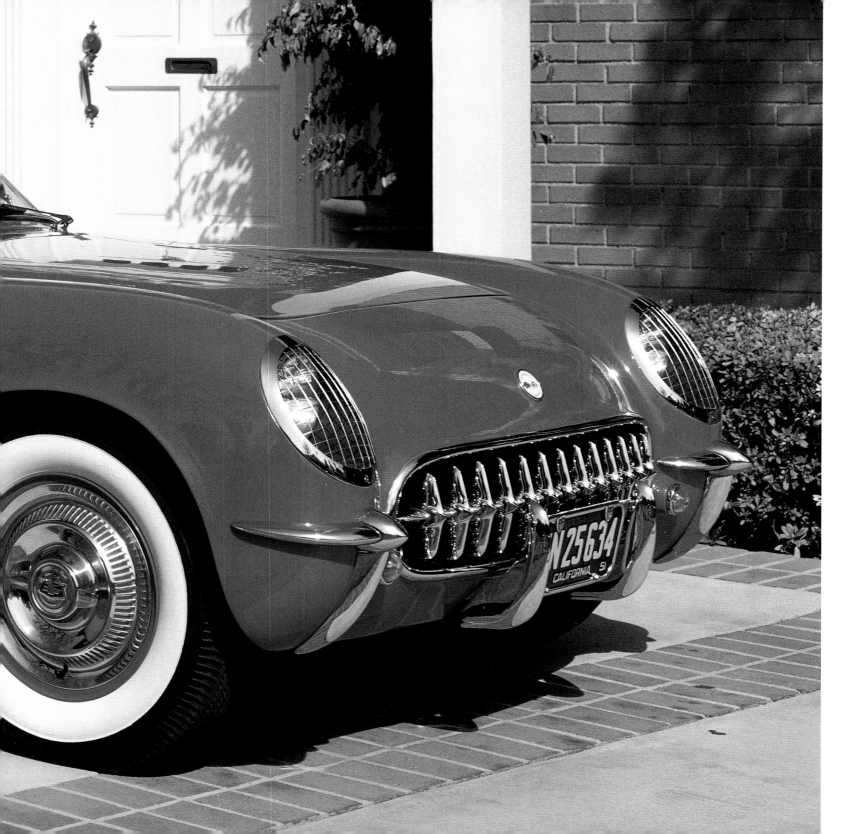

In 1955, Chevrolet attempted to improve the Corvette with the addition of a V-8 engine. It was not an engine option but a separate model distinguished both by the V-8 and a large gold V in the Corvette nameplate. (Lon Berger collection)

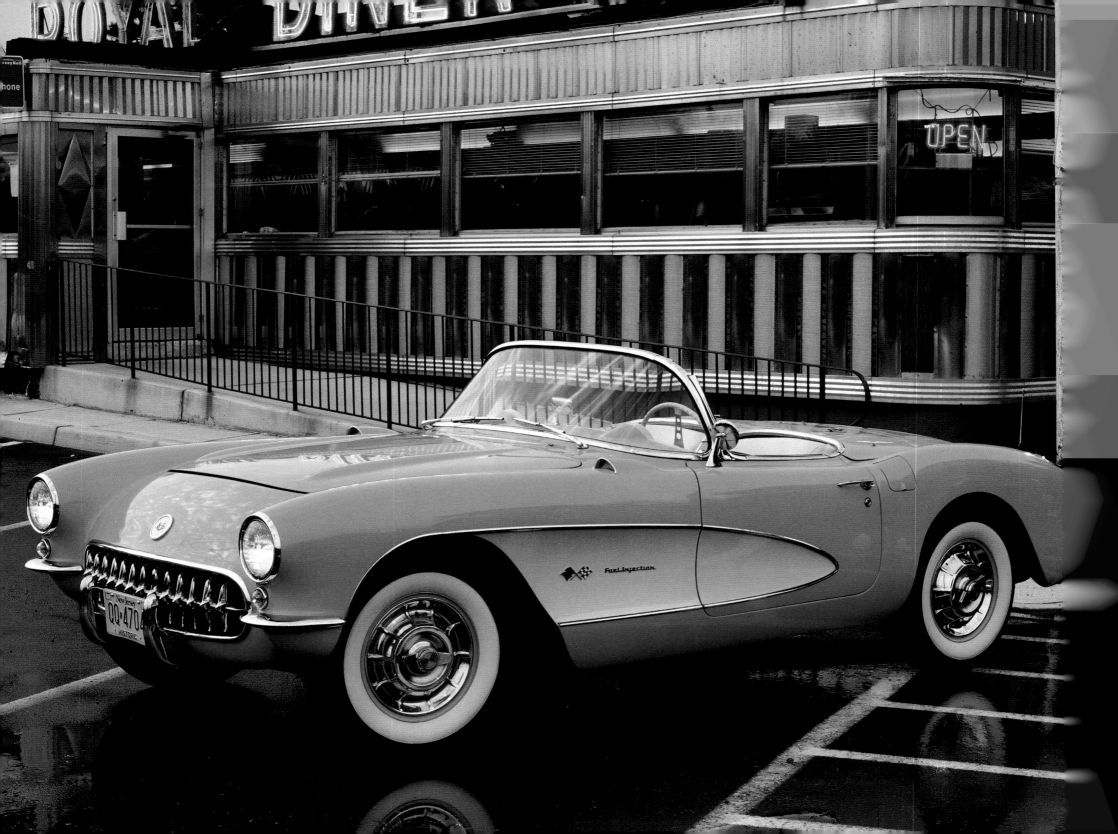

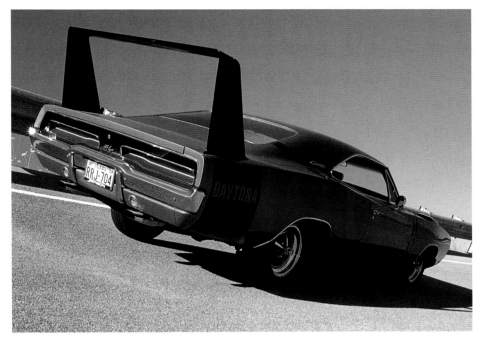

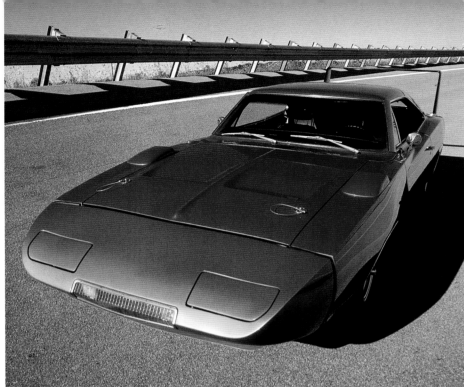

Designing an automobile is not easy. It requires great skill, equal amounts of patience and intuition, and above all *time*. That is what many people do not understand—the time frame in which stylists must work. Unlike most art forms, which depict the time in which they are created, the automobile stylist must think years ahead to when the car will actually hit the market. In the case of the 1970 Plymouth Barracudas, the concept and design work had begun in 1966.

For Chrysler, the 1960s was an awkward period. Their engines were ranked among the best in the world, but their body designs were tiresome. Chrysler stylists were in the unenviable position of trying to catch up to their competitors at Ford and General Motors. In 1966, when the next-generation Barracuda was being sketched out, the Ford Mustang had already established the "pony car" concept. Chrysler also knew that Chevrolet was at work on a model to compete with the Mustang for 1967. Whatever the Dodge and Plymouth Division designers did, the niche had already been established. What they needed to do now was redefine it.

The design of the 1970 models was crucial to the future of the Barracuda. The 1967 through 1969 models had been very successful in competition, but on the showroom floor, their conservative styling was a barrier even Hemi engines couldn't break through. What the Plymouth design staff needed was a clean sheet of paper to work on. In 1966, they got it.

ABOVE LEFT: *The high-winged Daytona was similar to the Plymouth Superbird, but the rear stabilizer was of a different design and angle than the Plymouth's.*

ABOVE RIGHT: *The long-nosed Daytona and Plymouth Superbird were designed for competition, but were also at home on the street, where they usually got quite a few looks. While the big Dodge hardly fits the description of a sports car, it was definitely not your daily driver!*

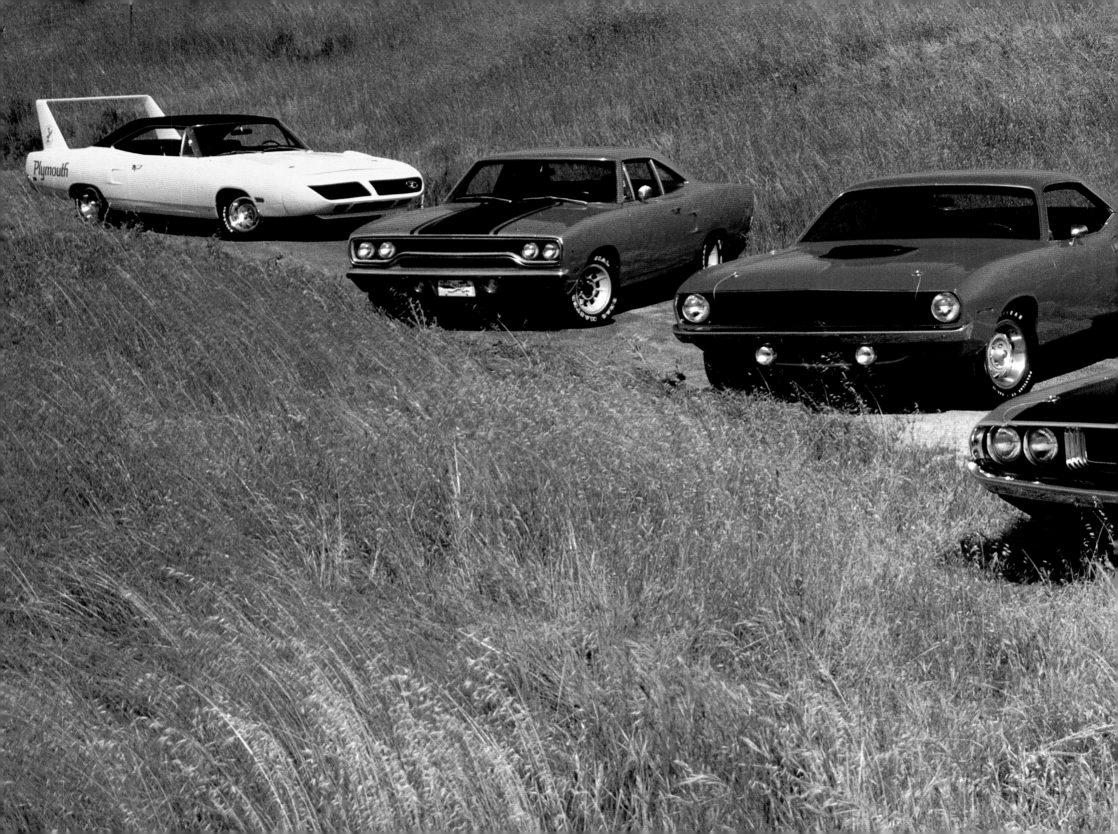

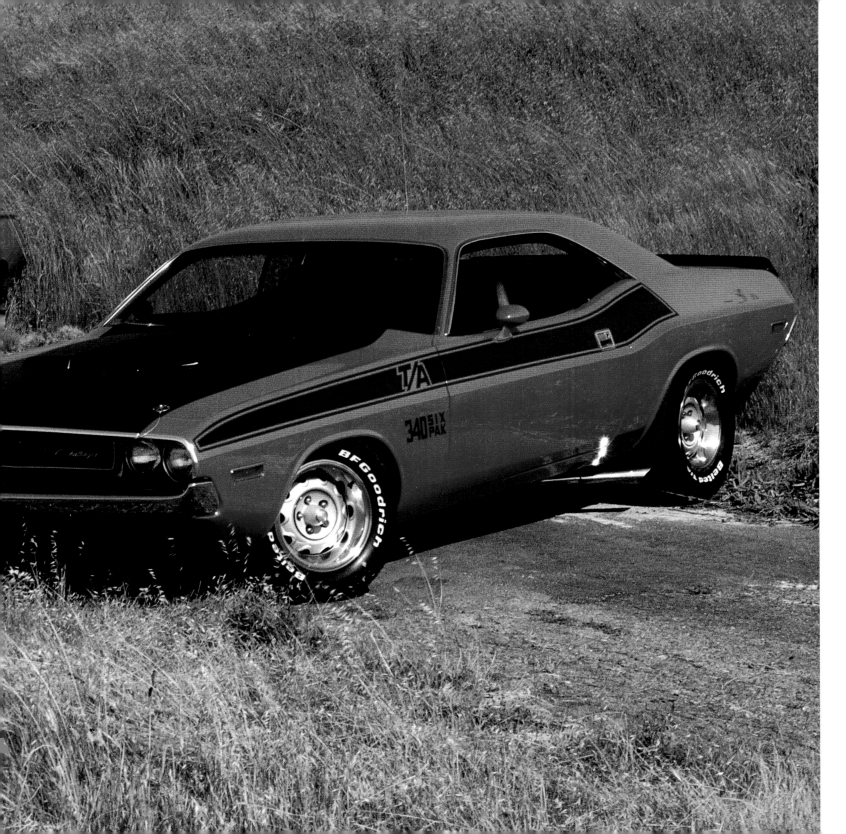

In 1970, Chrysler Corporation cut another performance notch in its belt, but this time it wasn't for building a fast car, which the company had been doing since the 1950s. It was for building a sporty-looking series of fast cars that defined an entire generation. Pictured from front to rear, the Dodge Challenger T/A (its Plymouth counterpart was the AAR 'Cuda), Plymouth Hemi 'Cuda, Road Runner, and Superbird.

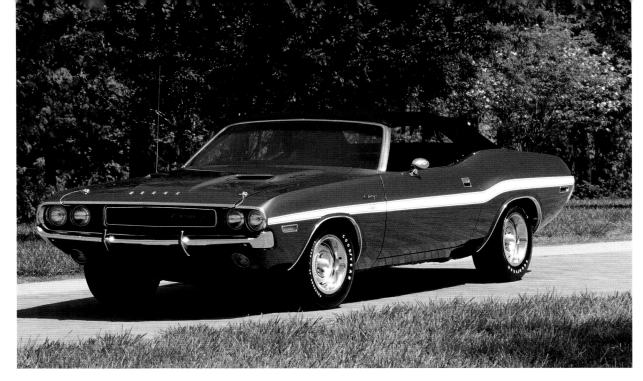

Not knowing what the Camaro would look like, the Barracuda's designers were lucky to turn out an even more spectacular design than that of the new Chevys. The styling of the 'Cuda's competition in 1970, the Mustang and Shelby, was pretty aggressive, but the Camaro was a little bit softer. The Plymouth design team had taken a gamble with the Barracuda, which was a radical departure from contemporary Chrysler product lines. Fortunately, Plymouth had an active, hands-on vice president of design at the time, Elwood Engle, a former Ford designer who had replaced Virgil Exner at the Chrysler styling helm in 1962. "He would walk through the studio every day hollering 'Get hot!' " recalls designer John Hurlitz, retired vice president of design for DaimlerChrylser. "He'd do crazy things to get us going," says former Daimler-Chrysler executive vice president Tom Gale, who worked on the 'Cuda's engineering team in the late 1960s. "He was really wild, and I think a lot of that enthusiasm came across in what we did back then. The 'Cuda simply blew everyone away in Detroit."

It made the Mustang look old, the Camaro and Firebird tame, the Pontiac GTO heavy-handed, and all the rest—the Olds 4-4-2, Chevy Chevelle, et al.—just big cars with big engines. Plymouth and Dodge had indeed redefined the high-performance market for the coming decade.

Dodge and Plymouth stylists had taken Ford's long-hood, short-rear-deck theme and made it their own. The contours of the 'Cuda and Challenger T/A were more well defined than the Mustang's. Accentuated by a high trunk, short roof, and the smooth, undisturbed flow of the body from bumper to bumper, the styling was as close as any American automaker had come to linear aerodynamics. The windshield wipers were recessed; the door handles were flush to the body; and the front-end sheet metal was carried right to the leading edge, then sharply turned under. The same was done to the rear of the car. From any angle, the 'Cuda was a continual line.

The 1970 models represented a perfect marriage of design and engineering. The Rapid Transit System name,

ABOVE: *The Challenger T/A was more stylish than the AAR 'Cuda and targeted a different market. The AAR was aimed squarely at Mustang buyers, while the T/A, marketing people believed, would appeal to buyers interested in a Mercury Cougar. Anyone who didn't buy the AAR or T/A missed out on one of the all-time great American muscle cars.*

OPPOSITE: *Equipped with the 426 Hemi and Shaker hood scoop, the 1970 and 1971 Hemi 'Cuda was a formidable car, with one very interesting-looking engine!*

conceived by Jim Ramsey of Young and Rubicam—Chrysler's advertising agency—put the final touches on the entire 1970 program.

The future of Dodge and Plymouth and muscle cars in the coming decade seemed bright and promising. And had history not taken another unexpected detour, that promise might have been fulfilled. In 1969 and 1970 Dodge and Plymouth had gone from building stodgy-looking cars with hot engines hidden under their hoods to building dynamic, youthful-looking cars that had engines coming through their hoods!

The RTS was made up of five basic models: 'Cuda, GTX, Sport Fury GT, Road Runner, and the Valiant Duster 340. The 1970 'Cuda series (apart from the stock Barracuda and Gran Coupe) offered enough options to custom-tailor a car to most anyone's tastes, from a mild 275-horsepower, 340-cubic-inch V-8, to a 335-horsepower 383, a 375-horsepower 440, a 390-horsepower 440 six-barrel, and a road-ripping 425-horsepower, 426-cubic-inch Hemi. The engines had equally impressive compression ratios of 10.5:1, 9.5:1, 9.7:1, 10.5:1, and 10.25:1 respectively, and an assortment of carburetors from a single Carter AVS four-barrel in the 340 and 440, to one Holley AVS four-barrel in the 383, three Holley deuces in the 440, and dual Carter AFB four-barrel carbs in the Hemi. The hot-ticket items, however, were the Hemi 'Cudas and Road Runners. The 1970 Plymouths could leave a trail of burnt rubber behind every shift. The real eye-catcher, however, was the Hemi 'Cuda's Shaker air scoop protruding through a cutout in the hood. The sides of the scoop had bold lettering that read "Hemicuda." A Chrysler guy once said this was done so that Mustang and Camaro owners could know exactly what car it was that had blown them off!

Only 652 Hemi 'Cudas were built in 1970, 284 with four-speeds and 368 with Torque-Flite. The 1971 Hemi models were to be the last flat-out, no-respect-for-noise-or-fuel-economy high-performance cars of the era. In 1972, the 426 Hemi, 440 Six Pack, and 383 were gone. The muscle car era had come to an abrupt end at the hands of government regulations, fuel emissions standards, high insurance premiums, and rising prices at the fuel pump. For sports car and performance car enthusiasts, the thrill was gone by the early 1970s, and so too were the cars. More than a decade would pass before Detroit dared to build another high-performance sports car.

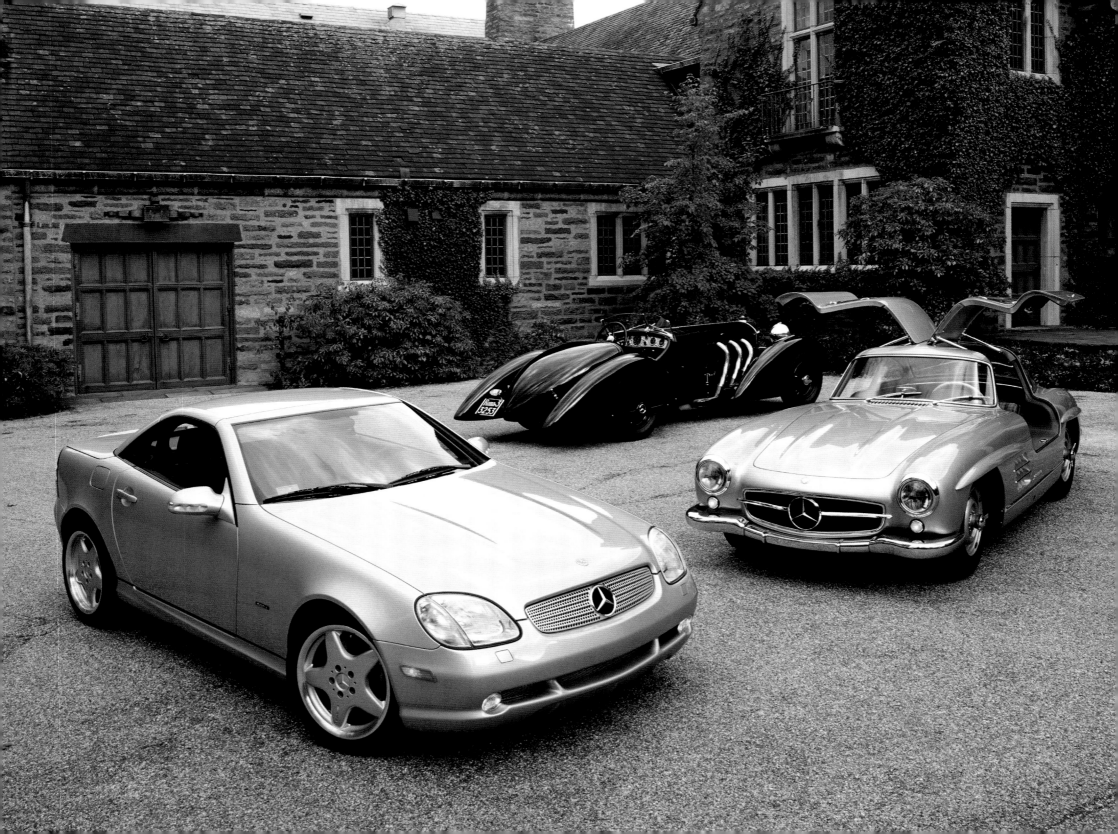

CONTEMPORARY LINES
Modern Sports Cars

Preserving company heritage has been part of Mercedes-Benz styling for over a century. The lineage that connects the 2002 Mercedes-Benz SLK and the 1955 300 SL is evident in many of the styling cues used for the new model, such as the contour of the grille opening, the silver star emblem, and a modern version of the SL hood power bulges. (Ralph Lauren collection and Mercedes-Benz)

THE ART OF THE SPORTS CAR HAS NOT BEEN LOST IN THE PRESENT . . . IT'S JUST A LITTLE HARDER TO FIND. WE HAVE A WORLD FAR MORE CROWDED THAN A HALF CENTURY AGO, AND WE HAVE TECHNOLOGY THAT PERMITS YOUNG STYLISTS TO DESIGN CARS ON A COMPUTER RATHER THAN ON A DRAFTING TABLE, AND TEST THEM IN A CYBER WIND TUNNEL WITHOUT BUILDING A PROTOTYPE. THIS HASN'T MADE THE CHALLENGE OF DESIGNING AN AUTOMOBILE ANY EASIER THAN IN THE DAYS WHEN CLAY MODELS WERE SCULPTED AND FULL-SIZE LOFTINGS WERE DONE ON GIANT CHALKBOARDS. CREATIVITY STILL COMES FROM THE IMAGINATION OF AN INDIVIDUAL. THE EXECUTION HAS CHANGED, BUT NOT THE ART.

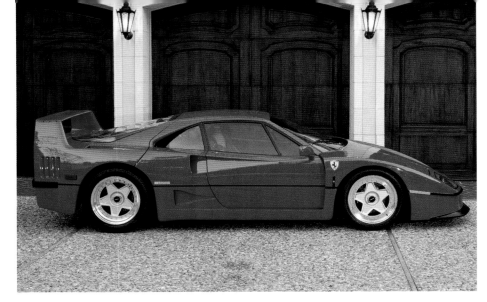 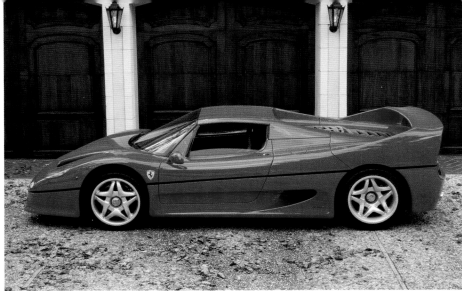

ABOVE LEFT: *To commemorate Ferrari's 40th anniversary in 1987, Pininfarina designed a racecar for the street, the F40. Powered by a twin-turbo V-8, the car had a lightweight composite body and a bare-bones interior—not even door handles. The F40 was a styling tour de force but not a particularly comfortable car to drive. It was blunt-force trauma on four wheels.* (Jerry J. Moore collection)

ABOVE RIGHT: *After 50 years, Ferrari needed a car to personify half a century of production, and for the 1997 F50 Pininfarina designed a body around what were essentially Formula 1 racing components. The body is one of the most beautiful ever—the interior is modern, functional, and comfortable.* (Jerry J. Moore collection)

Since the late 1930s, the demands of aerodynamic principles have in one form or another dictated the shape of an automobile. The early aerodynamic theories of Professor Wunibald Kamm of the Stuttgart Technical University were proven correct by Pininfarina in the 1960s with phenomenal sports cars such as the 250 GTO, 250 GT Berlinetta Lusso, and 275 GTB.

When you think about it, have we really come that far from the days when stylists taped strands of wool to the bodies of prototype cars and had them driven at high speed along a stretch of highway so the wind flows could be observed from a chase car? Or from the era of Joseph Figoni and Jacques Saoutchik, who expounded on a simple principle of nature, that a smooth, curved surface presented less resistance to the elements than a blunt surface? One could cut through the air like a rapier or bludgeon it like a sledgehammer, aerodynamics vs. horsepower. The art of the automobile was achieving harmony between the two.

No one will argue that there are too many facsimile designs today, cookie-cutter cars whose lack of identity is their identity. You buy a name, not a style. Still, there are exceptions, sports cars in particular, created by men with imagination who use today's tools as electronic tufts of wool rather than copy machines.

Pininfarina has been designing Ferraris for half a century, each more spectacular than the last, and this has kept the Cavallino Rampante at the forefront of sports car design almost from the beginning, when Sergio Pininfarina's father put pencil to paper and created the very first Ferrari cabriolet in 1952.

For Ferrari's 40th anniversary in 1987, Pininfarina designed the F40, and a decade later for the 50th-year celebration, the F50. Both are extraordinary designs in Ferrari's lineage, modern cars that still have ties to the past. This can also

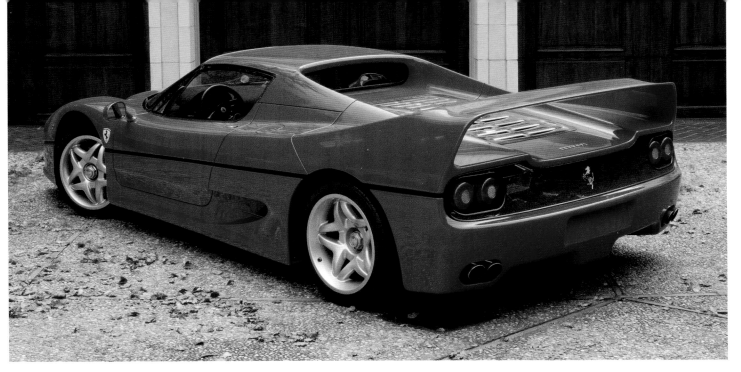

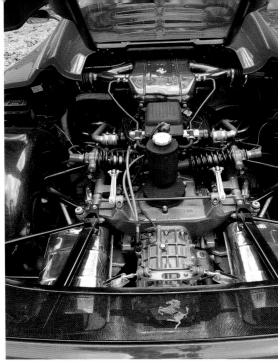

be said of another Pininfarina creation, the elegant 550 Maranello, the only front-engine Ferrari Berlinetta since the legendary 365 GTB/4 Daytona was built 29 years ago. Thus it is with every great design that a link with tradition exists.

Mercedes-Benz sports models also bear this out by repeating styling cues from earlier eras. One has only to look at the sporty 2002 SLK to see a reprise of the 1954 Mercedes 300 SL somehow blended into the design. And Jaguar, more than any other of the world's historic automakers, has seized its past to re-create the legendary XKE in the guise of the new XK8 coupés and convertibles. With the 911, Porsche has evolved a single design for nearly 40 years, a feat no other automaker has ever even attempted.

Chevrolet has never abandoned the Corvette, which will celebrate its 50th year in 2003.

Then there are the heroic designs, outra-

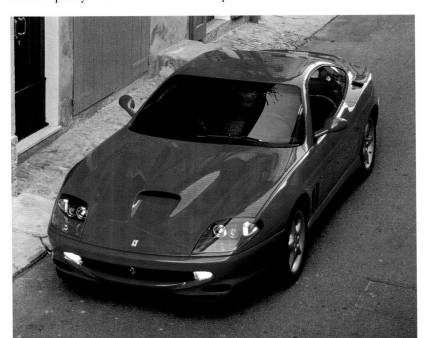

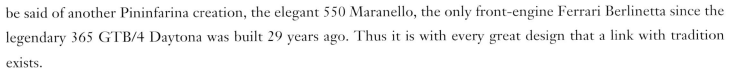

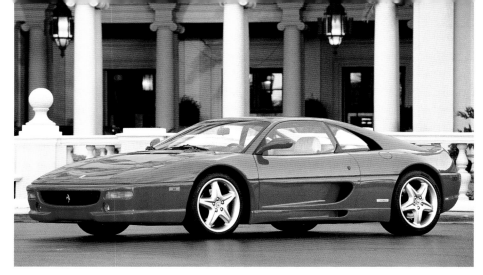

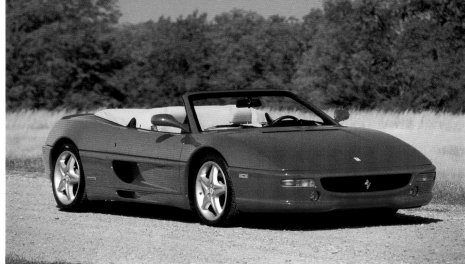

ABOVE LEFT AND RIGHT: *"Every new car is a challenge because each time we have to reaffirm that we are good enough to redesign a car which brings such satisfaction to the owner," says legendary Ferrari stylist Sergio Pininfarina. The F355 Berlinetta and Spider satisfied everyone by redefining the design of mid-engine sports cars. The F355 was hailed as the best Ferrari ever.*

RIGHT: *A glimpse of the future. The Mercedes-Benz Vision SLR design study blends futuristic styling from the current Mercedes Formula 1 World Champion "Silver Arrow" racecar with classic design elements from the famous Mercedes SL sports car and SLR racers of the 1950s. The evocative design of its arrow-shaped front end is based on the Formula 1 racecar that Mika Häkkinen drove to victory in the 1998 World Championship. These racecar design cues also appear in the Vision's cockpit and along the body. The long, chiseled hood, sweeping fenderlines, and unique doors hark back to the 300 SL sports cars of 1954 and the 1955 300 SLR racing version, which legendary drivers such as Juan Manuel Fangio and Stirling Moss piloted to numerous victories. The dramatic look of the SLR design study incorporates a double spoiler across the front of the car and a new interpretation of the familiar Mercedes-Benz "face," featuring four oval headlights. The good news is they're going to build it.* (DaimlerChrysler photo)

geous perhaps, but intended to be, such as the Lamborghini Diablo VT and the Dodge Viper GTS, two cars that symbolize unrestrained styling, something that when it works produces beguiling cars, and when it doesn't leaves us with comic-strip exaggerations, parodies on design that are either swept under the carpet and wished away or idolized like the Lamborghini Countach. Styling, like beauty, is all in the eye of the beholder. Some of us just have better eyes.

As we embark on this journey that is the 21st century, the automobile will evolve in ways that we cannot yet imagine, but the styling of the 20th century will undoubtedly have a great influence on what we see in the years to come.

Looking ahead, Mercedes-Benz has created the Vision, a model of what the next generation sports car might look like. It is a car that breaks new ground in design, engineering, and technology, a car as new as a sunrise, but so firmly linked to the past that it embodies the entire history of the Mercedes marque. Quite an achievement. With the next generation SL having made its debut in 2002 as a 2003 model, the innovative Vision SLR will not be far behind.

The art of the sports car will continue to evolve in the 21st century, and wouldn't it be interesting if it all starts over where it began 100 years ago, with a Mercedes?

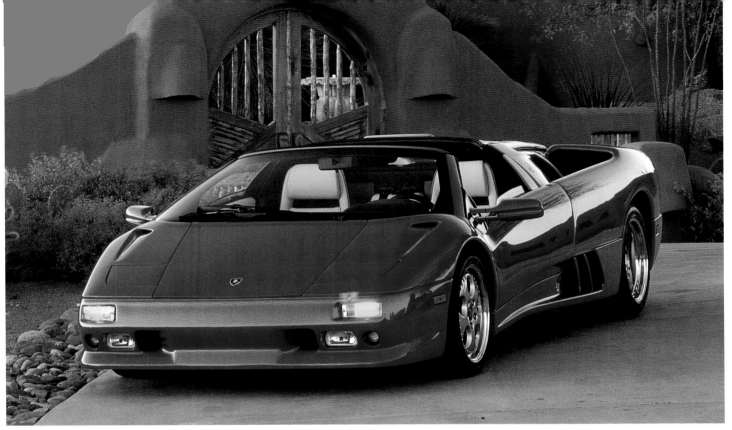

LEFT: *How far can designers go? As far as the budget allows. For the Lamborghini Diablo VT, the 12-cylinder, mid-engine, all-wheel-drive successor to the Countach's throne (from which the Countach had, mercifully, abdicated), stylists created a car that has kept heads turning since the late 1990s. It is one case where going to extremes actually worked.*

BELOW LEFT: *Taking a page from its own past, Jaguar addressed the problem of designing an all-new sports car that would reinterpret the legendary XKE. In 1997, the XK8 did just that. If we compare it with the original XKE coupé, the similarities are remarkable.*

BELOW RIGHT: *Change can be a good thing. Invention is even better. The Dodge Viper GTS is the first new American sports car since the Shelby 427 Cobra, an interesting occurrence since Carroll Shelby had a hand in the Viper's creation. By no small coincidence the GTS coupe resembles a modernized version of the legendary Shelby Cobra Daytona coupe.*

Index